THE ART OF
ROBERT E. McGINNIS

ROBERT E. McGINNIS · ART SCOTT

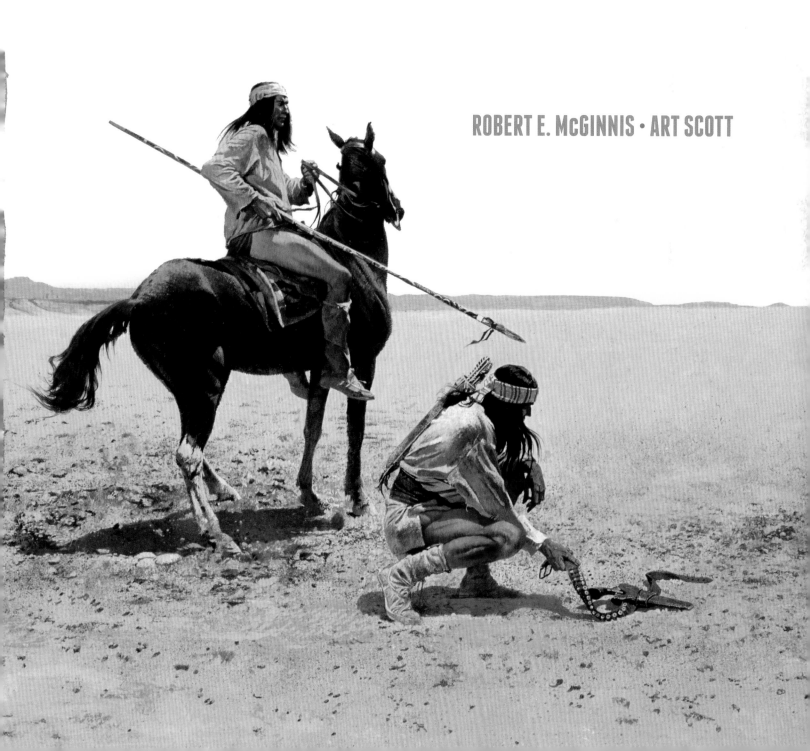

THE ART OF ROBERT E. McGINNIS
Standard edition ISBN: 9781781162170
Limited edition ISBN: 9781783291014

Published by
Titan Books
A division of Titan Publishing Group Ltd
144 Southwark St
London
SE1 0UP

First edition: October 2014
10 9 8 7 6 5

Consulting Editor: Kyle McGinnis

www.titanbooks.com

Did you enjoy this book? We love to hear from our readers. Please email us at readerfeedback@titanemail.com or write to us at Reader Feedback at the above address.

Author Dedication

For the DAPA-EM gang: sharp minds, fast friends.

Author Acknowledgments

First of all, profound thanks are due Robert McGinnis; without his genius, talent, and industry this book would not exist.

Second, a book project of this complexity requires input and assistance from many hands. Kyle McGinnis was a tireless and responsive source of images and information. At Titan, thanks go to Steve Saffel, Jo Boylett, Tim Scrivens, Nick Landau, Vivian Cheung, Laura Price, and Obi Onuora. Thanks also to Charles Ardai, Robert Wiener, the folks at Heritage Auctions, Bob Speray, Jimmy Palmiotti, and Walter Simonson for material assistance and support.

Finally, I wish to acknowledge those friends—some no longer with us—who over some forty-odd years have provided support, information, and goodies in my obsessive collecting and cataloging of the work of Robert McGinnis: Wally Maynard, Paul Langmuir, Alvin S. Fick, Lance Casebeer, Graeme Flanagan, and Ray Torrence.

ROBERT E. McGINNIS

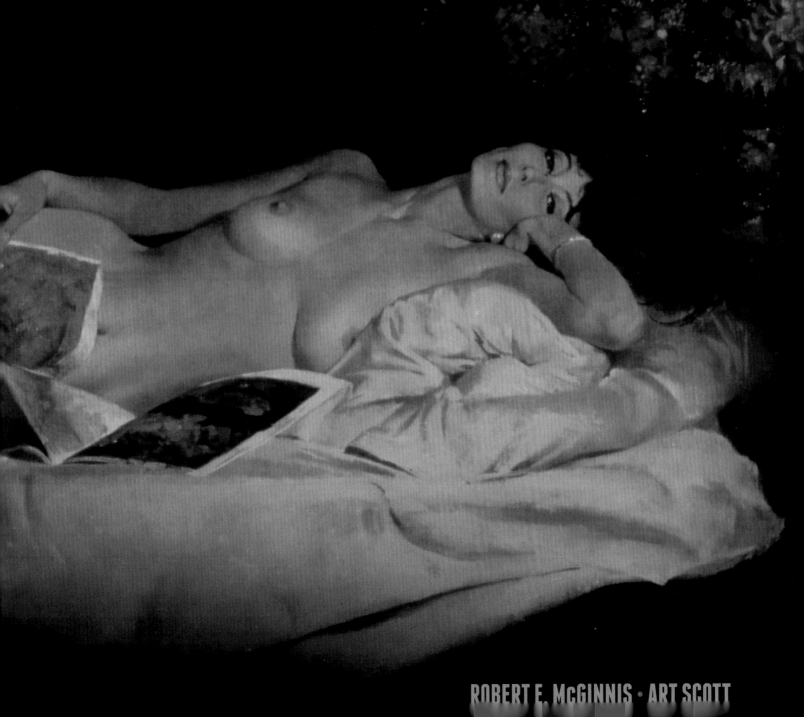

ROBERT E. McGINNIS · ART SCOTT

DEDICATION

To Ferne, companion and wife, whose caring grace, wisdom, and artistic gifts shaped existence and home.

ALONG THE WAY

Miss Brand
Harold Rice
Walt Disney
Alvin Fick
Dr. Wallace Maynard
Paul Langmuir
Arnie Fenner
Paul Jilbert
Art Scott
Mike Hooks
Walter Brooks
Dale Phillips

Don Gelb
Al Allard
Barbara Bertoli
Rolf Erikson
Robert Wiener
John English
Frank Kozelek
Len Leone
Ed Brodkin
Smolen-Smith-Connolly
Bill Gold
Charles Ardai

Sal Lazzarotti
Larry Laukhuf
Mitch Itkowitz
Terry Brown
Shannon Stirnweiss
Willis Pyle
Shere Hite
Andrew Wyeth
Mildred and Nolan McGinnis
Son – Kyle McGinnis

↓ **Buckeye Battle Cry:** c.2001, egg tempera on panel [hereafter "on panel" is omitted in the interest of brevity]

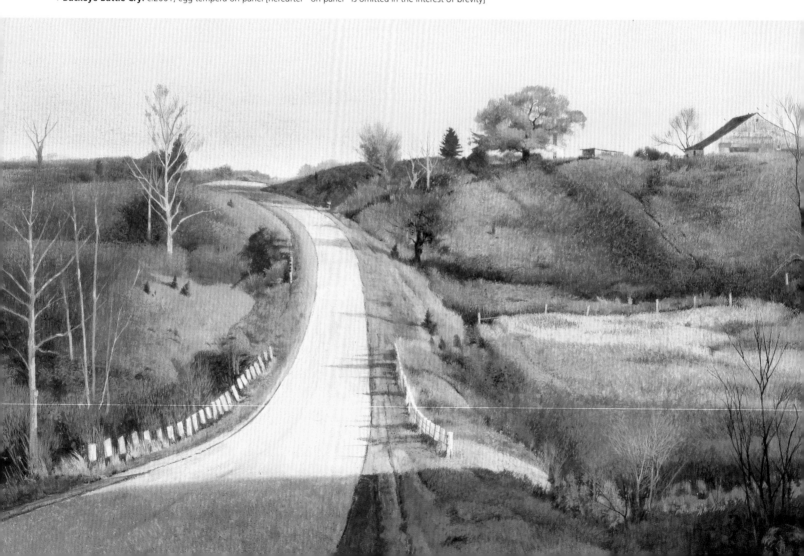

CONTENTS

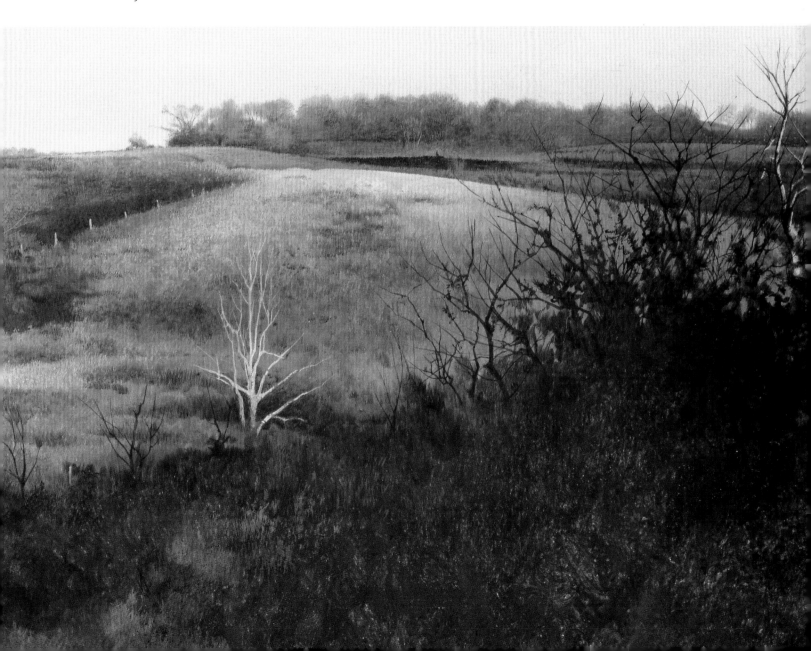

INTRODUCTION

Robert E. McGinnis's career as a professional artist spans eight decades; the earliest piece dates from about 1947, the latest from 2014. Happily, he is still painting, in the grip of a unique talent and an irresistible impulse to create beauty and capture ideas, emotion, and character on illustration board and canvas, in tempera and oil. Quoting McGinnis:

"Painting is addictive. There is never enough time, never enough satisfaction, always ahead is that moment when it will all come together in triumph, a moment, I suspect, eternally evanescent. Nonetheless, painting is a good friend and I'm fortunate to be blissfully under its spell.

"My desire to paint intensifies with each passing day. There's so much I want to do, and there's often indecision. Which and what should I do first? I get excited about everything, because I so often see beauty around me... I get myself into trouble because I want to paint it all.

"The most surprising thing to me is the grip painting gets on a person. I find that painting becomes more exciting as you go on; the deeper you get into it the more consuming the absorption. I used to do many different things—I loved trout fishing and camping and sports—but now all I want to do is paint. I can't really say why, but it's been true down through history that artists never just walk away; they paint until the day they die. They strap brushes to their arms, they're propped up, but they're painting.

"It's a wonderful thing. You never think about quitting. Because you're making something tangible, and it's your own—there's satisfaction in that. When you finish a painting you know it's the only one like it in the world, because it's yours, good or bad. You did it."

The greater part of McGinnis's huge body of work is conventionally labeled as illustration. His works for book covers, magazine stories, and movie posters place him in the front rank of American illustrators—one of the most widely seen and admired in the latter half of the twentieth century. His colleagues at the Society of Illustrators recognized that fact when he was elected to the Illustrators' Hall of Fame in 1993. At McGinnis's induction, Terry Brown, director of the society, stated:

"If a person is judged as the sum of their life's experience and an artist is judged by the sum of the expression in their work, then Bob McGinnis is so truly deserving of the society's Hall of Fame.

"The consistency and his individual style, his volume, and the independent point of view which he brought to every blank surface he faced, has added not only to his own stature, but to that of all illustrators who struggle for respect and self-expression within the constraints of the commercial world."

He is fully worthy of inclusion in the pantheon, to stand beside Pyle, Wyeth, Parrish, Cornwell, Rockwell, and the rest (though McGinnis, a genuinely humble and modest man, is uncomfortable with being placed in such exalted company).

There has always been a distinction, a cultural divide, between what is called "illustration" and what is called "fine art." The subject surely drives most working illustrators crazy. For those not invested in making this distinction, and to most people viewing a painting, this distinction would seem trivial or irrelevant. The picture is the picture, regardless of the circumstances of its creation and purchase,

↓ **h.i.s. clothing advertisement:** c.1954, magazine tearsheet

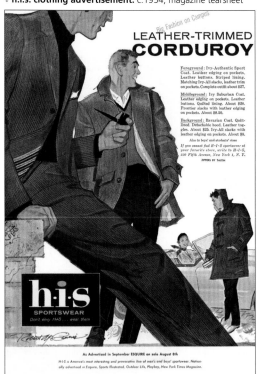

↓ **Canada Dry advertising display:** c.1954, proof

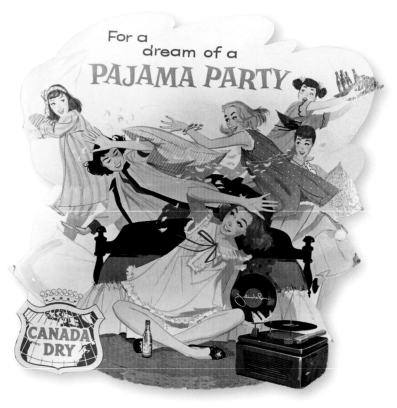

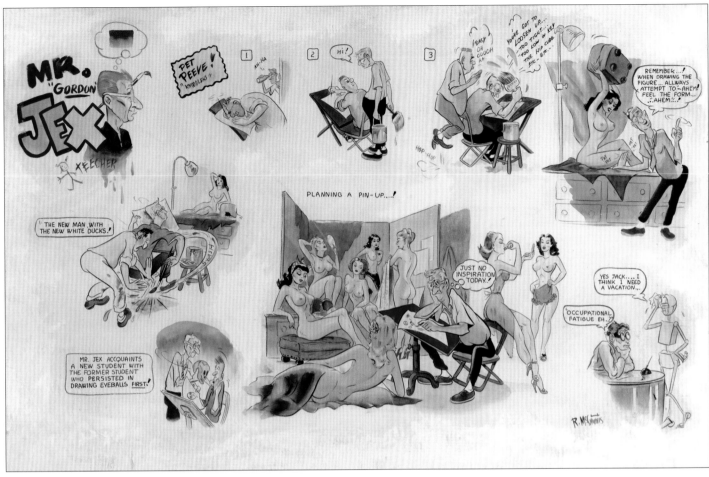

↑ **Mr. Jex:** c.1947, watercolor and ink

or the esthetic notions of the artist. Look at it, evaluate it on its own terms. Does it delight you, repulse you, amuse you? Does it stir up ideas or memories or emotions? In a 1993 *Art of the West* magazine article McGinnis speaks sensibly about this:

"I'm still doing fine art in my illustration work. There is no difference in attitude. The only difference in illustration is the collaboration with the author, art director, and publisher, compared to my other paintings where I am the sole source of creativity. One is not superior to the other."

Until you come to the final chapter, displaying McGinnis's gallery paintings, the images in this book are indeed *commercial* art. They were commissioned and paid for to promote the sale of goods: books, magazines, movie tickets—even, early in his career, such things as furniture, clothing, dog biscuits, and ginger ale. That McGinnis was a talented, productive, and reliable workman, and that his paintings were exceptionally effective engines of commerce is attested to by his long career at the top of the profession.

More concretely, it is also attested to by the professionals he worked for, such as Len Leone, former art director at Bantam Books:

"When I commissioned him to illustrate a particular title I knew I would receive something superior to what was being done. First of all, the guy could 'draw up a storm.' Second, McGinnis had, and has, a superior, almost sixth sense about color. I would marvel at this aspect of his art. He had a unique way of using color by not using much color. Yet strangely, his illustrations always appeared colorful—sensitively, selectively colorful."

And Frank Kozelek, former art director at Signet Books:

"He always wanted to give you his best effort to choose from. He was always concerned with your reaction to his work and always ready to do more on a project if you weren't totally happy with either

↓ *Master Detective* **magazine:** March 1956 issue

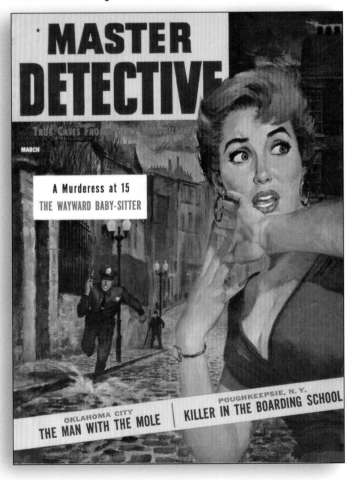

a sketch or a finished painting. I don't think I have ever met an artist with less apparent ego—though his work could have supported a very healthy one."

And Don Smolen, former art director for publicity at the United Artists film studio:

"Perhaps the finest illustrator of women that ever was, was Bob McGinnis, or is Bob McGinnis to this day. If you wanted paintings of beautiful women, in my opinion as an art director, there was no one better than Bob McGinnis. That's how we came to Bob, it was simple. I didn't know anybody else that could do what he could do."

Truth be told, the label "illustrator" is inadequate, even misleading, as applied to McGinnis. Consider the more than two hundred covers he painted for detective novels in his first decade as a paperback artist, the covers that made his reputation as a superlative painter of beautiful women. Those covers are not illustrations in the usual sense—visualizations of scenes in the story. They are *portraits*. And they are portraits of *real women*, his models. As with any portrait artist, he made adjustments to face and figure to portray the subject in a flattering light, and to give the viewer a sense of her personality. Apart from instructions to match the hair color to the woman in the story, he usually had *carte blanche* in selecting, posing, and dressing those women and placing them in settings that his visual imagination suggested would provide striking images.

How is that different from what Rembrandt and Gainsborough and Sargent and even da Vinci (like McGinnis, a lefty) did?

In presenting examples of his long career as an illustrator, we are fortunate to have many of the original paintings available for reproduction. Until the 1970s, when the terms of the standard contract changed and companies began to return the original art to the artist, the publisher owned the paintings, and once they had served their purpose they were often regarded as bulky nuisances, thrown away or given away, or warehoused and forgotten—like the Ark of the Covenant at the end of *Raiders of the Lost Ark*.

Much of the artwork by illustrators of McGinnis's generation has been irretrievably lost or scattered to the winds, though sometimes a treasure trove is unearthed, as happened in a Penguin-Signet warehouse some years ago, bringing to light many Carter Brown covers by McGinnis, along with important works by Avati, Maguire, Meltzoff, and others. McGinnis managed to retrieve and retain an atypical portion of his work in the 1960s, and we are able to present that artwork in its original form here.

In selecting images for this book, we have tried to strike a balance between showcasing "greatest hits"—paintings and posters that McGinnis fans and collectors all know and admire—and presenting work that many readers have not seen. McGinnis's magazine work, particularly for *Guideposts*, has remained largely under the radar. His more recent fine art paintings of landscapes, nudes, and the Old West—apart from several reproduced in the book *Tapestry*—are only seen by collectors who receive gallery brochures and follow online art auctions. We have also allotted space for some of his pencil sketches and color roughs, and have turned up some amazing finished illustrations that were somehow never published.

Above all, we have tried to showcase his incredible range—in style, in technique, in subject. Most famous illustrators, fairly or not, become identified with one thing: Gibson for his portrayals of modern women of the later nineteenth and early twentieth centuries, Remington for his scenes of the American West, Rockwell for his sentimental portrayals of middle America, Berkey for his colossal spaceships. So it is with McGinnis and his slinky, sexy, smart women. Had the pinup calendar still been popular when he appeared on the scene, he surely would have been lauded as the great pinup artist of the second half of the twentieth century, successor to Petty, Vargas, and Elvgren.

In fact, after the death of Alberto Vargas, *Playboy* magazine

approached McGinnis to take over their pinup page, a high-profile and presumably lucrative gig. McGinnis was not interested, in part because he felt the magazine's attitude toward women was "immature, adolescent." Also, he wasn't in sympathy with *Playboy*'s concept of ideal feminine beauty either, as expressed by their centerfold playmates, which he said were, "Too *zaftig*, too tan, too young." The *Playboy* pinup assignment went to Olivia De Berardinis.

But gorgeous women are just one aspect of McGinnis's work. He is a terrific cartoonist, caricaturist, portrait painter—of men, women, children, and even animals—landscape artist, poster artist, and chronicler of historical scenes, of human emotion and human drama.

A distinguished illustrator and art teacher of a later generation, Christopher Fox Payne, spoke of McGinnis's influence and stature in a recent issue of *Greenwich* magazine, where he said, "Bob McGinnis is absolutely a giant in this field. And there's only a handful of them. You look at his work and you just marvel at it—but of course he shies away from compliments."

To which we add the words of Don Smolen: "You know, the only person that doesn't believe Bob is a genius is Bob."

After a while words are superfluous. Go look at the pictures.

† **WWII Defense Plant – Ohio:** c.1944, house paint on canvas; painting by Nolan McGinnis, father of Robert McGinnis

EARLY LIFE AND CAREER

Growing up in Wyoming, Ohio farm country near Cincinnati, Robert McGinnis's affinity for art surfaced early. He wanted to draw his favorite comic strip character, Popeye, and his father, himself a talented artist, took his hand and guided it in drawing the cartoon sailor. At his mother's urging, he attended Saturday drawing classes at the Cincinnati Art Museum. After high school, he went west to California to learn animation as an apprentice at Disney. That career pathway was cut short when the United States entered World War Two and the Disney studio switched from producing theatrical cartoons to making training videos for the armed forces and morale and propaganda films for the home front.

McGinnis served a stint in the Merchant Marine, and returned to Ohio to study art at The Ohio State University (and in addition, hold the line as guard on the OSU football team). Around 1947, he began studying at a private art school in Cincinnati run by Jackson Grey Storey, and from that experience we have the earliest piece of art in this book—a delightful page of cartoon and caricature—McGinnis's affectionate tribute to Mr. Gordon Jex. Quoting McGinnis:

"Gordon Jex was doing pinups, trying to break into the big pinup calendar company Brown & Bigelow. He was working upstairs on his pinups and he was teaching downstairs. It was an old Victorian house in Cincinnati, and Jex and Grey and his wife lived there... [Jex would] sit down with a big watercolor brush; he knew his anatomy, every inch of anatomy. He could talk about it, and demonstrate it, make watercolor sketches and drawings. Then he'd show you how to make a step-by-step assemblage of an illustration. Drawings, and sketches, and a finished painting—he was a great teacher. He was the first I'd found who could just sit down and put a picture together."

From Storey's school, McGinnis worked in a Cincinnati advertising art studio, drawing television sets and mattresses for department store ads. A meeting with noted illustrator Coby Whitmore—a McGinnis hero, who specialized in painting beautiful and sophisticated women—inspired him to move to New York with his wife, Ferne, in 1953, and take a shot at the Big Time.

He signed on with the Fredman-Chaite commercial art studio, and found himself working alongside other soon-to-be-star illustrators: Frank McCarthy, Bob Peak, Mitchell Hooks, Bernie Fuchs. Two samples from that period are here, an ad for sportswear, and a display piece for Canada Dry that points the way to the sort of subject matter that would shortly become McGinnis's bread and butter. His first magazine work, assignments from Fredman-Chaite, appeared on covers for *True Detective* and *Master Detective* in 1956.

In 1958, Robert McGinnis ran into Mitchell Hooks and his agent on a Manhattan street corner. They suggested that he take a shot at painting paperback covers. Walter Brooks, art director at Dell, liked the look of his portfolio, and handed him a couple of assignments. *Built for Trouble* and *So Young, So Cold, So Fair* were his first published covers. Very quickly, he had work from other publishers. *The Red Scarf*, his first for Fawcett Crest, is one of the earliest examples of the fully realized "McGinnis Woman."

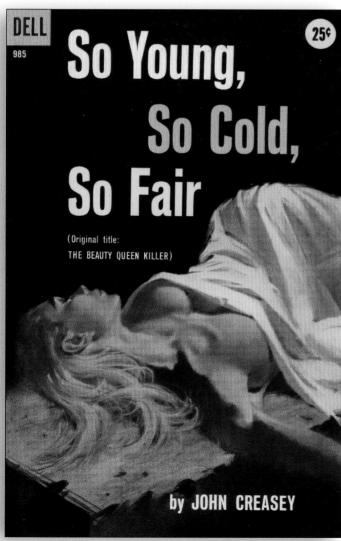

↑ *So Young, So Cold, So Fair*: 1958, Dell paperback

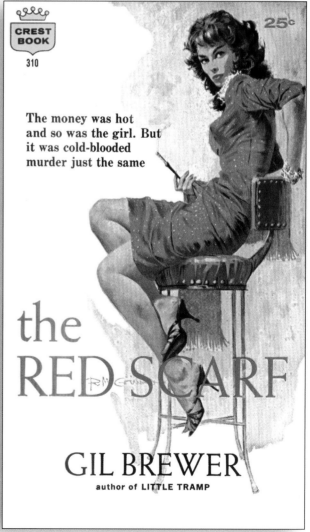

↑ *The Red Scarf*: 1959, Fawcett paperback

AN INTERVIEW WITH ROBERT McGINNIS

I n January 2014, Robert E. McGinnis took part in a lengthy interview with the author. In it, McGinnis provides rare insight into his personality, his working methods, and his beliefs about art. These are the highlights:

THE EARLY PAPERBACK SERIES

Art Scott [AS]: The first major chapter on your paperback work covers the three long-running detective series: Mike Shayne for Dell, Carter Brown for Signet, and Perry Mason for Pocket Books. Was there a difference in the way each art director wanted you to work your style specific to those characters, or did you come up with a way that you were going to approach each one?

Robert E. McGinnis [REM]: The publishers had a reader's report accompanying every book they published. They passed these reader's reports out to everyone who worked there. They had a synopsis of the story, the characters, and the period—locales and stuff like that—about four or five pages. That's what I'd usually get from the art director, and seldom would I get any direction from them. I'd submit pencil sketches, but they always wanted me to make sure the hair color was right. That's about it. Particularly with the twenty-five Milo Marches I did, they'd hand me the reader's report. Rolf Erikson was the art director—I don't know if I'd show him the sketches first, I think I did, and he'd say, "OK Bob," and that was it.

AS: Who decided to put James Coburn on the covers?
REM: That was my doing, and I was amazed that I got away with it! I thought, "One of these days he's going to give me a call."

AS: I don't think the legal precedent for celebrities owning their image rights had been set, though it took hold not long after that.
REM: I don't know, but I was braced for a call from him.

WHAT IT TAKES TO DO A COVER

AS: One cover I wanted to ask you about is *The Merry Adventures of Robin Hood* [1985]. That's a very unusual perspective; in the film business I think they call it a high crane shot.
REM: Yes, a bird's-eye view.

AS: I was wondering, because the book is by Howard Pyle, and illustrated by Howard Pyle, whether you were inspired to do something special for it.
REM: You're right, I was. I thought, "How can this be, that my name would be associated with the great Howard Pyle?" I did work hard on it; it was very difficult. I even climbed in a tree and photographed branches coming down. I hired two models, and Bob Osonitsch took photographs looking down, with bows and arrows and the costumes. Osonitsch used to photograph for most of the illustrators—he had models and would photograph them. He did a good job on these action poses. But I did go out in the woods and climb up a tree and photograph the branches. Those weren't models, they were real

trees, and I had to get the angles right. And I had a movie still, I think, of the procession beneath, the soldiers walking below. It was a very difficult painting, and complex, but I was inspired to be associated with Howard Pyle.

AS: Well, you're both Hall of Famers, though you weren't in 1985 when you did the painting.
REM: He's a giant; I can't get near him. Anyway, I enjoyed it. I'm glad you brought it out.

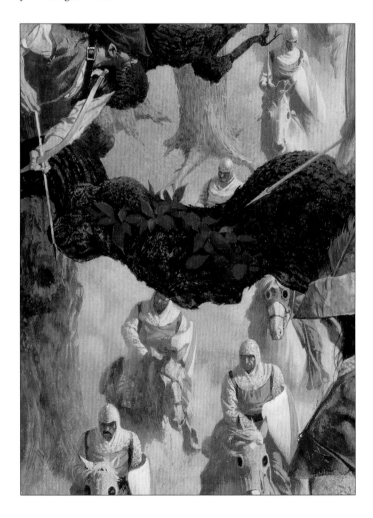

RESEARCH AND ROMANCE

AS: In the 1970s, you were doing the romances and the big covers with the wraparounds, really elaborate things, like *Princess Daisy* and *Cathay* and *The Journeyer*, that required a lot of research, and they're big paintings. How much more work was it to do a big, complex historical wraparound painting as opposed to, say, doing a single portrait of a woman for a Mike Shayne cover.
REM: It required a lot of research. You really have to get the background correct. I have a wonderful filing system—it was designed by Al Parker, one of the founders of the Famous Artists correspondence course. I got a copy of his filing system and I've used

it all my life. Every time I see something that I think would fit into a painting, or something interesting, I file it away. I can go to my files rather quickly, and I have a bunch of picture books here in the studio, and I can go to those.

AS: Do you have a similar system for model photos?
REM: I have contact sheets of all the black-and-white photos of models, yes. I work from black-and-white for paintings of women. I'd use a roll of film with twelve exposures and make a contact sheet of those twelve exposures and file those. I have a file cabinet filled with contact sheets of all those pictures I've taken. But things have changed; you can't buy film. I've printed my own film, developed my own negatives, but you can't even get chemicals, or paper—unless you go to New York to a specialty shop. The small camera stores don't carry any of that stuff any more. It's terrible; I had a Rolleiflex camera, the best Rollei you can get, but I don't use it any more because you can't get film.

AS: For the stuff you did in the '60s, private eye novels and the like, you typically worked at twice the size of the finished book cover, two-up. Which is rather small compared to some other illustrators. There are paintings by Avati and Meese, for example, where they worked three or four times printed size.
REM: I know! I don't know how Avati produced the monumental amount that he did, working so large. It's tiring and difficult.

AS: Did you work two-up even for the big panoramic things like *Princess Daisy*?
REM: That was a little larger than usual, but not a whole lot. That was one of the larger ones I've done, really. The Bruce Nicolaysen ones were large, such as *The Pirate of Gramercy Park*. Those were large and required a lot of New York City history.

AS: It always seems, in your historicals, that you wanted to work a sailing ship or boat into the picture, whenever you had an excuse to do so.

REM: You're correct there. It's a symbol of romance, escape to the sea—it's a nice symbol. I used that a lot, but it was part of the story, too. *Pirate's Landing* was one about the early settlers in Plymouth and that has the *Mayflower* in the background, I think.

MODELS

AS: There are a couple of models you used often in the paperback private eye era. Lisa Karan was your model for many, like *The Venetian Blonde* and *The Scrambled Yeggs*. And of course, there was Shere Hite.
REM: I'm surprised you remember Lisa Karan. She's great. She really had [the right] proportions, just amazing.

AS: Once you were into the '70s and doing all of those big romances by Rosemary Rogers and Johanna Lindsey, were there any models that you preferred?
REM: Yes, one was a girl who worked at *Guideposts*—these names elude me—and she later undertook the printing of my depiction of the Pilgrim village, *Freedom's Gate*. She posed for some of those romantic covers. She was very attractive. Now some of these models worked down at Bob Osonitsch's photo studio. They were available down there and he would have them come in, because they were costume things, and the costumes were important, and you could get rental costumes in New York. He knew where to get that stuff. So a lot of those girls were posed working in New York City, and I didn't really know them.

Shere Hite was my favorite, though Lisa Karan was equally good. Shere had great ideas—she would go to thrift shops and get very tasteful, expensive garments, and she'd bring them along in a big valise and bring them out. I benefited a good deal from her good taste and refinement. She once told me, "You don't know how difficult it is to be a model. You have to work constantly on your nails and hair and everything else." It was real hard work and you can't take it for granted.

← **The Merry Adventures of Robin Hood, detail:** *See page 85 for the complete painting.*

→ **The Housewife:** 1971, pencil sketch; *Cosmopolitan*

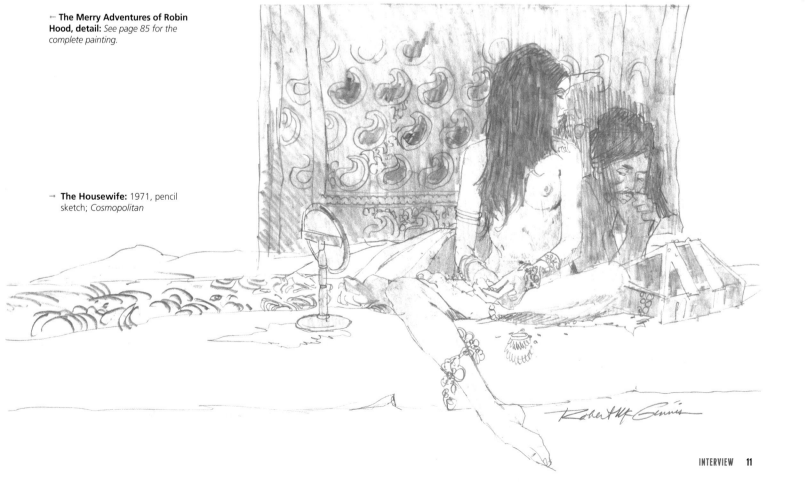

She was with Wilhelmina [Cooper, the famous model and agent], and she and Wilhelmina were good friends. Shere was not quite tall enough to be a runway model, but I could make those changes necessary to stretch her legs out a little bit. Other than that, she had everything. She had a fascinating, versatile face. She looked great.

AS: You actually appear, as a model, in the *Guideposts* painting called *What's the Rush?*. Though, unlike a lot of illustrators, who use themselves as models all the time, you haven't made many Hitchcockian cameo appearances in your paintings.

REM: Well, I don't qualify—I don't look good as a model. That's the truth. I didn't think I had what it took to be a good model. There, in a pinch, I had to do something and [stand] behind Bill Potter. He was a doctor—he's passed away. He was a very good model. He lived here in Old Greenwich.

AS: You've used a lot of friends and neighbors in Old Greenwich—that's another sort of Rockwell thing—and you've used your own children a lot.

REM: Yes, I was always shy to ask somebody to model. It's really difficult for me to do that, it seems like a silly thing to do. I didn't want to bother people. It took a lot of courage to ask them.

AS: I can't imagine, if you asked an attractive woman to model for you, if she ever saw one of your paintings, that she would do anything but jump at the opportunity.

REM: Well, it's sort of worked out that way! That's true. I think the ladies wanted to be seen, and they wanted to escape obscurity, and they wanted to have their confidence intact. Flattery, it works.

AS: To be painted and be portrayed as a goddess—it's got to be catnip to a model.

REM: It is. That's the effect that showbiz has!

MOVIES AND AGENTS

AS: In this book we present two versions of *Comes a Horseman*. There's your painting and then the poster. We've all heard the story of having to stretch James Bond on *Diamonds Are Forever*, but this is an even more interesting example of manipulation. For the poster, the studio flipped the painting around so Jason Robards is on the right instead of left, and they faded him out, as if his face is in shadow. It looks like either James Caan or Jane Fonda—who are the stars—or their agents complained that Robards is a supporting character and shouldn't be equally prominent.

REM: You're right on the button on that. I didn't realize that they had faded him almost to obscurity, Fonda in the middle—big star—and Caan on the left. Somebody else did that manipulation.

AS: Everyone who's worked on movie posters has said that in working with movie studios you have to answer to so many more people, including the art director, the marketing department, the actors and their agents.

REM: About agents—with *Semi-Tough*, I remember they were up against a terrible deadline and were depending on me to come through. Don Smolen came down from Westport, where he lived, at eight in the morning. He walked in and said, "Bob, is it ready?" I was working through the night on that one, and had just put the last touches on it. It shows Kristofferson and Reynolds on the bottom of the pile [of women]. They objected to that. I think they did print it somewhere, but the agents said they should be on top, not the bottom of the pile, because that diminishes their stature. And so I did the other one [the "Hike!" pose].

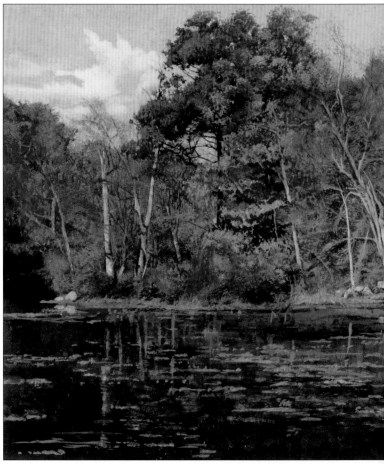

↑ **Poverty Hill Pond:** 2011, egg tempera

AS: The other one is the one you usually see.

REM: They insisted on Kristofferson and Reynolds being featured at the top. That ties in with what happened with the James Bond thing. He was not supposed to be below the women on either side. That's the way they do it—they're really zealous about their stature on the poster.

CATS IN A BARN AND ANDREW WYETH

REM: I'll tell you, there's one [illustration in *Guideposts*] that is probably the best painting I ever made. My daughter has it framed on her wall in her home. I can't believe I did it, and it's as close to Andrew Wyeth as I could ever hope to be. It's a bunch of cats in a barn [*Cat With No Name*]. Wait until you see the reproduction of it. I go and stand in front of it, and I can't believe I did it. I can always find fault, and failure, and something wrong with my paintings. I look at that and I can't find one stroke wrong anywhere to improve it or change it. It's as close to Wyeth as I'll ever get. And by the way, Wyeth is—you may be startled to hear this, but I think he is the greatest painter that ever lived.

AS: No, I'm not startled to hear it from you.

REM: He is without equal in history. You just take one of his paintings and sit down at a table and study it. You can study it all day, and discover little things in there that you didn't know existed. He was so intelligent, and so sensitive, and so real. He was even closer to the earth than Thoreau. People don't understand it in this country, that we had the greatest that ever lived. They can't believe it. But I've seen artists, all kinds, the best illustration has and all that, and he shines like a star above everyone.

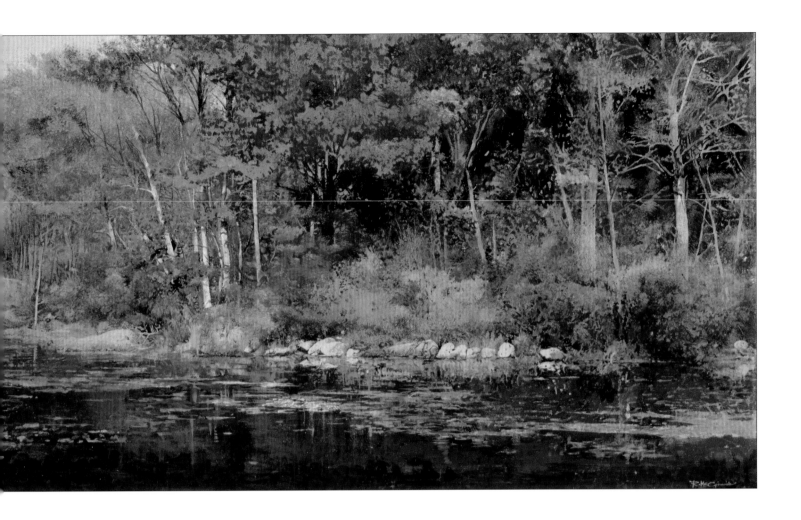

Paul Calle said the same thing. He said he went down to visit one time, he walked in, and there Wyeth was. He said it was like being in front of God. Paul Calle and I agreed that he was out of this world. Anyway, that's just a little aside here, but that's the way I feel about him.

AS: I knew you felt that way. I recall visiting you and seeing the framed letter that you received from Wyeth.
REM: It's still there on the wall. It's my most prized possession.

POVERTY HILL POND AND THE CURSE OF PERFECTIONISM

AS: One of the paintings we found for the book is *Poverty Hill Pond*, which is absolutely stunning. Is that relatively recent?
REM: Yes, it's about a year and a half old, I think. It's on the way to Newtown, Connecticut, where my daughter lives. It's a back-country road, and there's this beautiful pond. In the autumn it looks like that. I assembled several parts of it and put them together. I have a wonderful reproduction on the wall here—the colors are accurate—a giclée print on canvas. The original sold immediately. I'm very pleased with the color of that print.

AS: You're very attracted to earth tones in most of your landscape paintings, but this is really the opposite, it's just a riot of color, as they say.
REM: Well, that's it. Autumn is really overwhelming in this part of the country. You just can't believe what you're seeing in the way of color. But you play that against the gray of the trees and the woods,

and then you have bursts of color—it ranges from warm reds to cold reds, to oranges and yellows. You have all kinds of reds working together and relating, and it's just a nice change from the austerity of Andrew Wyeth. He once in a while would use color, and when he did it was just strong, just right. Anyway, I won't dwell on him again...

AS: You've alluded in the past to your perfectionism, getting over-finicky, and reworking and reworking. With gallery work, you're not up against a deadline where you *have* to stop painting, so how do you police the impulse to never be satisfied?
REM: You have to force yourself, and push yourself. Sometimes you finish a painting, and you say, "Well that's it, finally I'm finished. I like what I've done." Then the next day you come in and see things that could be improved, and you start in again with that. I can't really let it go unless it feels right inside. It's a feeling. It's the strangest thing. If it doesn't hit you, you know there's something missing, that something's wrong.

It could be bad drawing, or the abstract design is weak, but if you go back and you get a fresh eye, you can see things that need work. You can't just say, "Oh, that's done, and the heck with it," and send it out. I just can't do that. I don't know how to explain it, but you have to get it right.

Now I don't work as hard as Wyeth did to get it right. His wife said sometimes you'd think Andy would burst trying to get something right. It would drive him crazy, almost, until it was right, then he'd let it go as finished. That works in me, but not to the same degree. You kind of can sense when it's not right, and you have to hang in there even though you don't want to—it becomes labor. But then you put it away and come back the next day and then you see what's wrong.

I'm sure other artists go through the same thing, as both Betsy Wyeth and my wife, Ferne, understand.

SEVEN DECADES OF McGINNIS BOOK COVERS

When the mass-market paperback was introduced to American readers by Pocket Books in 1939, their business model was to sell quality reprints of classics, bestsellers, and works by popular authors. Though the books were small in size and inexpensive at just 25 cents, they were well made, printed on good paper—miniature hardcovers, in other words. Pocket strove to reinforce that notion by adopting the then-prevailing graphic style of hardcover dust jackets. Cover artists like H. Lawrence Hoffman and Leo Manso provided restrained, tasteful illustrations strong on graphic design and symbolism. The idea was clearly to take the high ground, and differentiate the look of their books from the other prevailing source of popular fiction, the pulp magazines.

Pocket Books releases were a huge success, and other publishers soon jumped into the paperback business. Many of them, like Dell, Fawcett, and Popular Library, came from the pulp magazine and comic book world. They had a different notion of what a cover should look like. They couldn't rely on best-selling titles and famous authors to sell their wares; their mantra was, "The cover sells the book." Most paperbacks were displayed in "spinner racks," face out.

Bright colors and exciting action delineated by realistic illustrators soon dominated the racks. The artists for Pocket's new competitors came from the pulps and from the "slicks," prestige fiction magazines like *The Saturday Evening Post*.

After World War Two, the pulps and fiction magazines declined rapidly. Paperback book covers became the hot market for veteran illustrators and talented up-and-comers alike. McGinnis's first paperback covers—in 1958 and 1959—immediately marked him as a major talent, and within two years he was doing upwards of fifty covers a year, thus launching an unparalleled career in book illustration. Seven decades later, he has painted more than a thousand covers.

The engine that fueled this career was the McGinnis Woman. The sophisticated look of Coby Whitmore's women influenced McGinnis's own notions of how to portray them. While most paperback illustrators of the period were wedded to the voluptuous starlet look—Marilyn Monroe and Gina Lollobrigida, for example—he looked to fashion magazines for prototypes.

The old pulp-style cover had been the standard—a scene from the book, usually featuring an attractive woman, either menaced or menacing. McGinnis's covers, however, were straightforward portraits of the principal female character, alluring and enigmatic, generating curiosity in the would-be customer, who was thus motivated to buy the book to find out who she was and what she was about.

The portraits he painted for the covers of the Mike Shayne books first defined the characteristics of the McGinnis Woman. She is slim, leggy, elegant, intelligent, and sensual, rather than merely sexy. She usually makes eye contact with the viewer, and in her gaze there is both an invitation and a challenge. That woman was the central ingredient in a new marketing concept for the private eye novels, and it dominated the racks in the '60s and early '70s.

McGinnis's work on the Carter Brown books was his most notable success. The lightweight and entertaining books by a prolific Australia-based writer had failed to find an audience in America,

and Signet was ready to kill the series. As an experiment, they put McGinnis to work. He painted a hundred stunning women on Carter Brown covers over a span of eleven years, and Signet sold tens of millions of books.

As male readership declined and female readership soared in the early 1970s, private eyes lost popularity. At the same time, Avon was the pioneer in developing a new genre of extra-steamy romance. Editor Nancy Coffey found the writers and defined the storytelling style, art director Barbara Bertoli defined the signature look of the books. They were dismissively referred to as "bodice rippers," but by whatever name, they sold like crazy. McGinnis readily made the transition from contemporary to historical, and modified the formula to suit. There was still the gorgeous McGinnis Woman, but softer and more yielding—not alone on the cover, but melting in the arms of her dashing suitor.

McGinnis's talent for painting women, while the touchstone of his paperback career, certainly isn't the whole story. He is incredibly versatile, bringing a dazzling technique and an imaginative eye to covers on literary classics, modern bestsellers, Westerns, spy novels, and children's books. Over the three-decade span from the '60s through the '80s, the McGinnis style helped to define the look of paperback books.

McGinnis's influence wasn't confined to the United States. His American publishers provided cover art transparencies to publishers in other countries with whom they had reprint and translation agreements. Hundreds of McGinnis covers—especially from the popular private eye books—have appeared on every continent (save Antarctica), in dozens of languages.

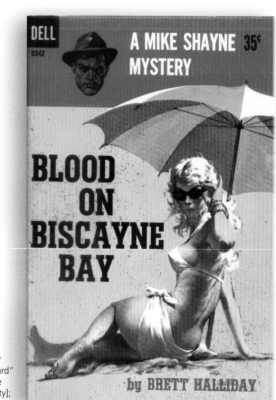

→ *Blood on Biscayne Bay*: 1960, Dell paperback

→ *Target: Mike Shayne*: 1960, tempera on illustration board [hereafter "illustration board" is omitted in the interest of brevity]; Brett Halliday, Dell

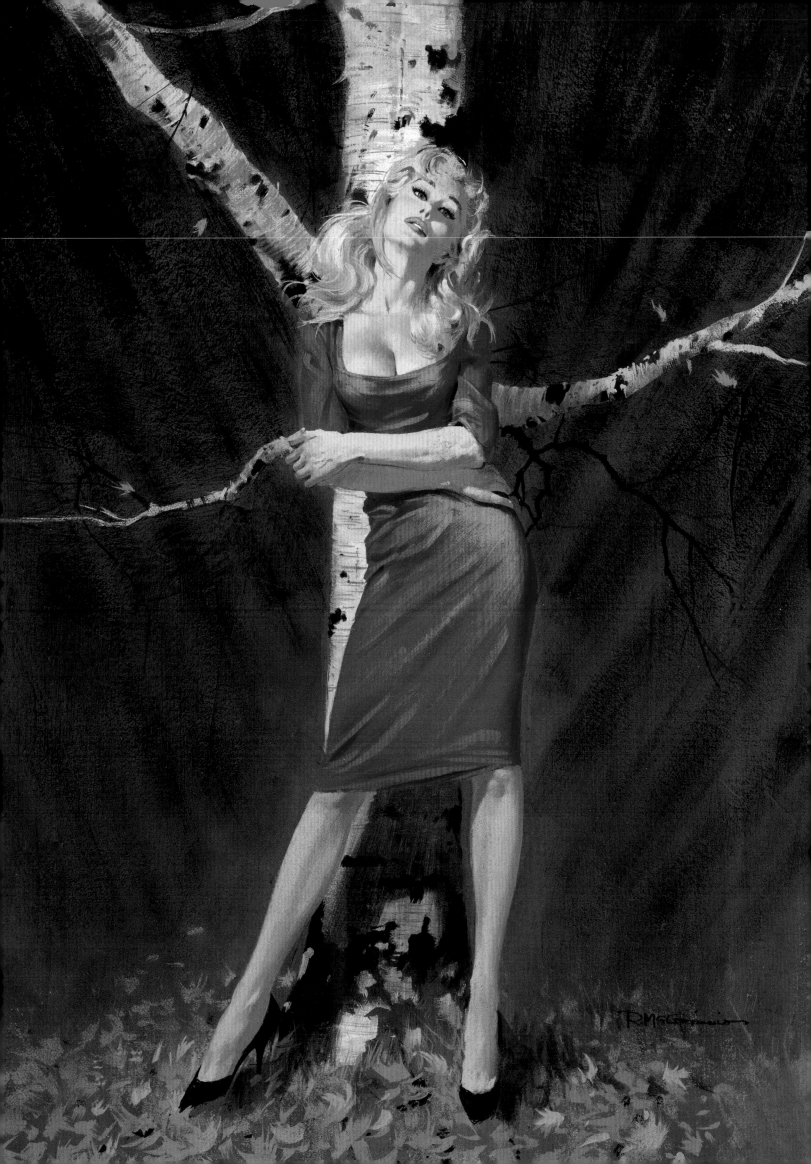

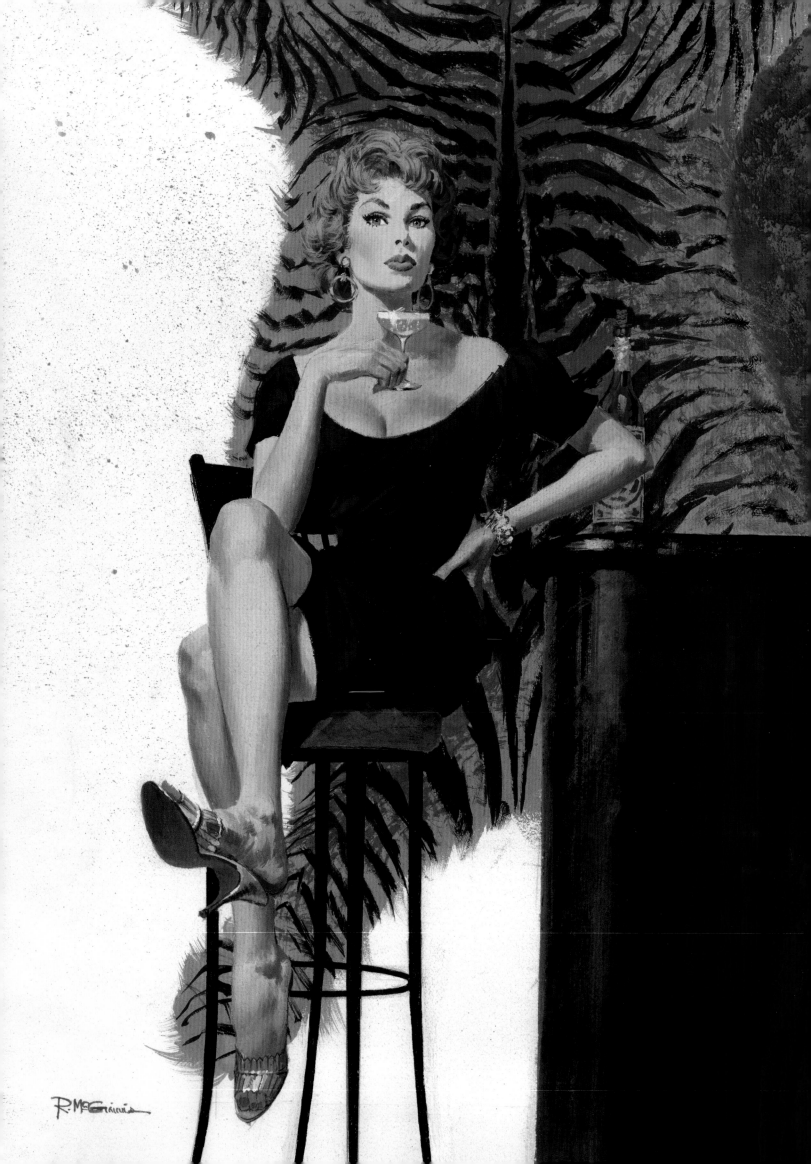

← **A Taste for Violence:** 1967, Dell paperback

↓ **Dangerous Dames:** 1965, tempera; Brett Halliday, Dell

← **Counterfeit Wife:** 1960, tempera; Brett Halliday, Dell

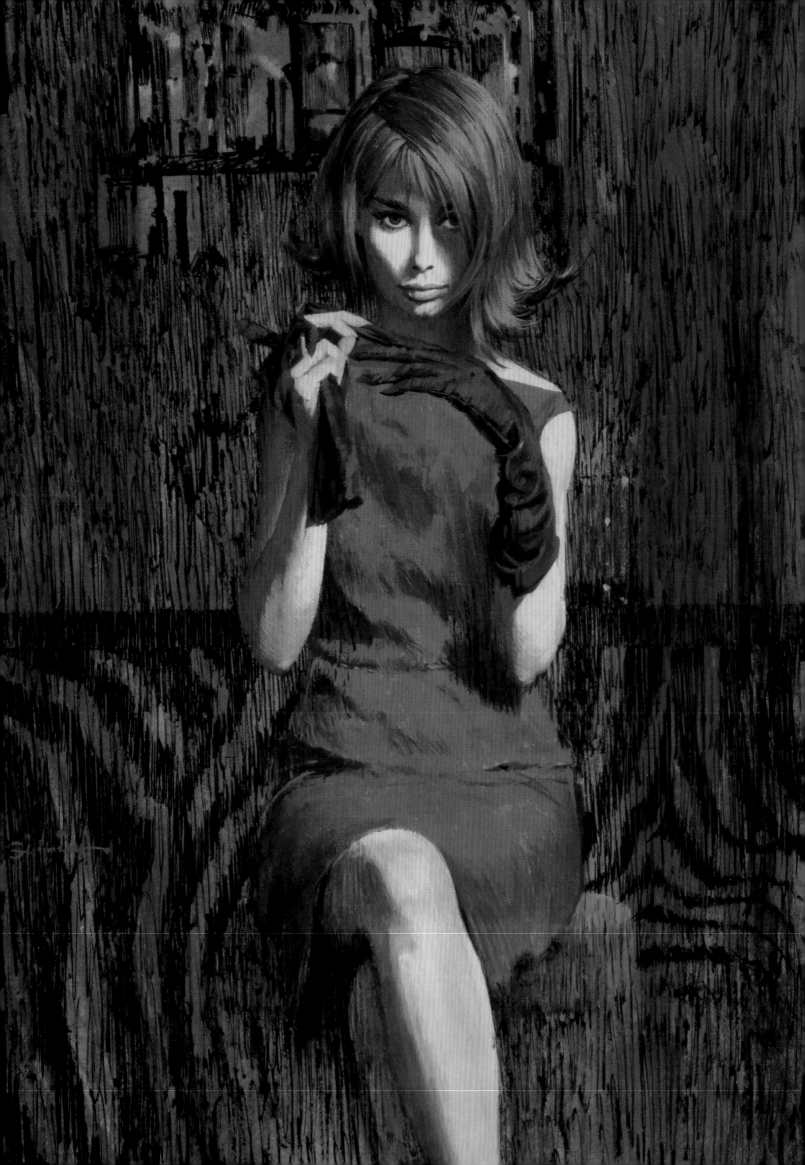

THE DETECTIVES
MIKE SHAYNE, CARTER BROWN, PERRY MASON

McGinnis's covers on three popular detective series early in his paperback career immediately cemented his reputation as a formidable illustrator. Moreover, they were the coming-out party for the McGinnis Woman. Showcasing attractive women on the covers of private eye novels was hardly an unusual concept, but these three series, from three different publishers, established a particular formula that proved to be a hugely successful sales tool:

a) A consistent cover design and series logo.

b) A woman alone, usually in repose or implied conversation with the reader.

c) Eye contact!

The Mike Shayne series from Dell was the first, and established the pattern. McGinnis painted eighty-six portraits of McGinnis women, beginning with *The Private Practice of Michael Shayne* in 1958. McGinnis's run on the series ended in 1968, when Dell switched to photo covers.

← **Never Kill a Client:** 1963, tempera; Brett Halliday, Dell

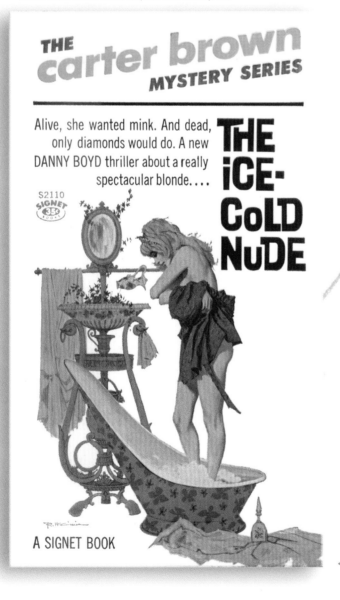

← *The Ice-Cold Nude:* 1962, Signet paperback and pencil sketch

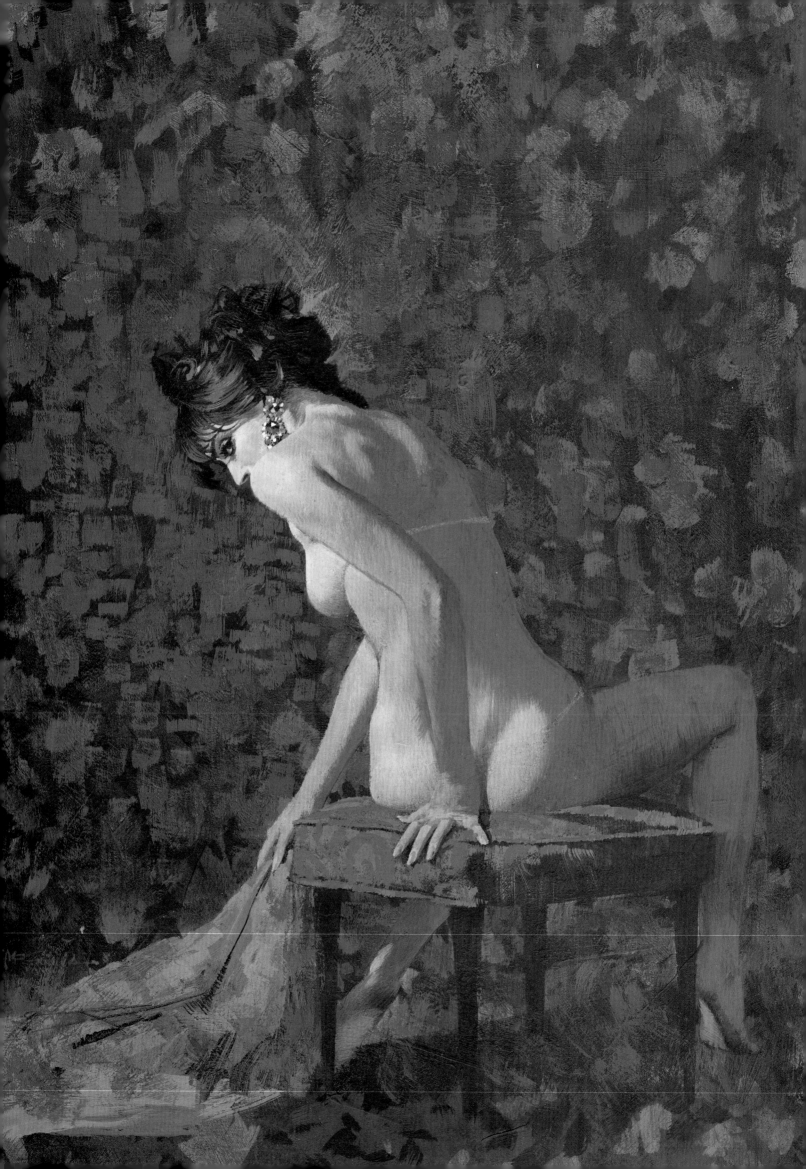

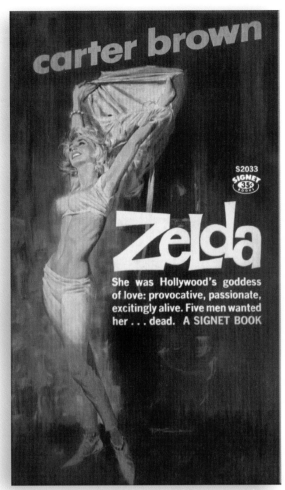

↑ **Zelda:** 1961, Signet paperback and pencil sketch

← **So What Killed the Vampire?:** 1966, tempera; Carter Brown, Signet

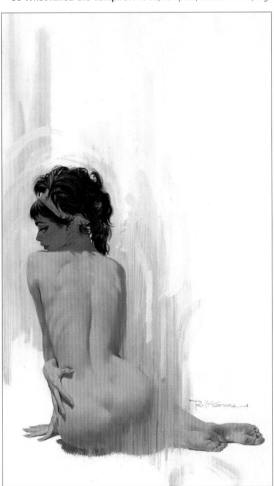

↑ **Angel!:** 1962, tempera; Carter Brown, Signet. The sixth McGinnis Carter Brown cover.

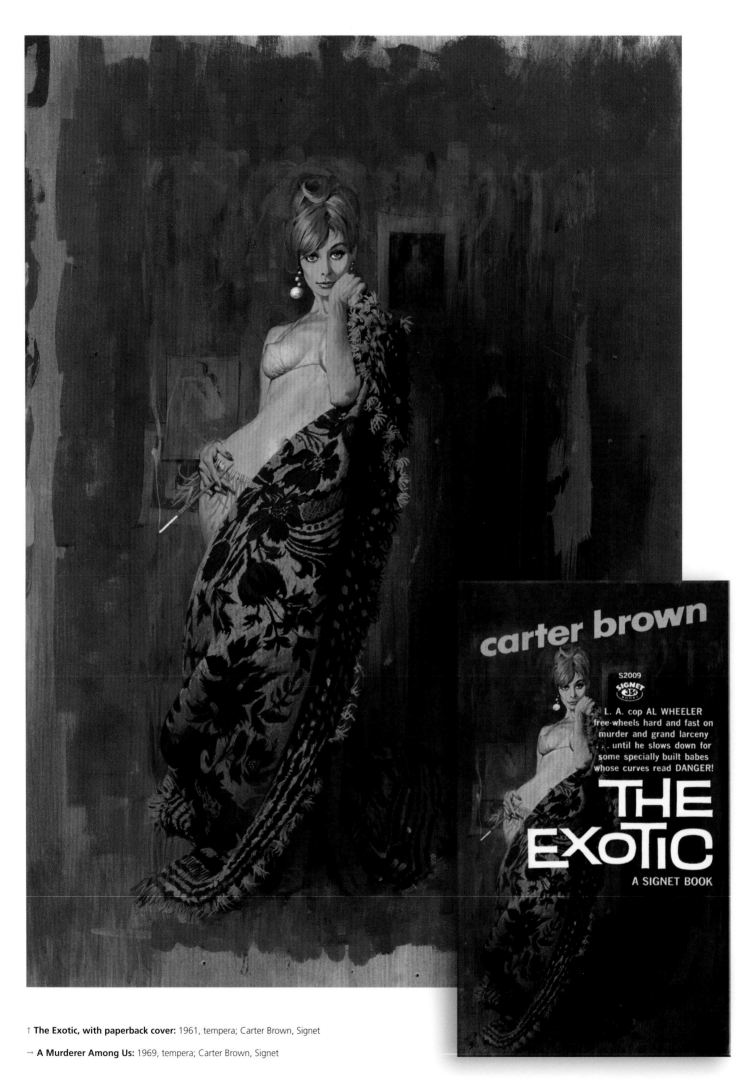

↑ **The Exotic, with paperback cover:** 1961, tempera; Carter Brown, Signet

→ **A Murderer Among Us:** 1969, tempera; Carter Brown, Signet

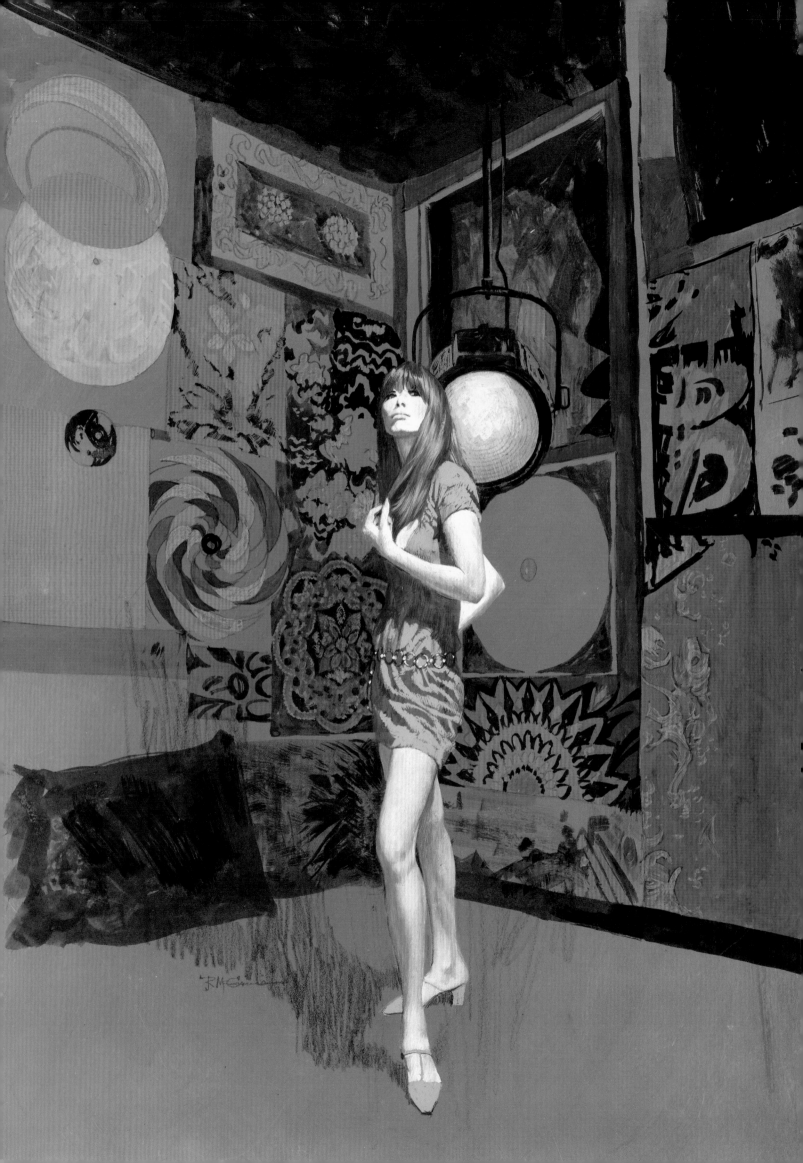

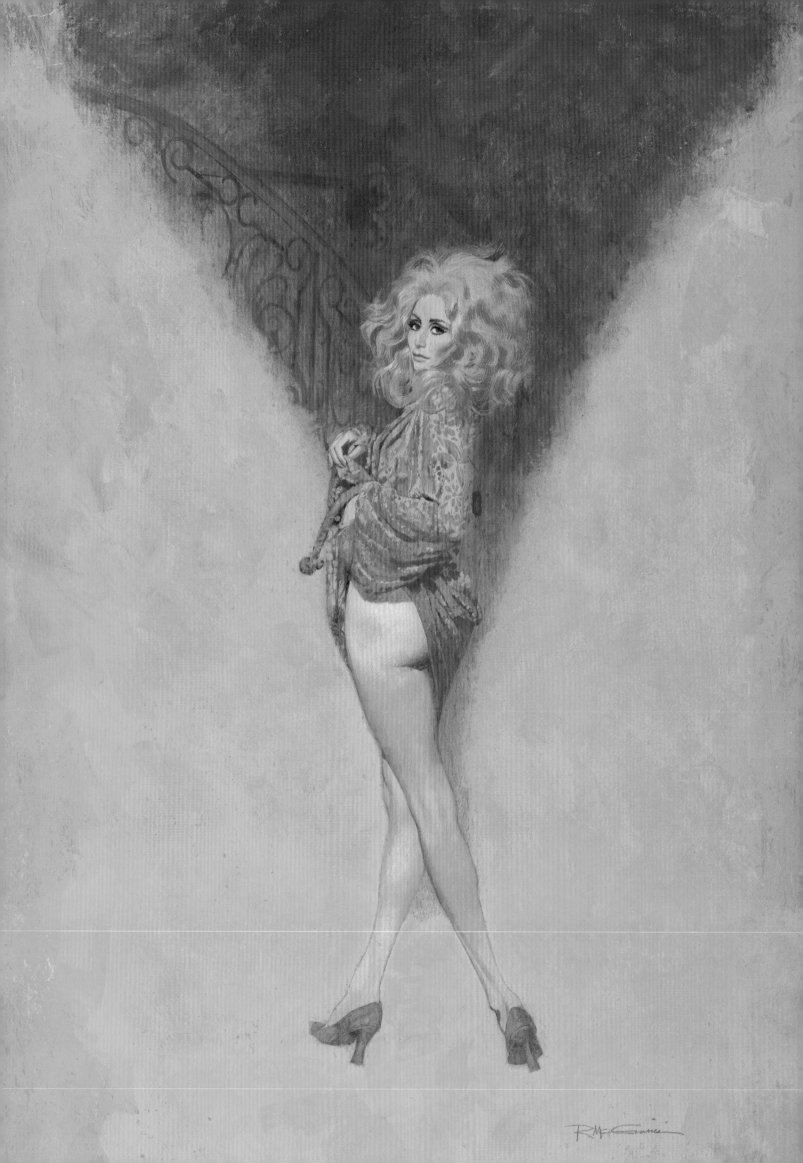

The Carter Brown series from Signet came next—the biggest and longest-running series of them all, and a high point of McGinnis's paperback career. He painted an even one hundred covers, from 1961 to 1972. His work in the last few years of that period is particularly noteworthy, with elaborate backgrounds and exotic costumes, many featuring a favorite McGinnis model, the gorgeous redhead, Shere Hite.

The Perry Mason series from Pocket Books is only thirty covers, from 1962 to 1964. It is important in that it demonstrates how McGinnis tweaked the formula to suit the market. The celebrated never-lost-a-case lawyer was a more "upmarket" character than the others, and popular with readers of both sexes. The women on the Perry Mason covers are generally cooler, more elegant, less overtly sexual. While still catching the male eye, they were as likely to snag a woman's interest, just as if she were gazing at a *Vogue* magazine cover.

→ **Pencil study of Shere Hite for The Unorthodox Corpse:** 1970

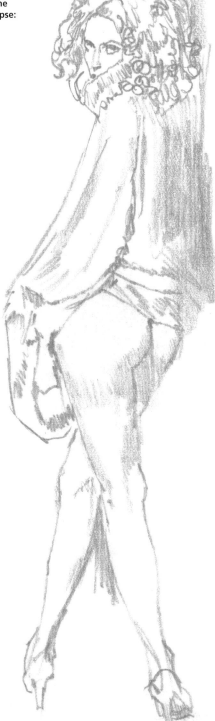

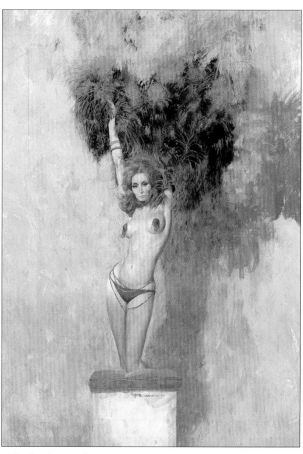
↑ **The Creative Murders:** 1971, tempera; Carter Brown, Signet

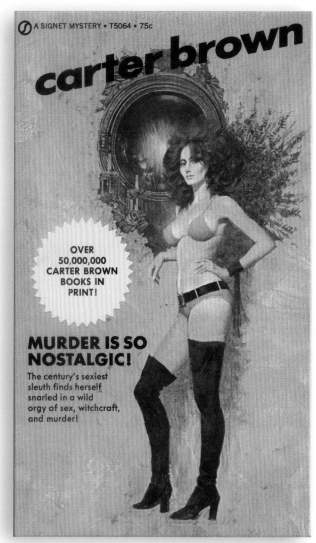
↑ *Murder Is So Nostalgic!*: 1972, Signet paperback. Shere Hite as a brunette; the 99th Carter Brown cover.

← **The Unorthodox Corpse:** 1970, tempera; Carter Brown, Signet. The model is Shere Hite.

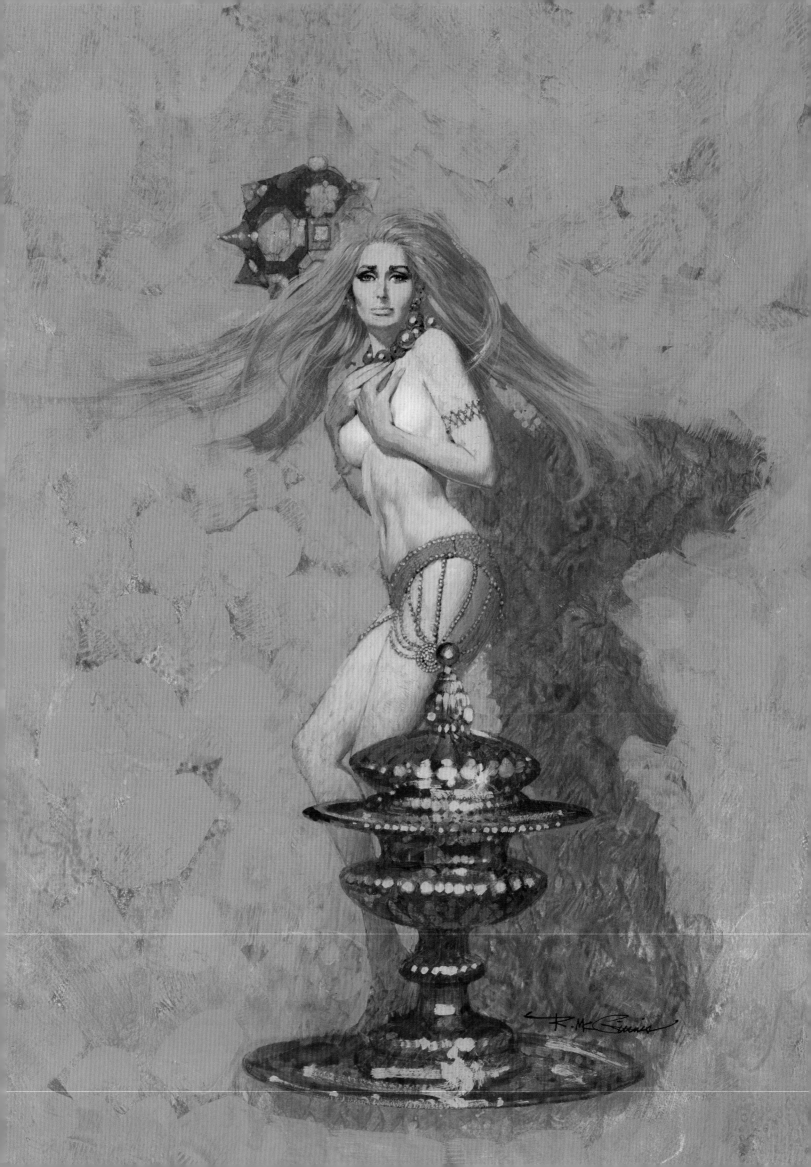

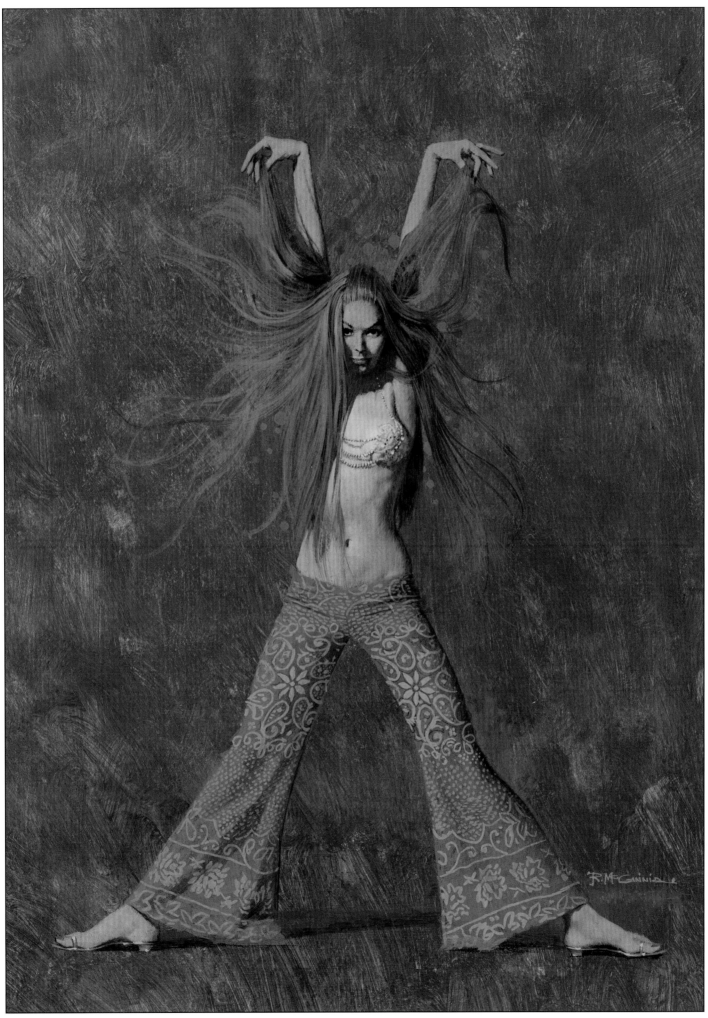

← **The Savage Salome:** 1970, tempera; Carter Brown, Signet. Shere Hite again.

↑ **The Streaked-Blond Slave:** 1969, tempera; Carter Brown, Signet

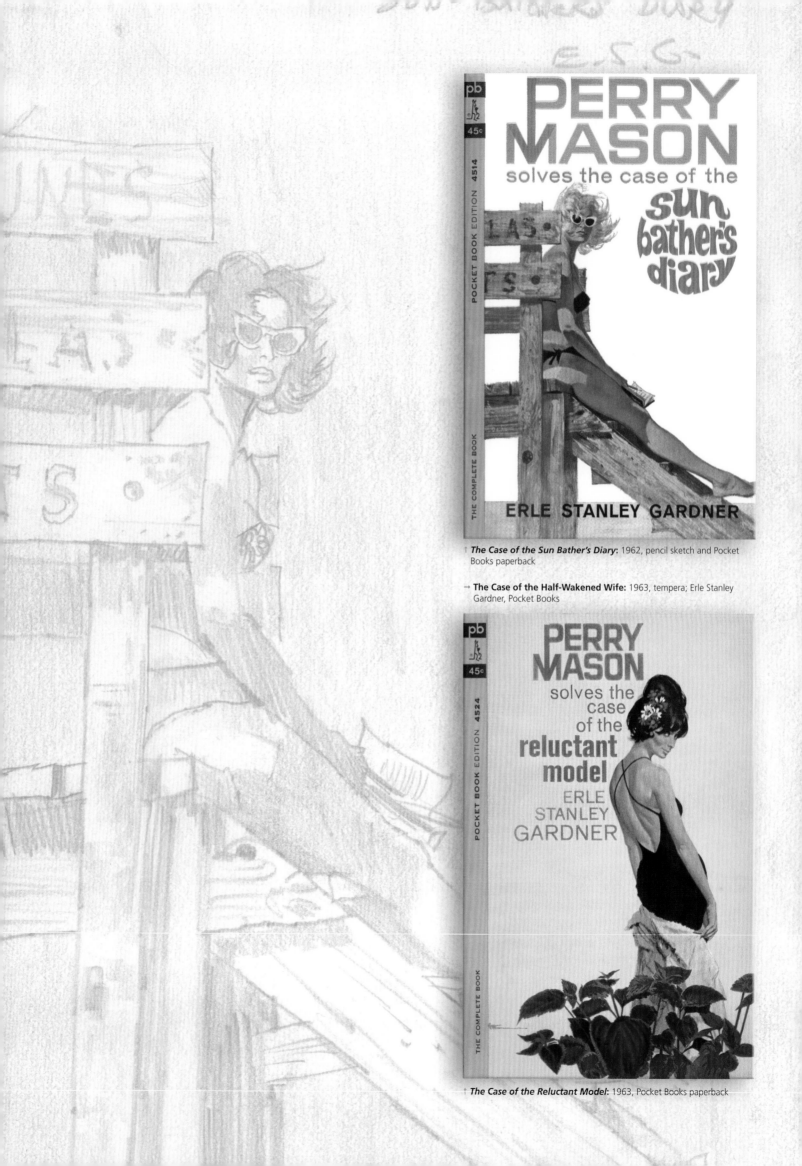

↑ *The Case of the Sun Bather's Diary*: 1962, pencil sketch and Pocket Books paperback

→ *The Case of the Half-Wakened Wife*: 1963, tempera; Erle Stanley Gardner, Pocket Books

↑ *The Case of the Reluctant Model*: 1963, Pocket Books paperback

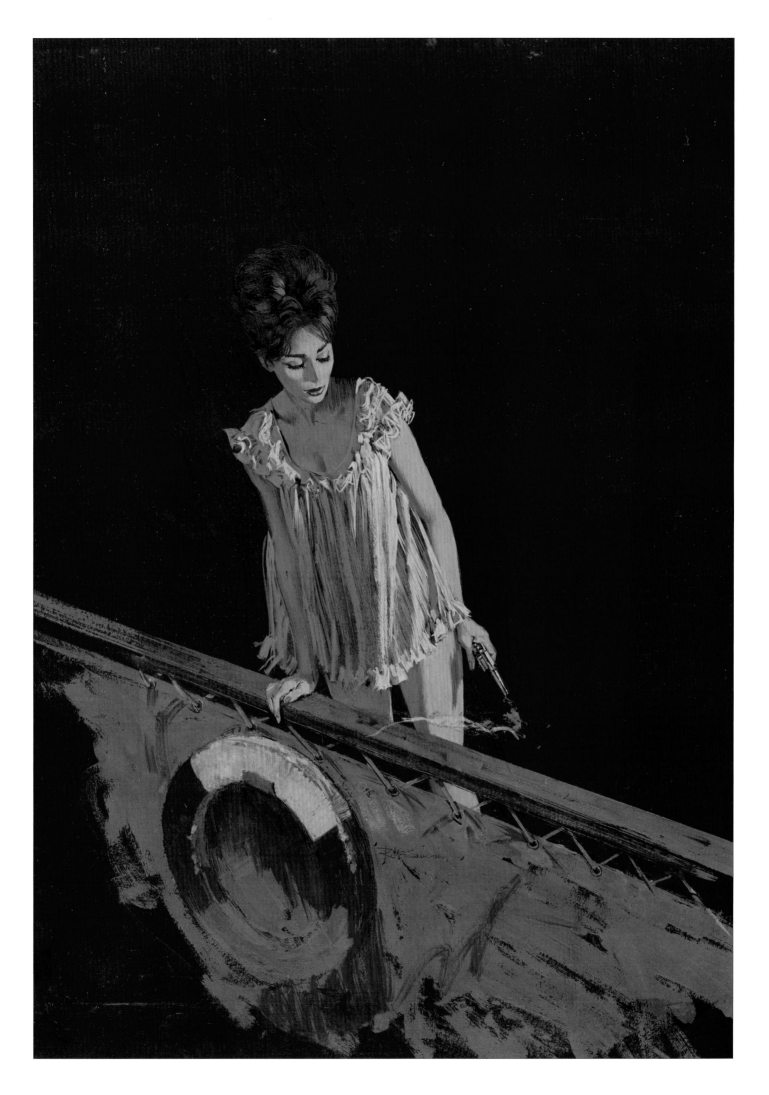

VARIETY AND ADAPTABILITY

In the 1960s, concurrent with the three main detective series, McGinnis painted an astonishing quantity of covers in a variety of genres—more crime fiction, contemporary novels, Westerns, and historical romances for eight paperback publishers. Again, beautiful women were a predominant element—it was by now his calling card with every art director in New York—but outside the crime series, McGinnis could spread out and present a variety of styles and subjects.

For Noël Coward's *Pomp and Circumstance*, McGinnis's talents for cartoon and caricature were on display—that's Coward at the back of the boat. It's the first of the many double-size "wraparound" covers he would paint in his career. His ability to suggest smoldering sexuality came to the fore in his covers for lesbian novels like *The Lion House*, and for subtle sexual humor on *Oh Careless Love*. His

covers for the then-popular *Tobacco Road*-inspired "backwoods" novels like *Shack Road Girl* and *Backwoods Teaser* are classics. *Take Off Your Mask*, one of his few non-fiction books, offers a lovely full nude, daring for 1959.

One of the truly iconic McGinnis covers is the wraparound he did for *Brooks Wilson Ltd.*, the ultimate "bevy of babes" fantasy. And by the way, the novel is about the trials and romances of a magazine illustrator. Extra inspiration?

His initial forays into the historical romance genre display his commitment to research and accuracy in rendering costumes, weapons, sailing ships, castles, and other details. The examples exhibited here range from Biblical times to the opening of the American frontier, with stops in sixteenth century Europe, the seventeenth century era of piracy, and the American Revolution.

→ **Moment of Danger**: 1959, tempera; Donald MacKenzie, Dell

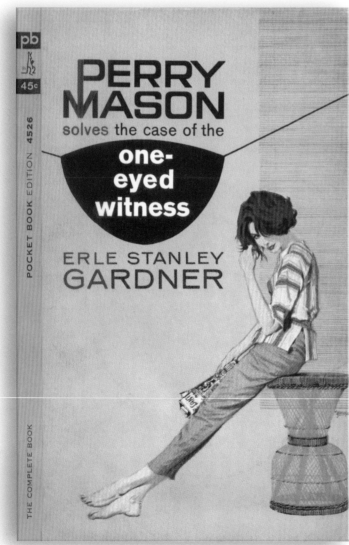

↑ *The Case of the One-Eyed Witness*: 1963, Pocket Books paperback

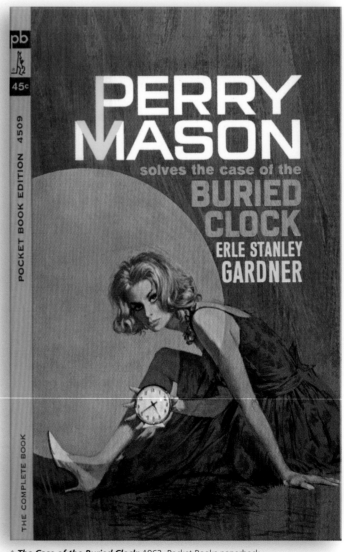

↑ *The Case of the Buried Clock*: 1962, Pocket Books paperback

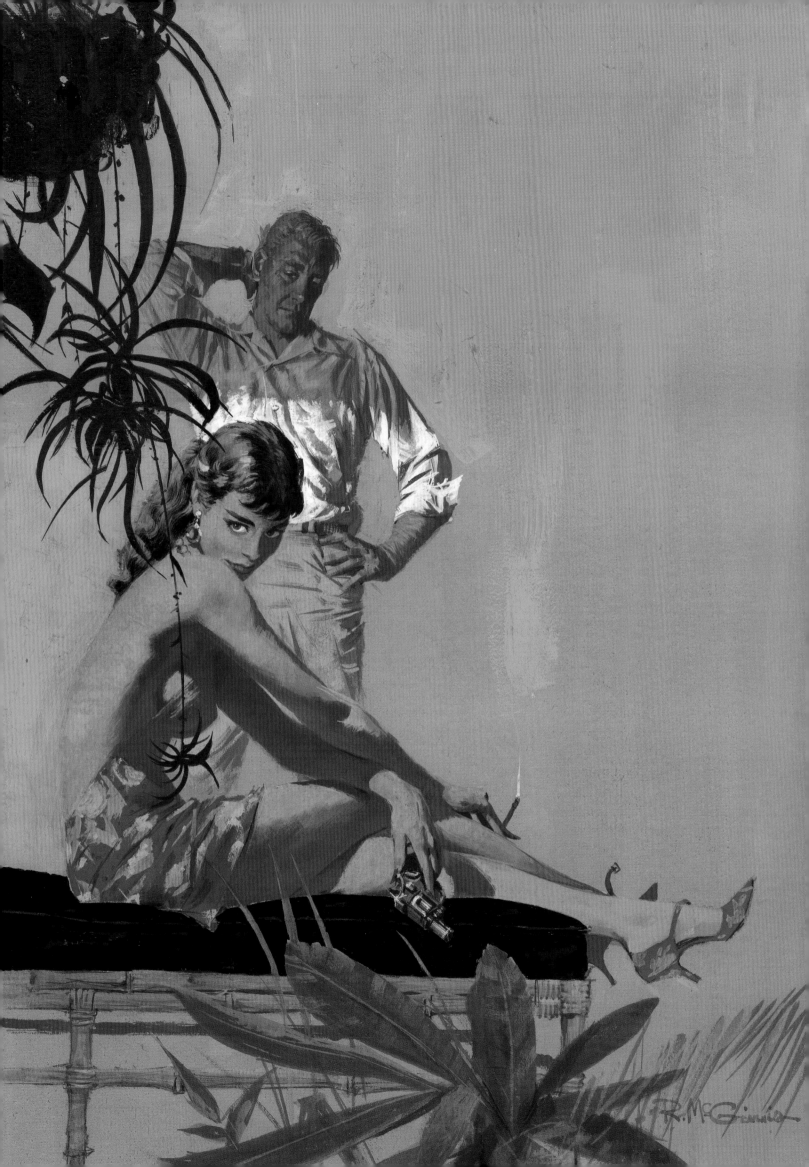

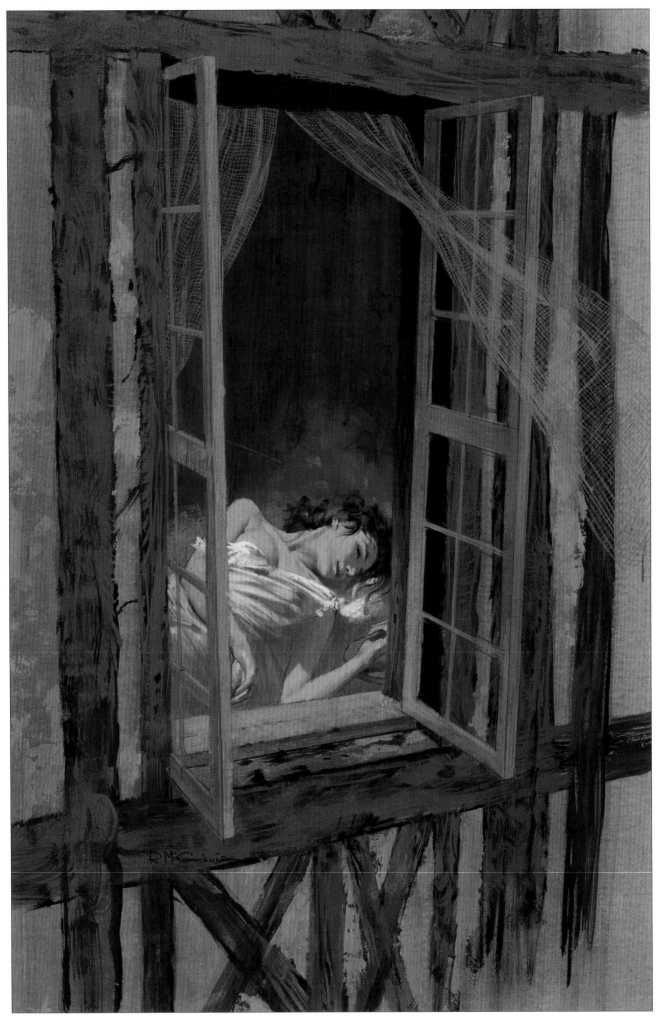

↑ **The Shrew Is Dead:** 1959, tempera; Shelley Smith, Dell

→ **Angel's Ransom:** 1959, tempera; David Dodge, Dell

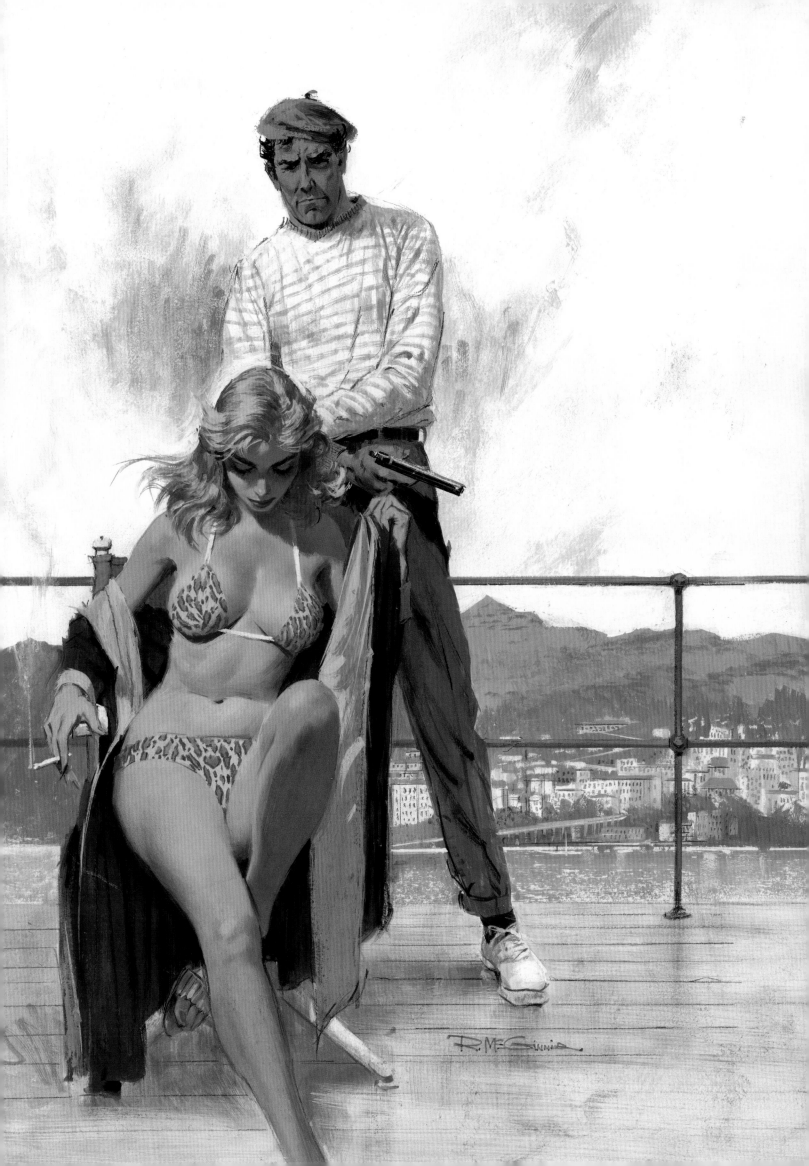

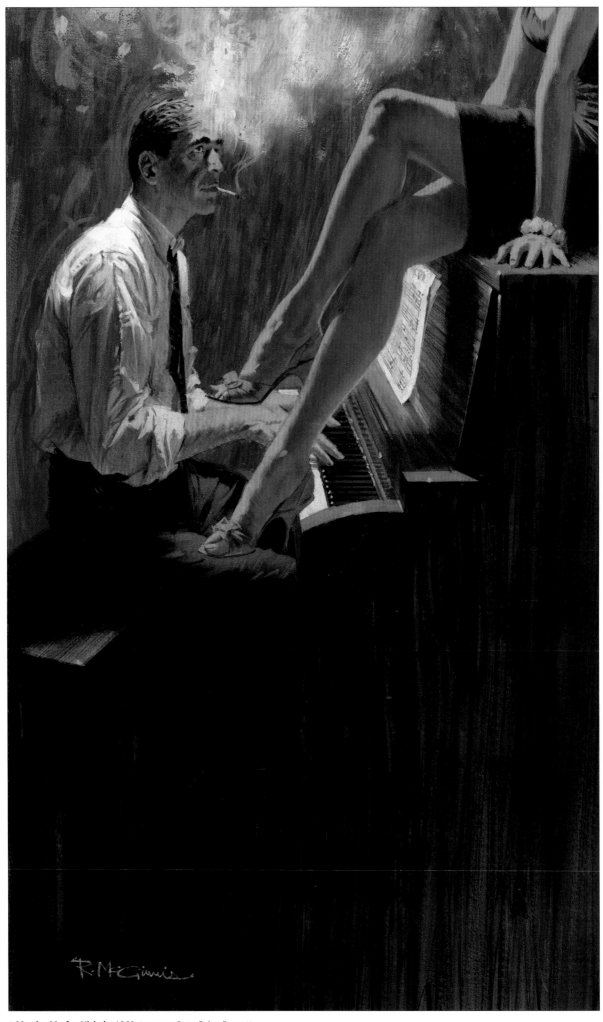

↑ **Murder Me for Nickels:** 1960, tempera; Peter Rabe, Fawcett

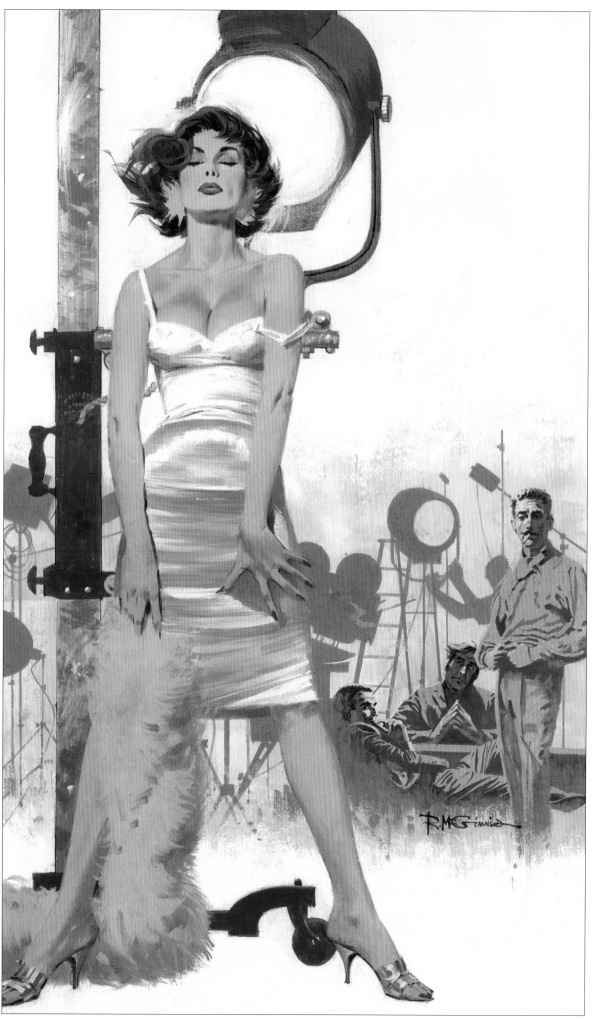

↑ **The Flesh Merchants:** 1959, tempera; Bob Thomas, Dell

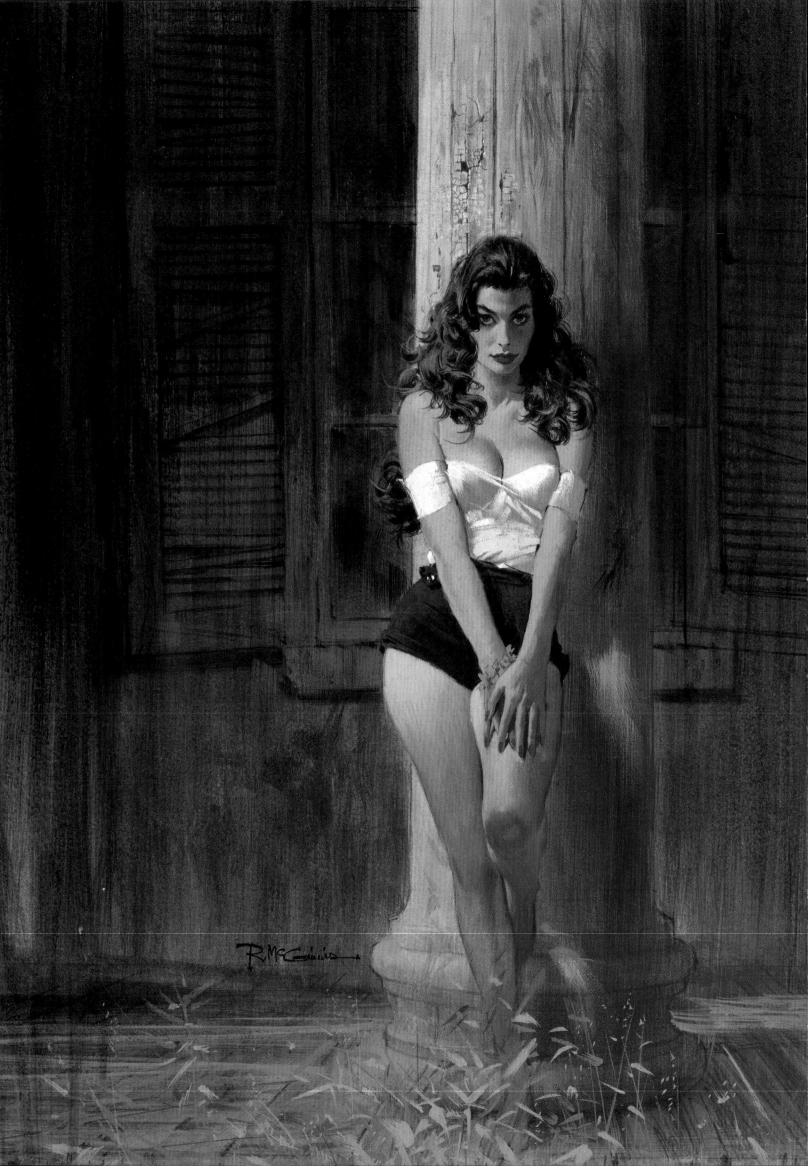

BERKLEY
DIAMOND
D2004
35c

A sharecropper's
daughter and the
men in her life

SHACK ROAD GIRL

Harry
Whittington

COMPLETE AND UNABRIDGED

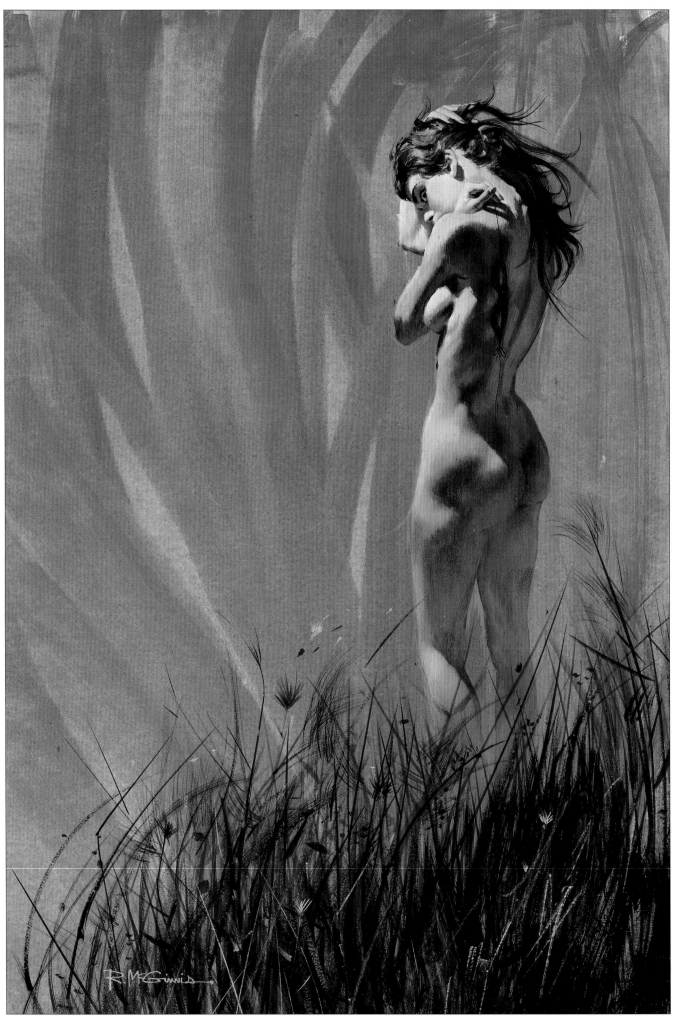

↑ **Take Off Your Mask:** 1959, tempera; Ludwig Eidelberg, Pyramid

→ **The Velvet Knife:** 1960, tempera; Irving Shulman, Popular Library

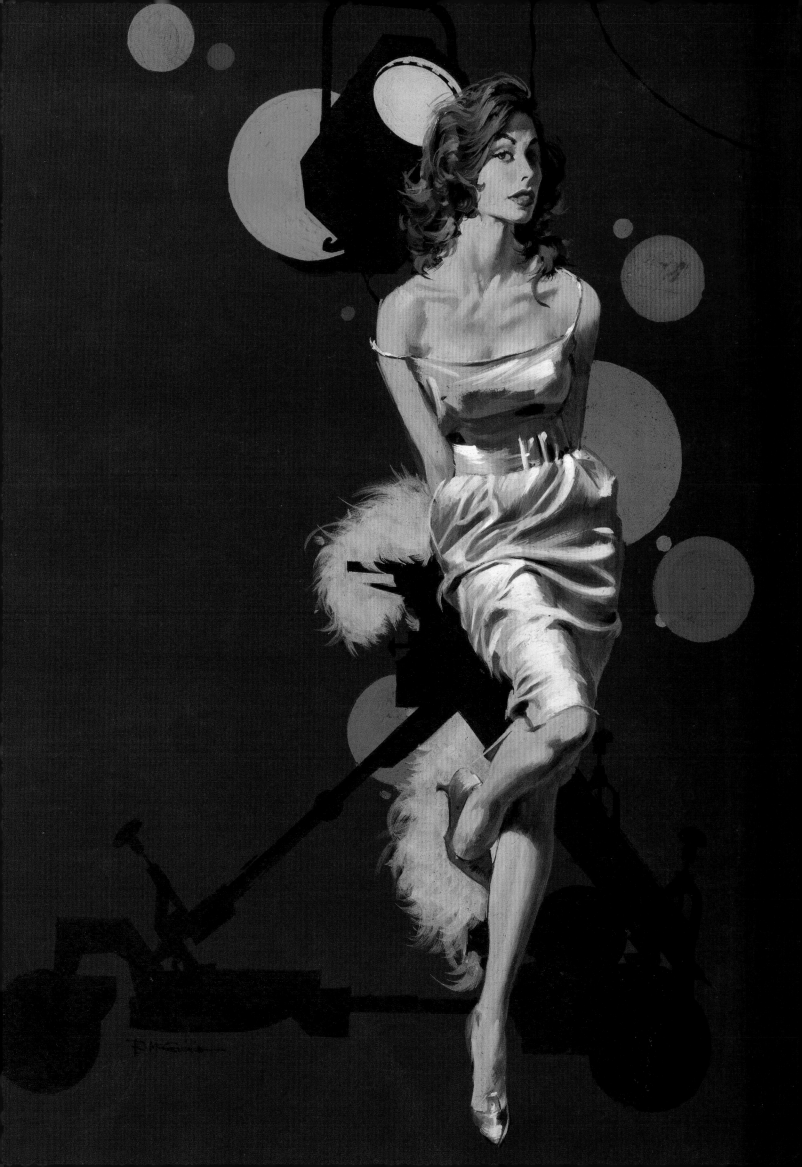

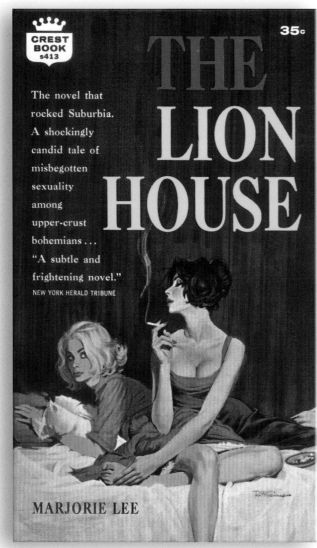

35c

THE LION HOUSE

The novel that rocked Suburbia. A shockingly candid tale of misbegotten sexuality among upper-crust bohemians... "A subtle and frightening novel." NEW YORK HERALD TRIBUNE

MARJORIE LEE

The Lion House: 1960, Fawcett paperback

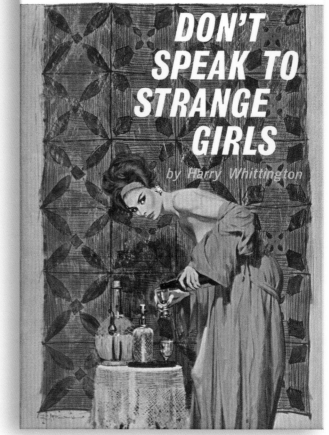

Her wildness was enough to warn a guy smart enough to sense the warning. Looking at her, you could feel your eyes bleeding. But when Joanne Stark beckoned, no man wanted to learn the hardest lesson of all —

GOLD MEDAL kl303

40c

DON'T SPEAK TO STRANGE GIRLS

by Harry Whittington

Don't Speak to Strange Girls: 1963, Fawcett paperback

Pomp and Circumstance: 1962, tempera; Noël Coward, Dell. One of McGinnis's earliest "wraparound" covers. → **Beebo Brinker:** 1962, tempera; Ann Bannon, Fawcett

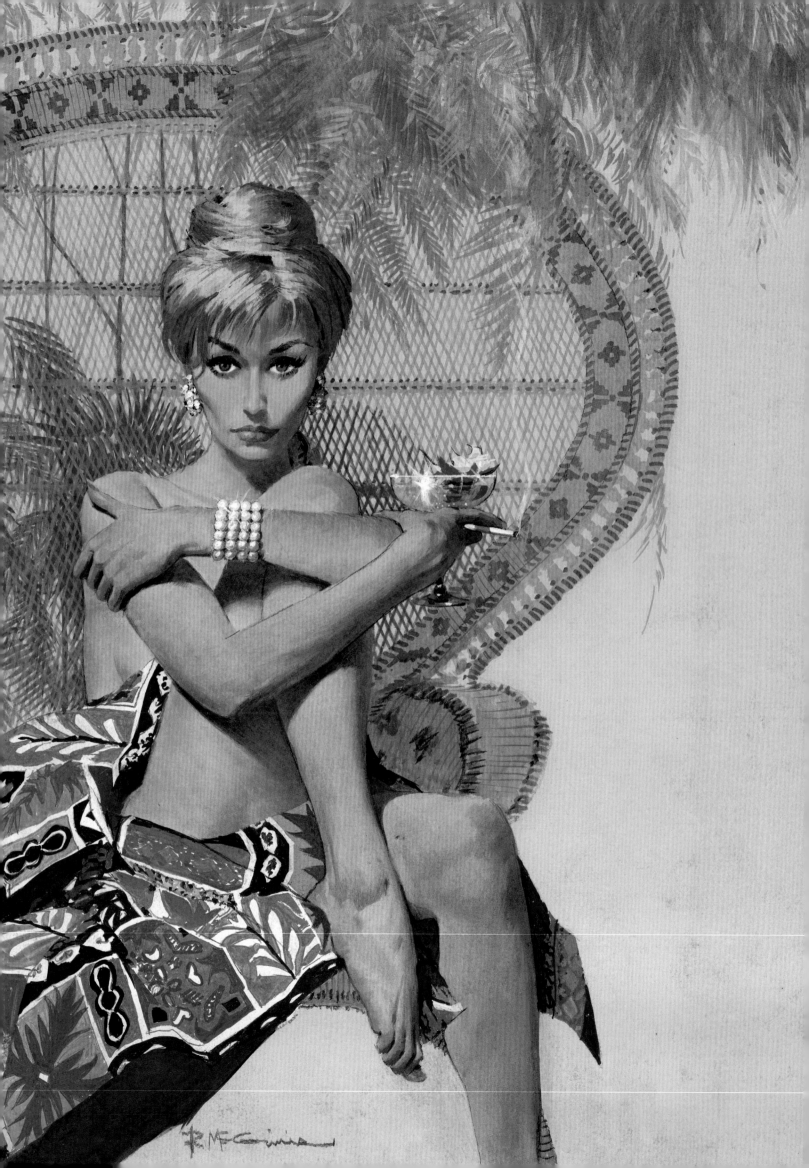

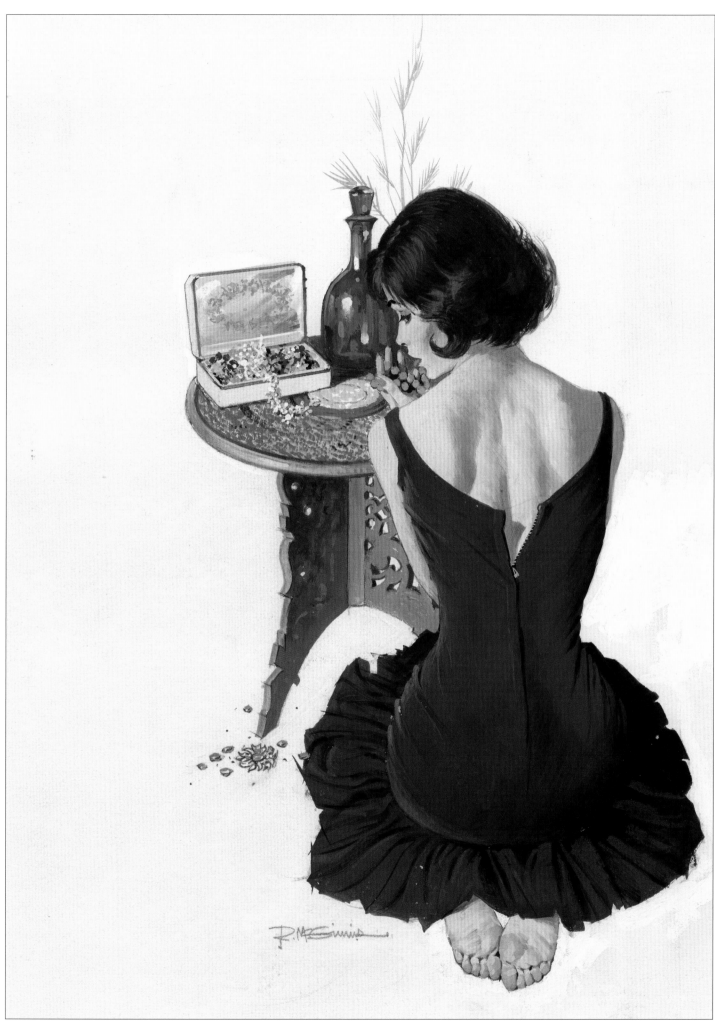

← **Some Women Won't Wait:** 1960, tempera; A.A. Fair, Dell

↑ **Crows Can't Count:** 1960, tempera; A.A. Fair, Dell

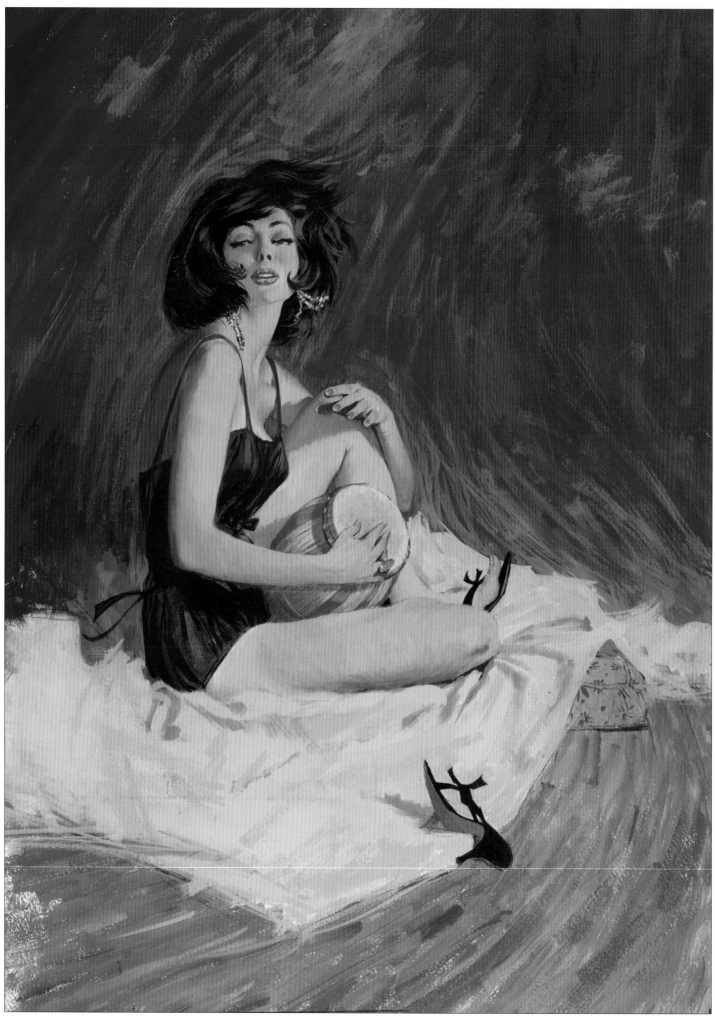

↑ **Angel Eyes:** 1961, tempera; Robert Dietrich, Dell → **An American Romance:** c.1961, tempera; Hans Koningsberger, Avon

The gray flannel suit comes apart at the seams in this boldly sophisticated (and deliciously explicit) novel of sex-on-the-rocks in Suburbia.

35¢
T-440

OH CARELESS LOVE

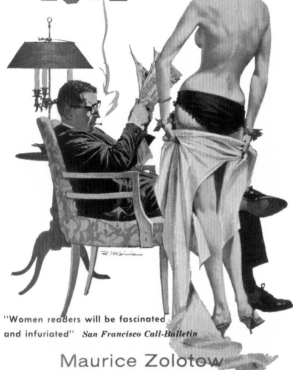

"Women readers will be fascinated and infuriated" *San Francisco Call-Bulletin*

Maurice Zolotow

↑ *Oh Careless Love:* c.1961, Avon paperback

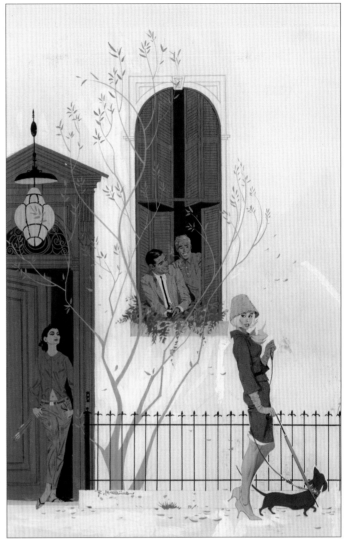

↑ **East 57th Street:** 1962, tempera; Alan R. Jackson, Dell

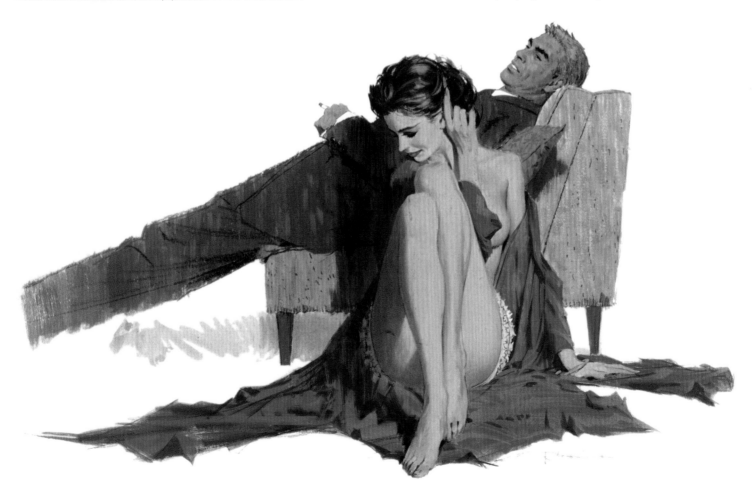

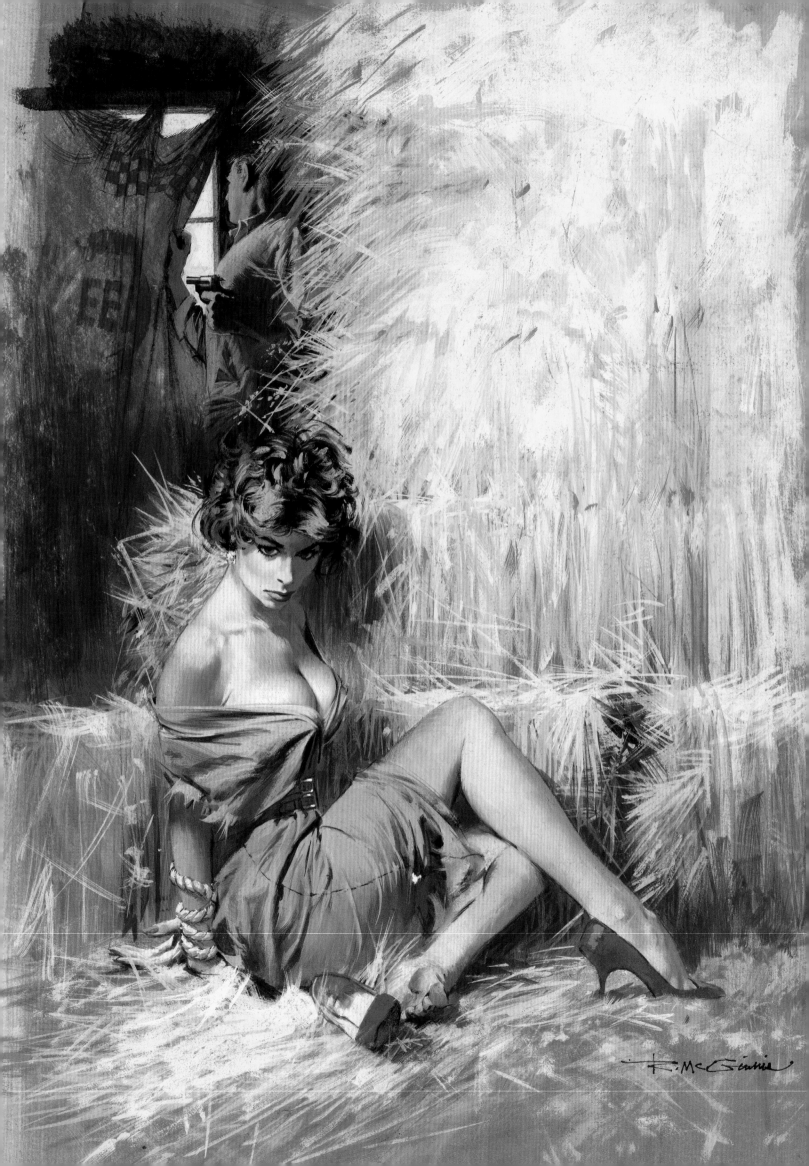

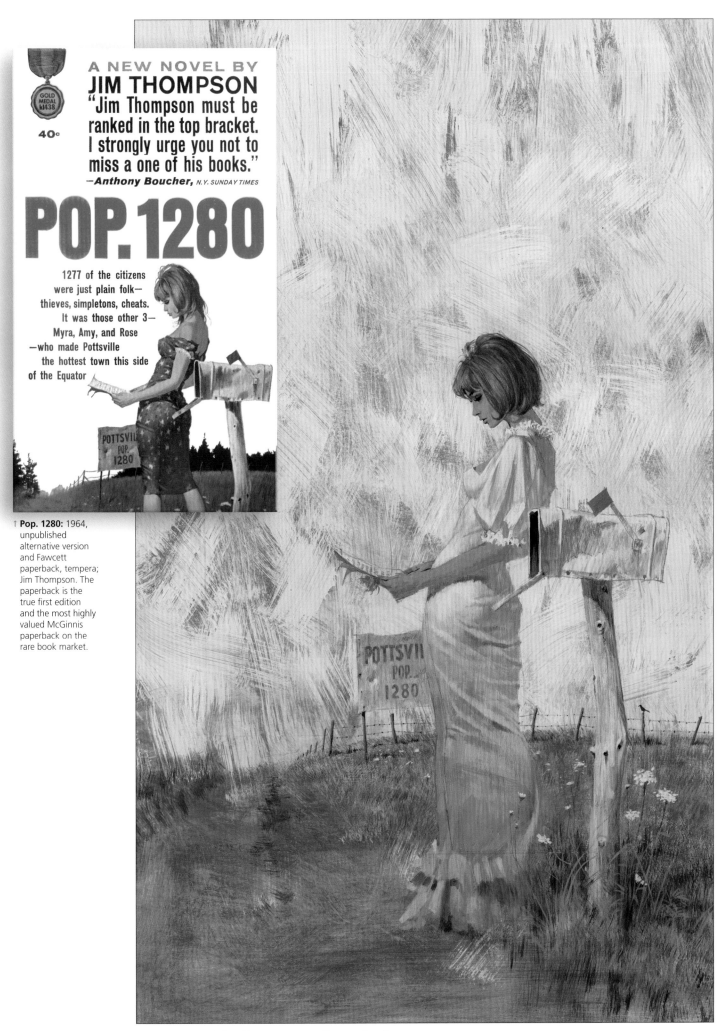

A NEW NOVEL BY
JIM THOMPSON
"Jim Thompson must be ranked in the top bracket. I strongly urge you not to miss a one of his books."
—*Anthony Boucher,* N.Y. SUNDAY TIMES

POP. 1280

1277 of the citizens were just plain folk— thieves, simpletons, cheats. It was those other 3— Myra, Amy, and Rose —who made Pottsville the hottest town this side of the Equator

40¢

GOLD MEDAL k1438

↑ **Pop. 1280:** 1964, unpublished alternative version and Fawcett paperback, tempera; Jim Thompson. The paperback is the true first edition and the most highly valued McGinnis paperback on the rare book market.

← **The Girl Who Cried Wolf:** 1960, tempera; Hillary Waugh, Dell

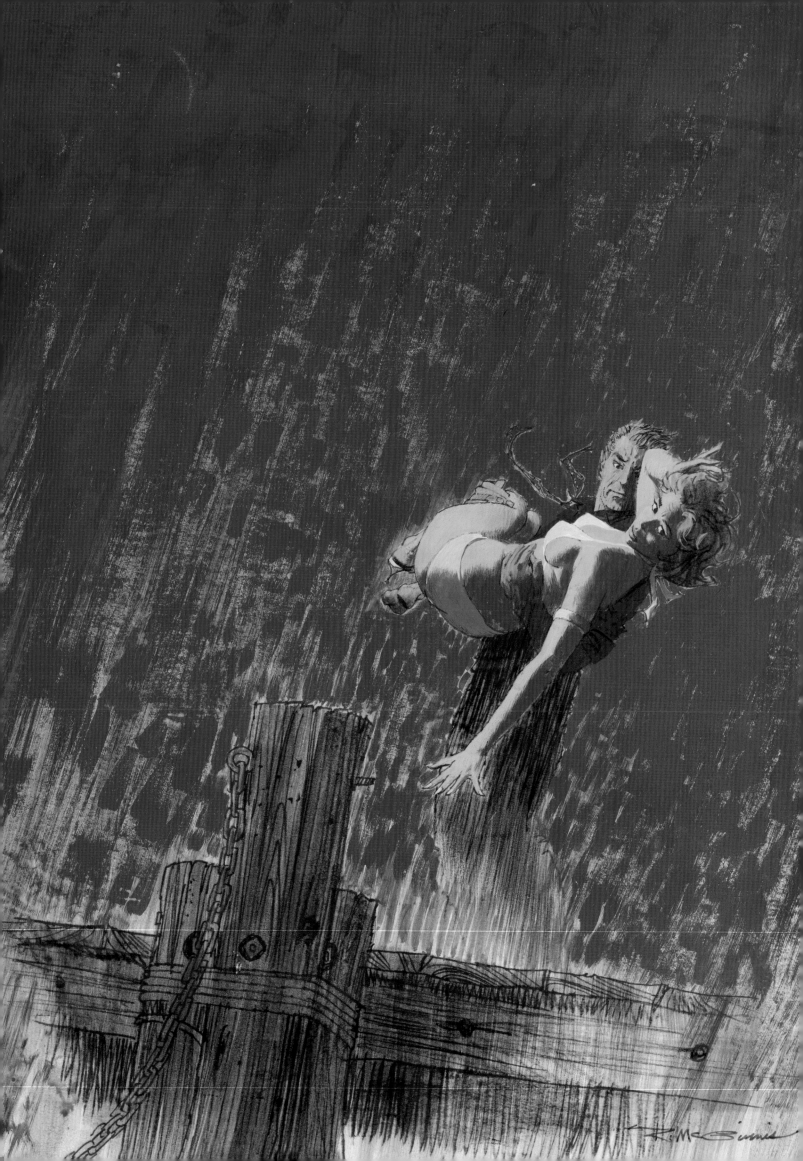

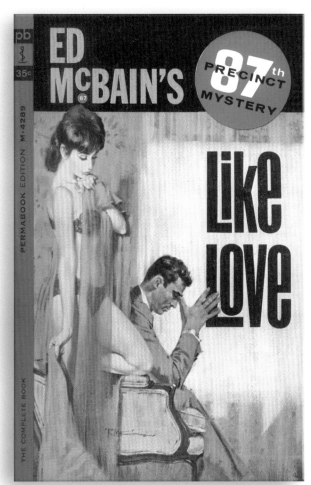

← **The Con Man:** 1962,
tempera; Ed McBain,
Pocket Books

↑ *Like Love:* 1963, Pocket Books paperback

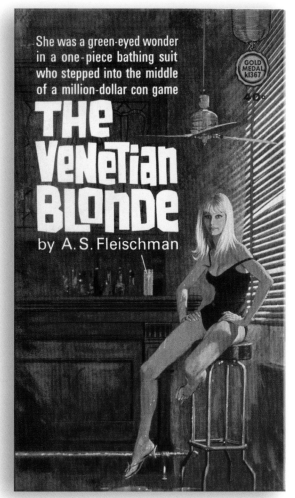

↑ *The Venetian Blonde:* 1963, Fawcett paperback

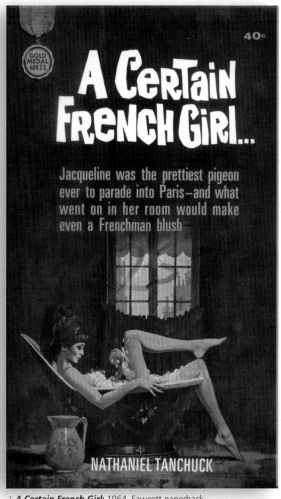

↑ *A Certain French Girl:* 1964, Fawcett paperback

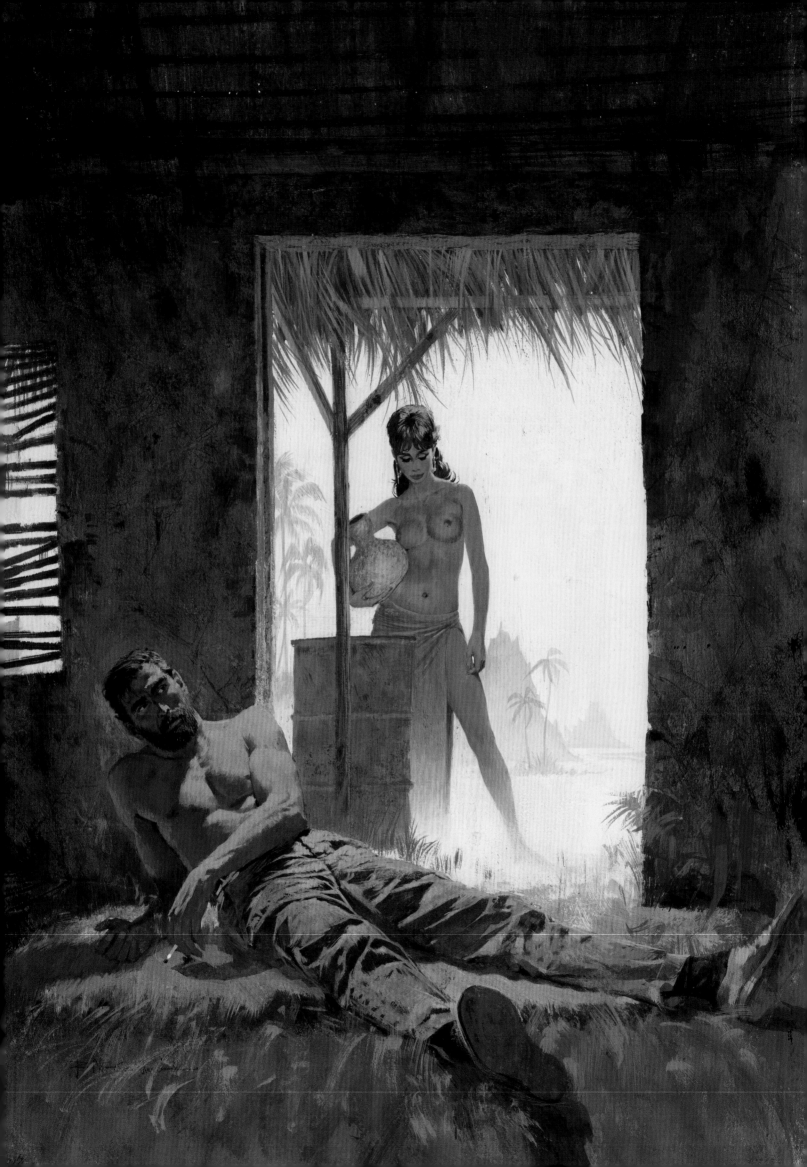

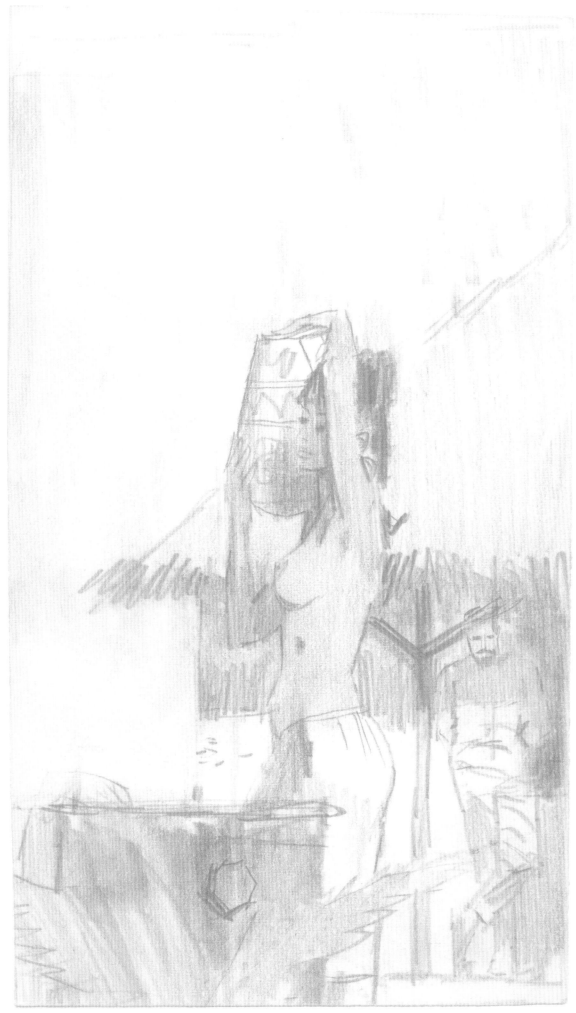

← **Color Him Dead:** 1963, tempera; Charles Runyon, Fawcett

↑ **Color Him Dead:** 1963, preliminary pencil sketch

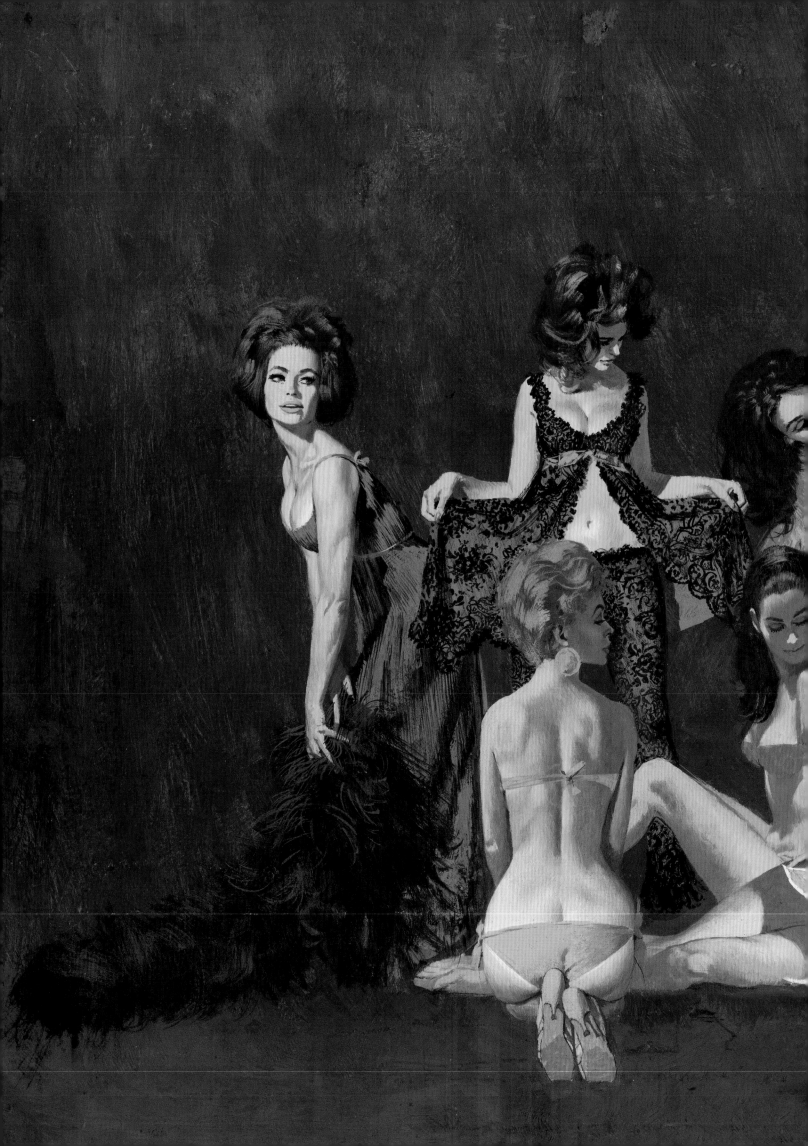

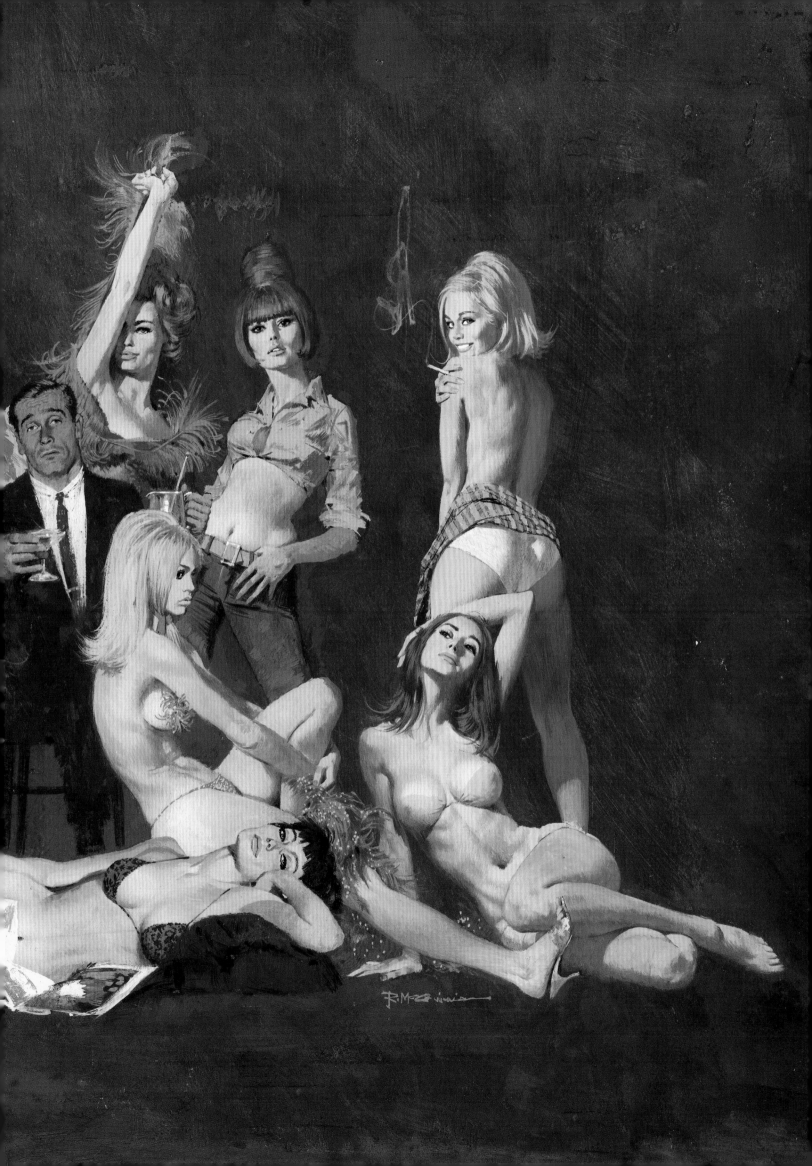

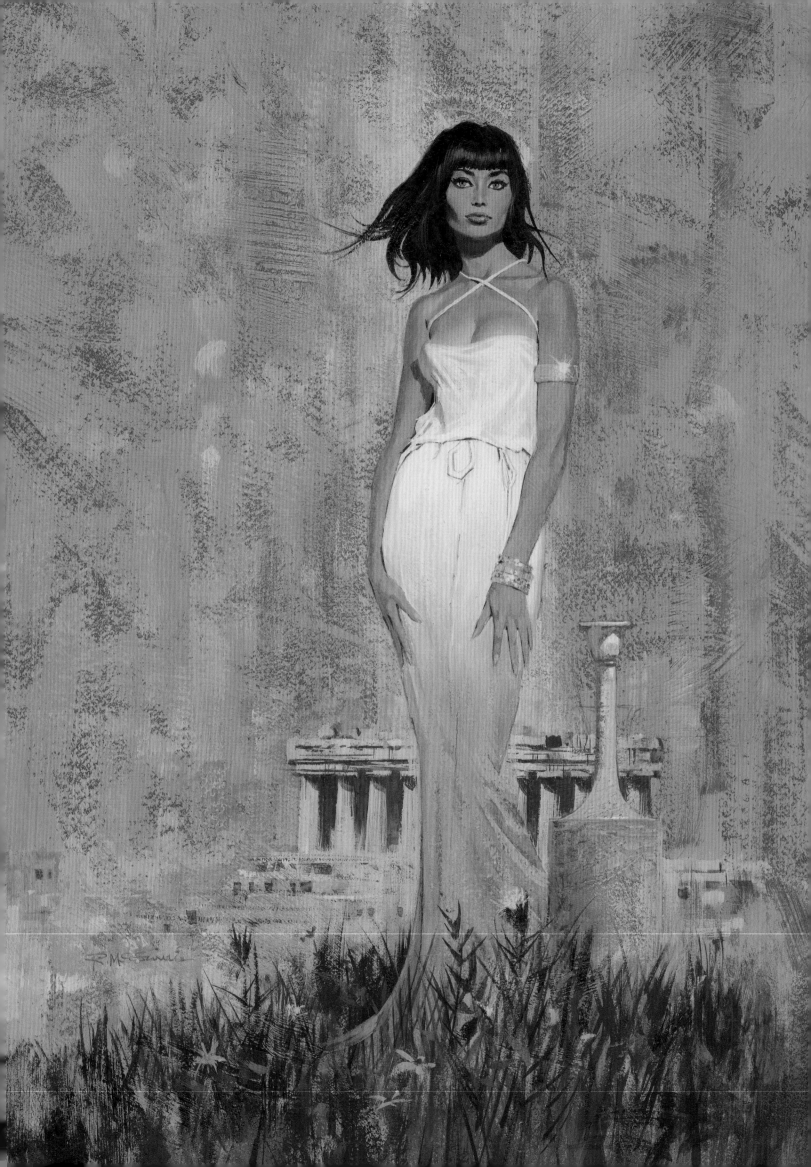

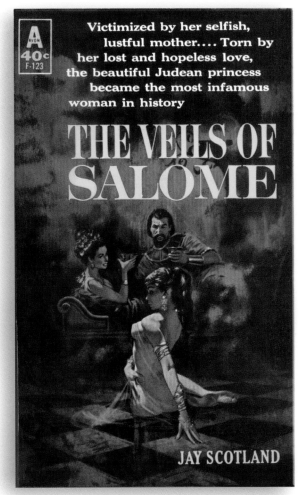

Victimized by her selfish,
lustful mother.... Torn by
her lost and hopeless love,
the beautiful Judean princess
became the most infamous
woman in history

THE VEILS OF SALOME

JAY SCOTLAND

↑ *The Veils of Salome:* 1962, Avon paperback

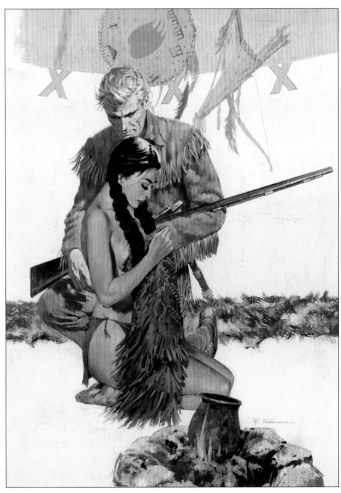

↑ **The Long Knife:** 1960, tempera; Louis A. Brennan, Dell

Previous spread **Brooks Wilson Ltd.:**
1966, tempera; J.M. Ryan, Fawcett

← **Rizpah:** 1962, tempera;
Charles E. Israel, Fawcett

← **Celia Garth:** c.1972, tempera;
Gwen Bristow, Popular Library

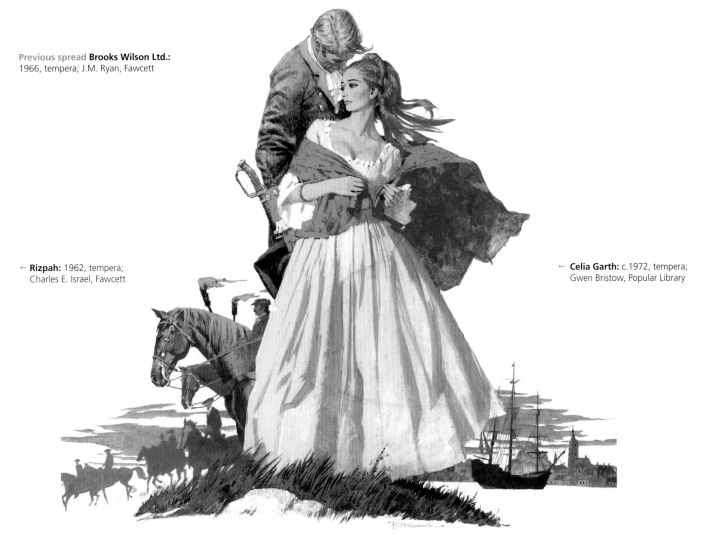

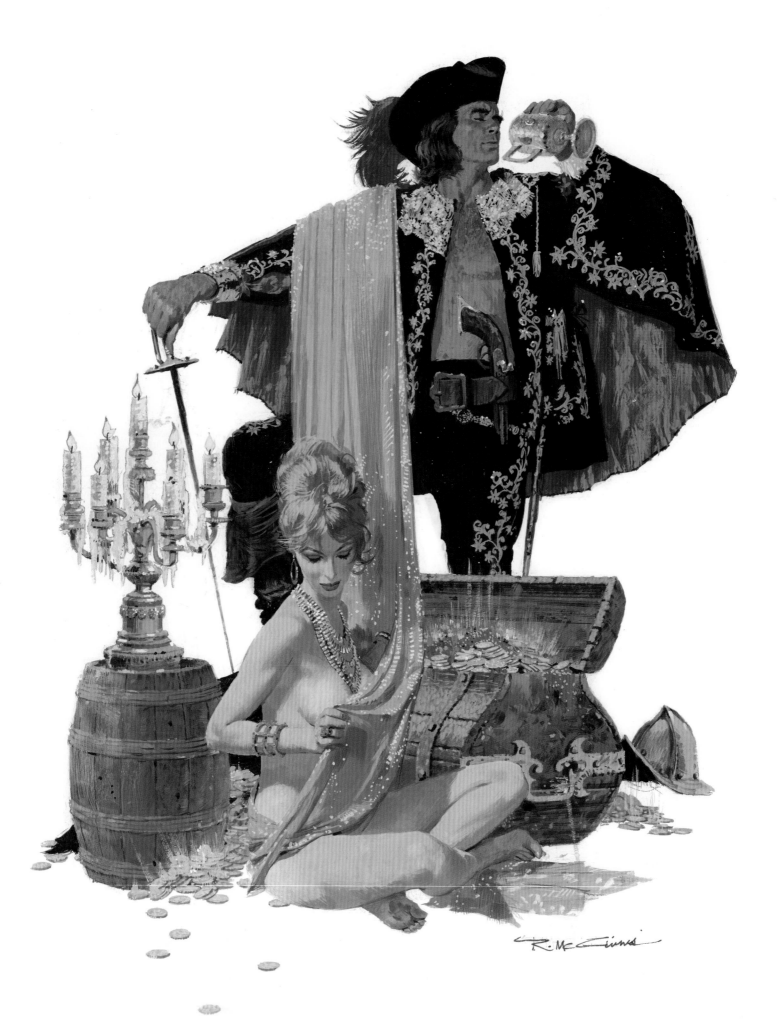

↑ **Captain Blood Returns:** 1963, tempera; Rafael Sabatini, Popular Library

→ **Pawn in Frankincense:** 1970, tempera; Dorothy Dunnett, Popular Library

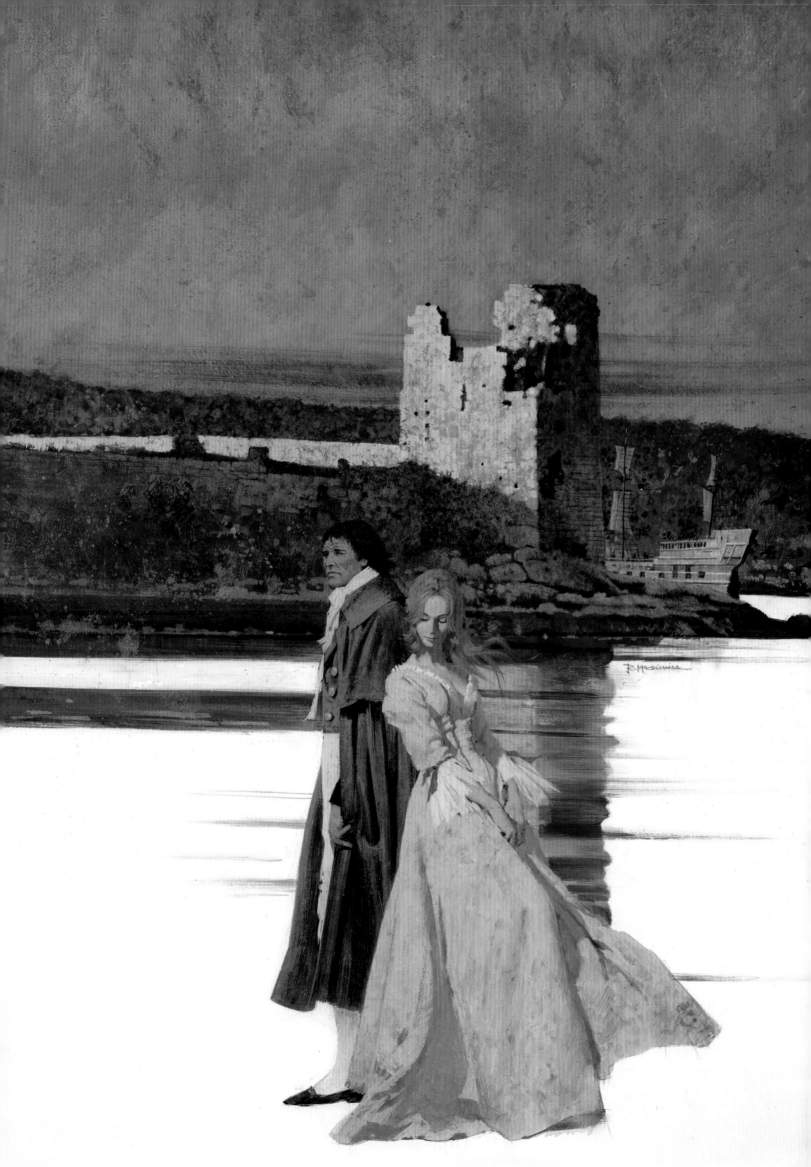

CRIME AND ESPIONAGE

In the early 1970s, as McGinnis's long runs with Mike Shayne and Carter Brown wound down, new work on major crime and espionage series appeared. The Milo March series—twenty-five titles—was somewhat different in that, instead of a woman alone on the cover, there was a woman and a man, and the man was, not coincidentally, a dead ringer for actor James Coburn—a creative marketing gimmick.

Over at Fawcett, McGinnis did a series of covers for the Sam Durell "Assignment" spy series, beginning in 1960 and ending in the mid-'70s. Most of the stories were set in foreign locales, allowing McGinnis to work interesting local color into the backdrops.

Along with the later Carter Brown paintings, the eighteen covers McGinnis did for the Shell Scott series from 1970 to 1976 are generally considered by illustration collectors to represent the high point of the McGinnis Woman. Richard S. Prather's semi-comic private eye tales inevitably featured a terrifically sexy female, and

McGinnis went all out, taking advantage of the unusual landscape format. On many of the covers, no text intruded on the painting, allowing him to create spectacular tableaux.

The prolific and popular crime and suspense writer John D. MacDonald was a Fawcett Gold Medal mainstay throughout the 1970s. McGinnis did several MacDonald covers in the '60s—four for Dell and some for Fawcett, most notably the iconic *On the Run*. It was his take on the *September Morn* (by Paul Chabas) motif, and was reprised on Prather's Shell Scott title *Strip for Murder*. Most of the MacDonald novels were non-series, with a wide variety of settings and themes.

McGinnis's fifty-odd MacDonald covers through the '70s are notable for their stylistic variety: some feature the classic woman alone; others are more poster-like, such as *Murder for the Bride* and *The Neon Jungle*; still others depict dramatic scenes, as in *Murder in the Wind*; and there are even still lifes, like *Contrary Pleasure*.

→ **As Old As Cain:** 1971, tempera; M.E. Chaber, Paperback Library. A ringer for Goldie Hawn joins James Coburn's double. The publisher insisted on bra and panties for the girl; McGinnis painted them out when he got the painting back.

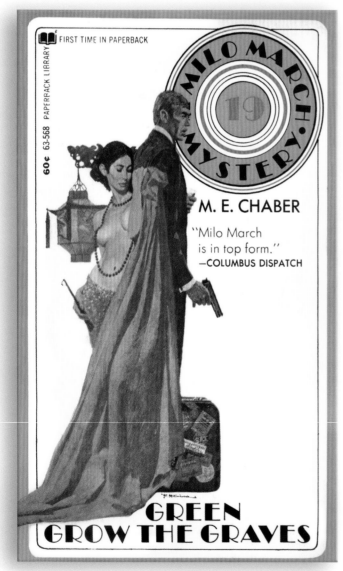

↑ *Green Grow the Graves:* 1971, Paperback Library paperback

↑ **Wanted: Dead Men:** 1970, tempera; M.E. Chaber, Paperback Library

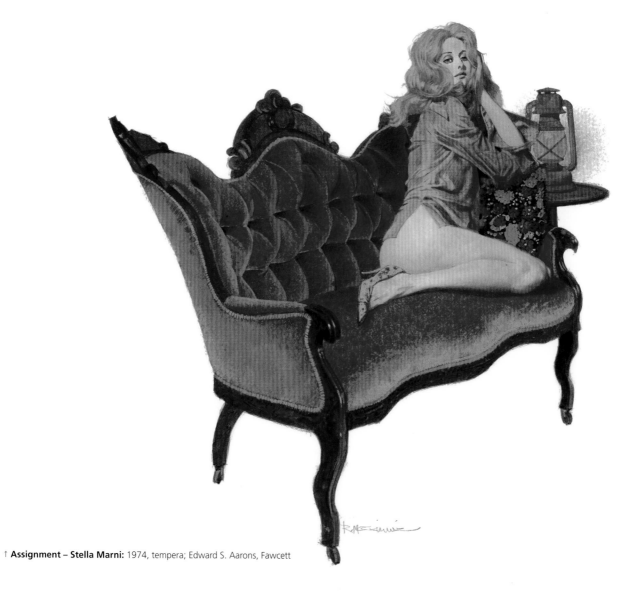

↑ **Assignment – Stella Marni:** 1974, tempera; Edward S. Aarons, Fawcett

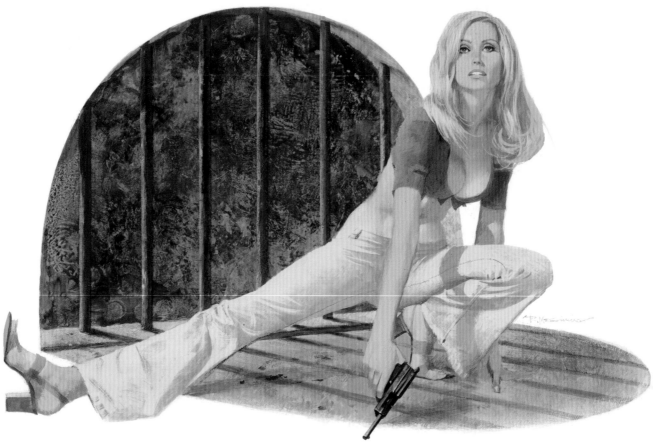

↑ **Assignment – Lily Lamaris:** 1973, tempera; Edward S. Aarons, Fawcett

→ **Assignment – Tokyo:** 1971, tempera; Edward S. Aarons, Fawcett

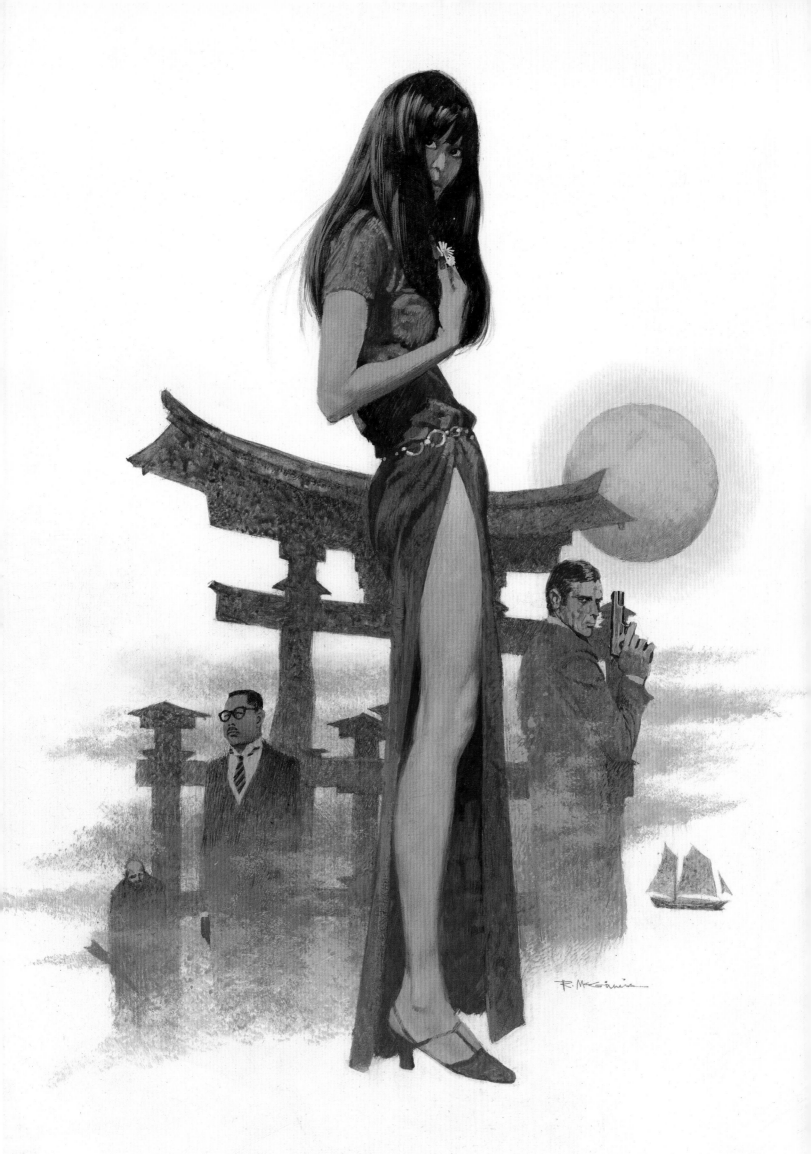

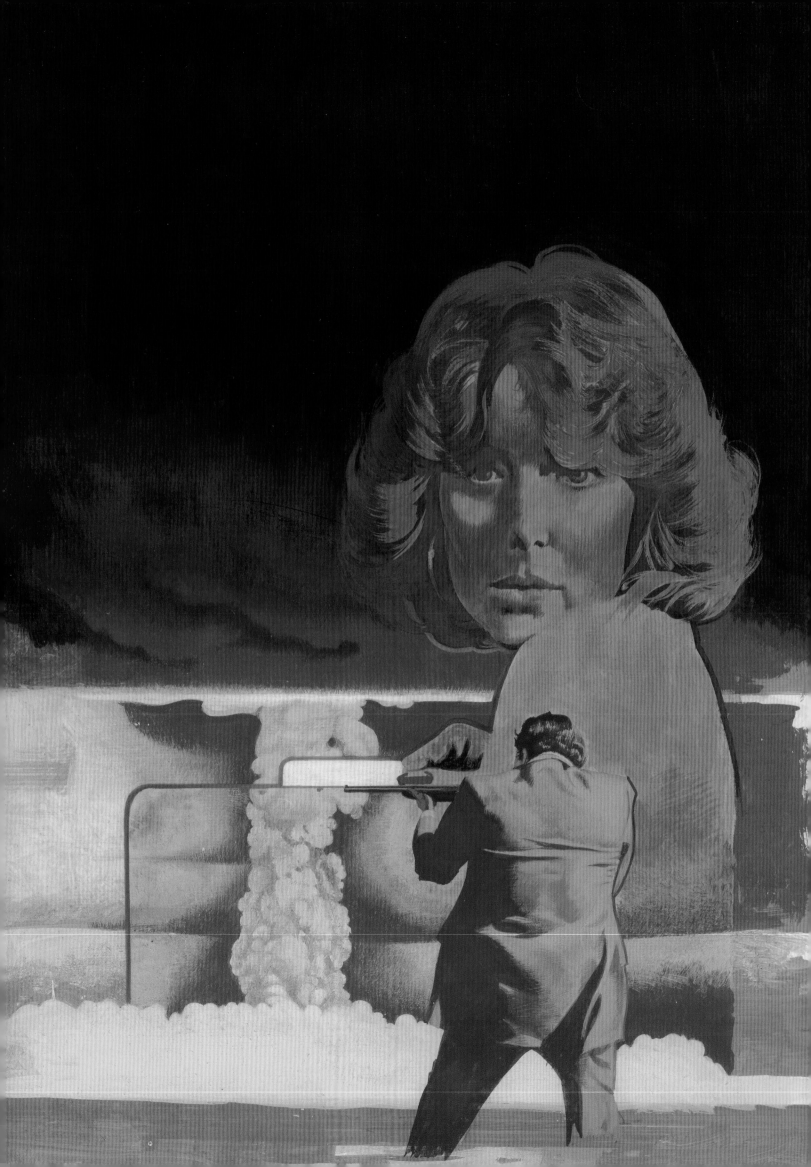

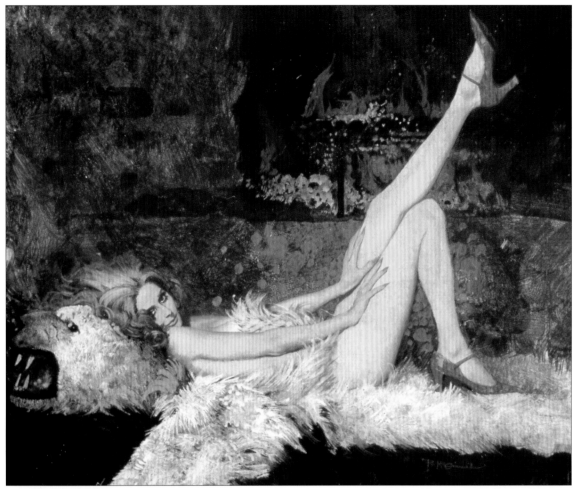

↑ **Always Leave 'Em Dying:** 1970, tempera; Richard S. Prather, Fawcett

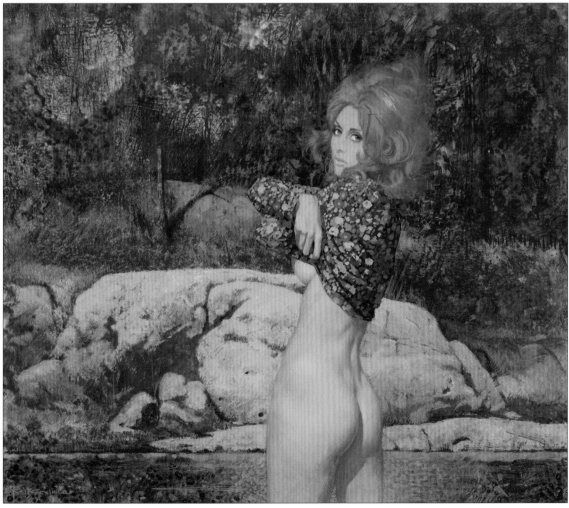

← **Assignment – Treason:** 1976, unpublished painting, tempera; Edward S. Aarons, Fawcett ↑ **Strip for Murder:** 1972, tempera; Richard S. Prather, Fawcett

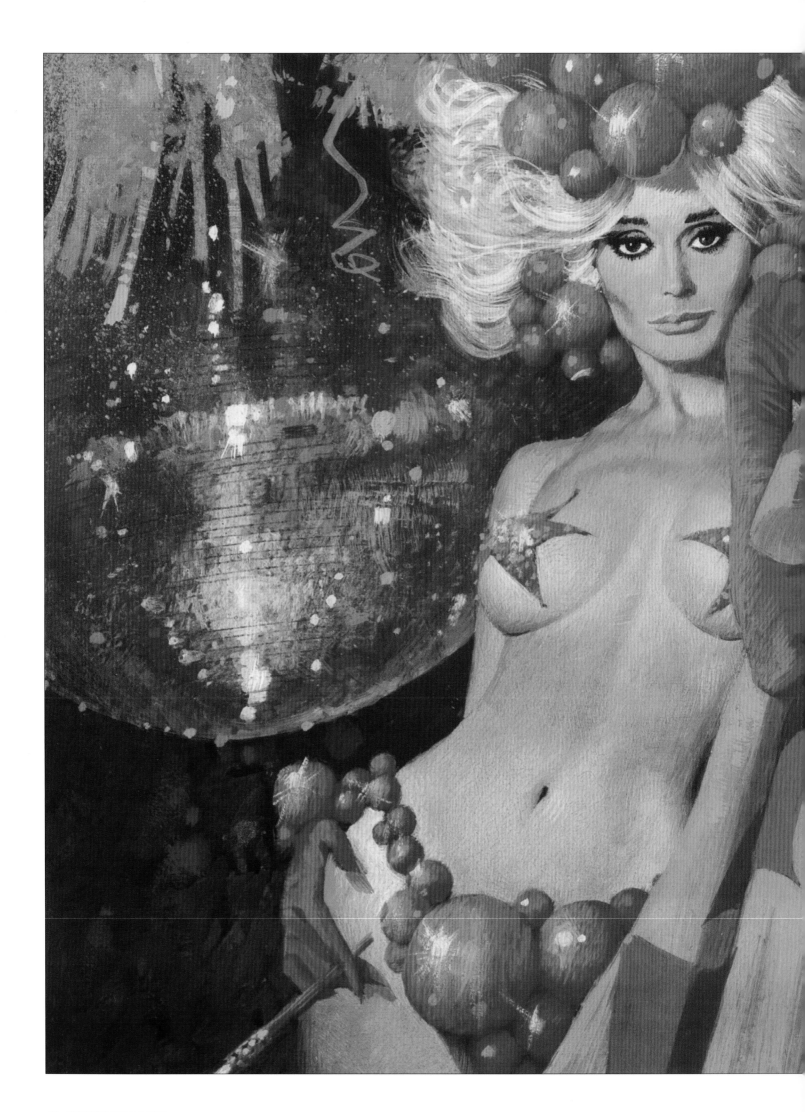

FAWCETT
GOLD MEDAL
T2677•75c

SHELL SCOTT

DIG THAT CRAZY GRAVE

Man, she had a shape
to make corpses
kick open caskets—
and she was
dead set on
giving me
rigor mortis

RICHARD S. PRATHER

↑ *Dig That Crazy Grave:* 1972, Fawcett paperback. All but one of the McGinnis Shell Scotts have the monochrome Baryé Phillips portrait of the character on the cover.

← **Kill the Clown:** 1973, tempera; Richard S. Prather, Fawcett

↑ **Shell Scott portrait:** 1975, tempera; Fawcett. This was intended to replace the Baryé Phillips portrait that had been on the covers since the 1950s, but Gold Medal dropped the series after Prather moved to another publisher. This image was used on only one edition.

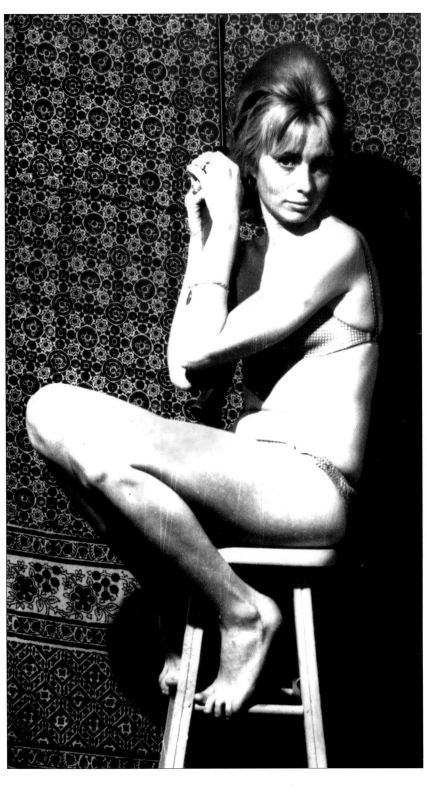

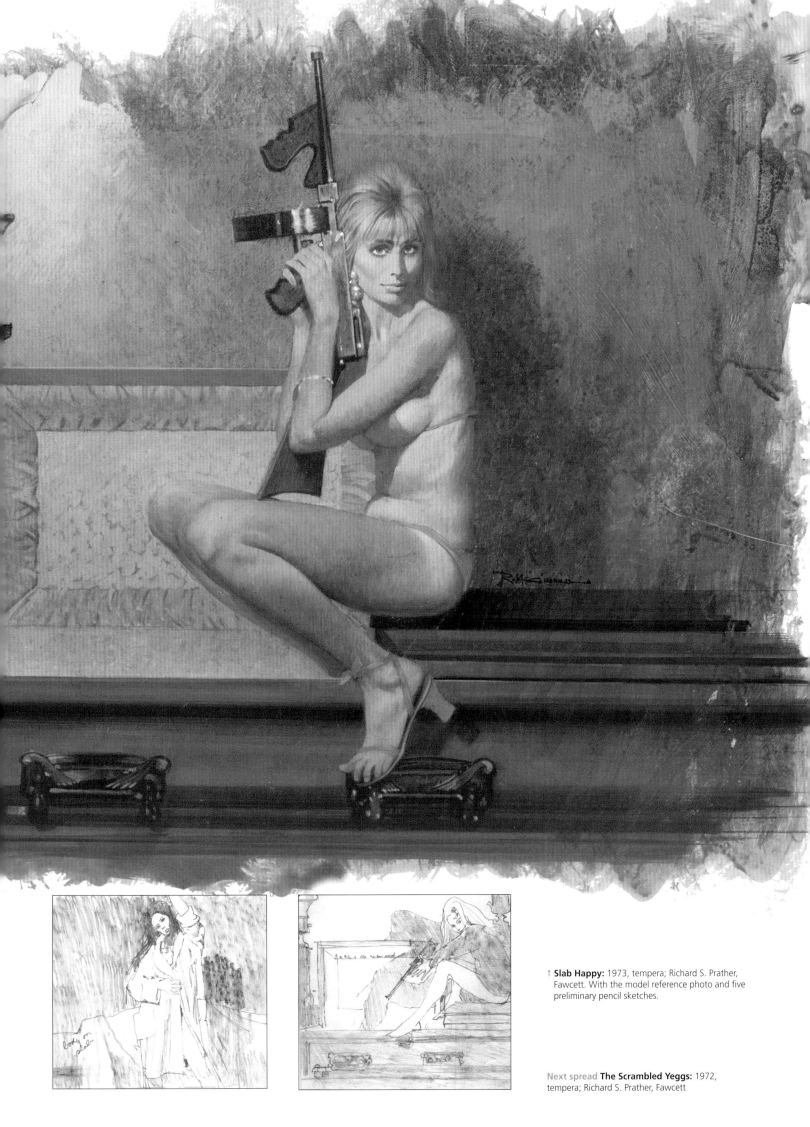

↑ **Slab Happy:** 1973, tempera; Richard S. Prather, Fawcett. With the model reference photo and five preliminary pencil sketches.

Next spread **The Scrambled Yeggs:** 1972, tempera; Richard S. Prather, Fawcett

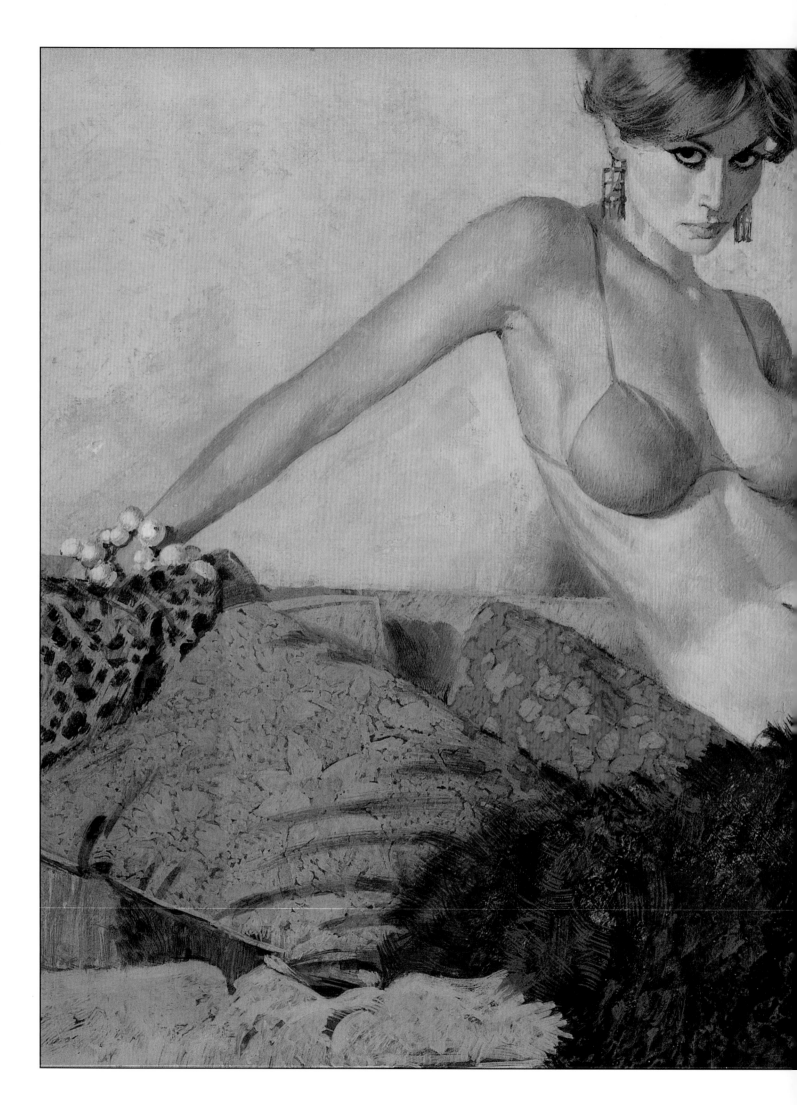

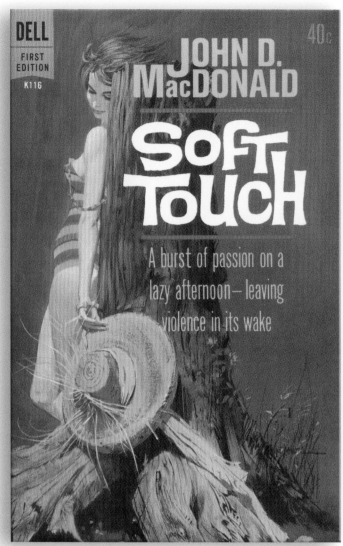

↑ **Soft Touch:** 1962, Dell paperback

↑ **Murder for the Bride:** 1974, tempera; John D. MacDonald, Fawcett

↓ **Contrary Pleasure:** 1980, tempera; John D. MacDonald, Fawcett

↓ **Deadly Welcome:** 1973, tempera; John D. MacDonald, Fawcett

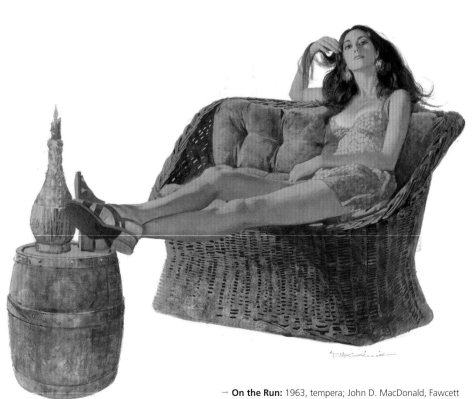

→ **On the Run:** 1963, tempera; John D. MacDonald, Fawcett

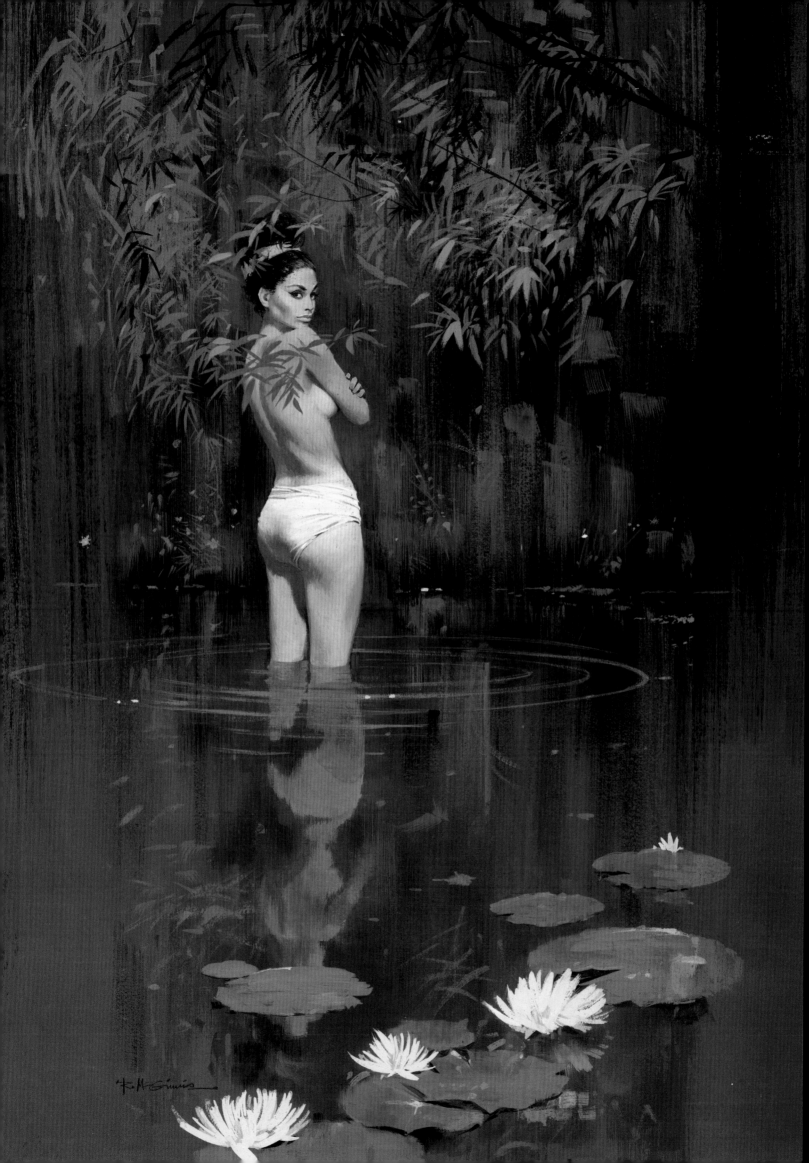

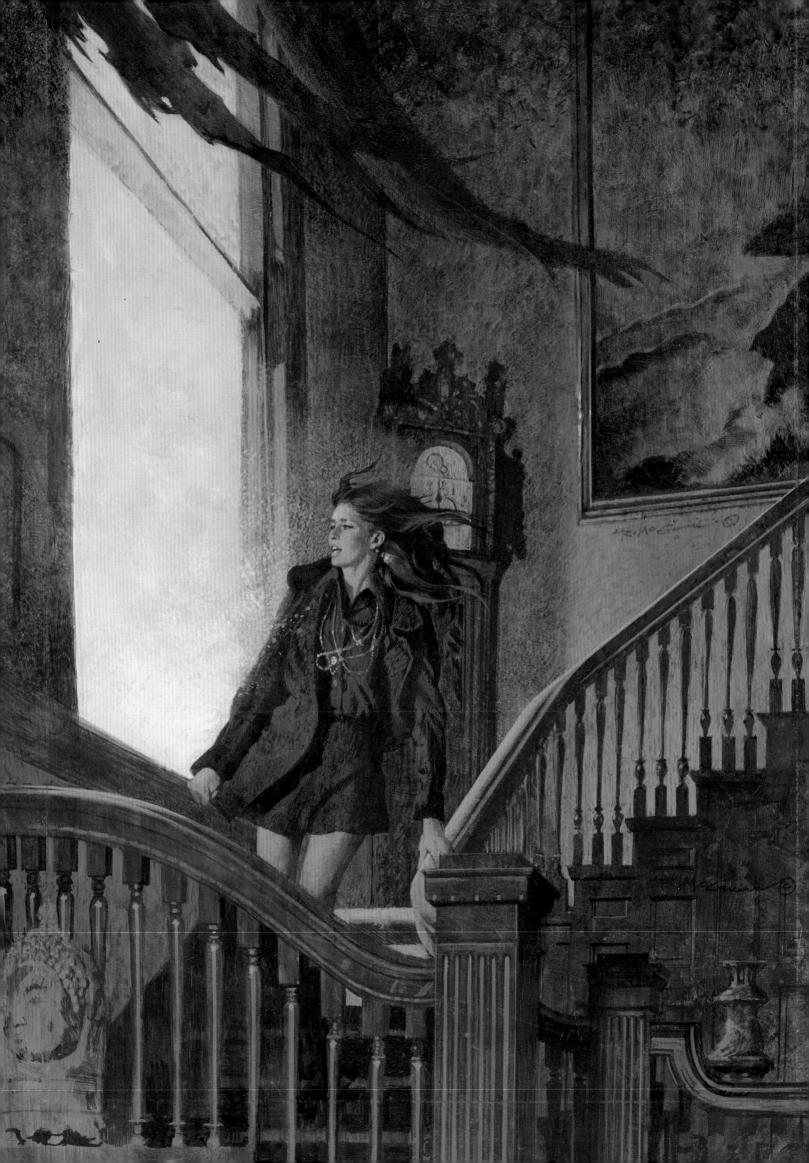

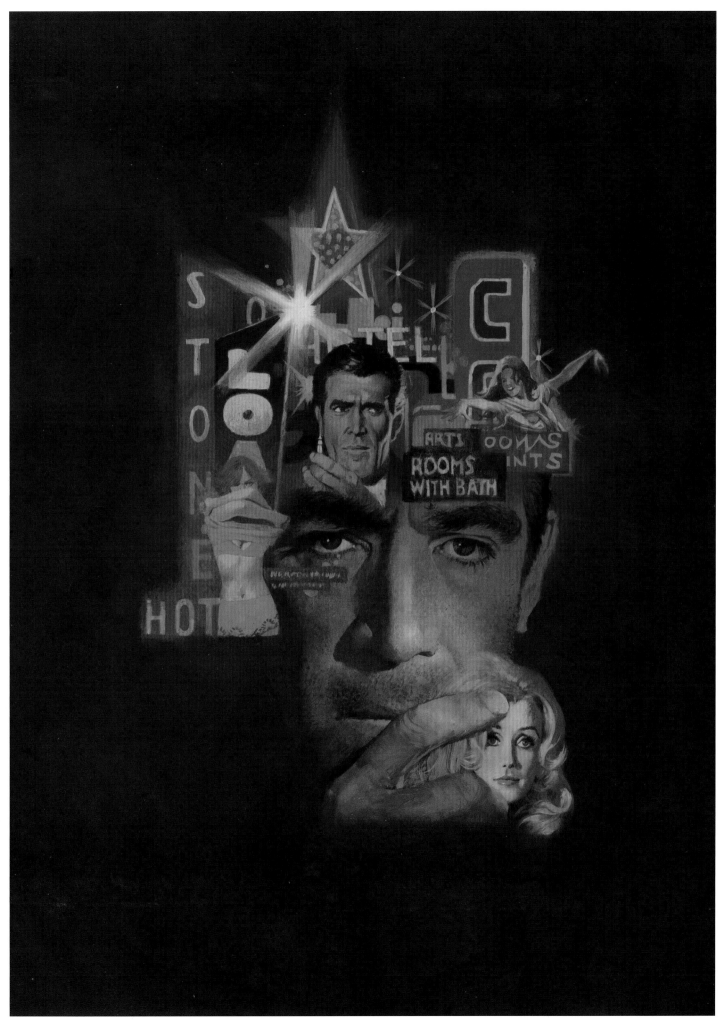

← **Murder In the Wind:** 1974, tempera; John D. MacDonald, Fawcett

↑ **The Neon Jungle:** 1976, tempera; John D. MacDonald, Fawcett

THE RISE OF ROMANCE

The John D. MacDonald books were the last big crime series for McGinnis. The era of private eye fiction had about run its course, and the paperback market readership demographics were strongly shifting to be largely female.

A sudden boom in so-called "Gothic" novels of romantic suspense, beginning about 1970, was a bellwether of this trend. The Gothic was a rather formulaic niche genre, and appropriately enough the industry's art directors nearly all settled on a very specific formula for the covers: night-time, a young woman in the foreground, fleeing in terror or at least clearly frightened, a gloomy castle or manor house in the background, with a light in one—and only one—window.

McGinnis executed the formula handsomely for Dell and Avon, but he also painted some striking departures, such as *The Coach Draws Near* and *A Change of Heart*, both for Dell.

The Gothic boom faded mid-decade, but as a general category, historical romance only got stronger. Avon was the leader in the field, and McGinnis was their star cover artist, getting the plum assignments on books by emerging writers like Rosemary Rogers, Elizabeth Norman, and Johanna Lindsey. His covers put the young and gorgeous heroines, and their handsome lovers, in beautiful period costumes and exotic, romantic settings—fields of flowers were a specialty. McGinnis's romance covers would influence the look of the genre for decades to come.

Meanwhile, mainstream contemporary fiction was always there to provide a break from past times and faraway lands. Books like *The Man Chasers* and *Gigante* featured classic McGinnis bunch-of-gorgeous-women fare, while covers for *The Best of Everything* and *Where the Red Fern Grows* demonstrated his ability to catch the eye, evoke a mood, and tell a story with any sort of subject.

→ **Whisper in the Forest:** 1971, tempera; Norma Ames, Avon

↑ **Come to Castlemoor:** 1970, tempera; Beatrice Parker, Dell

↑ **Castle at Glencarris:** 1972, tempera; Jean Vicary, Avon

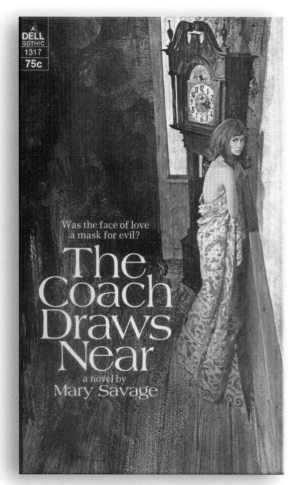

↑ *The Coach Draws Near*: 1972, Dell paperback

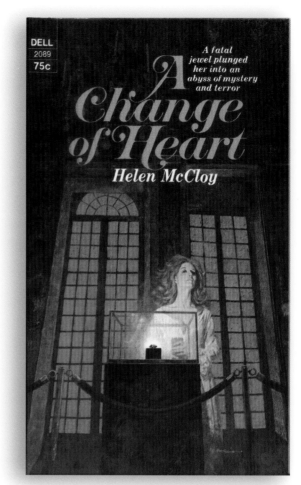

↑ *A Change of Heart*: 1974, Dell paperback

↑ **Gigante:** 1972, tempera; Sidney Mandel, Avon

↑ **The Man Chasers:** 1971, tempera; Ann Pinchot, Avon

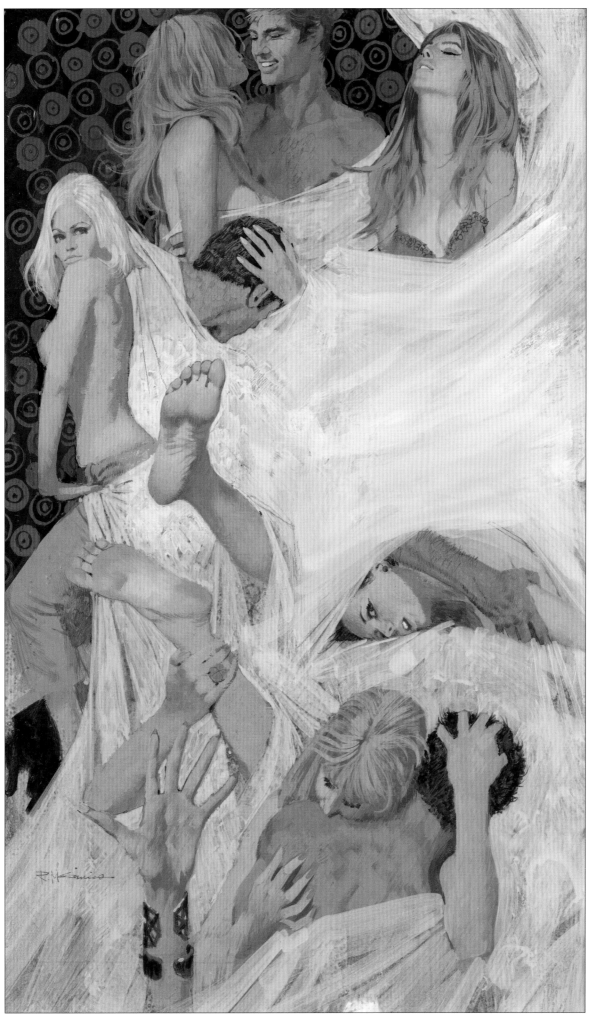

↑ **The Wow Factor:** 1970, tempera; Robert Terrall, Fawcett

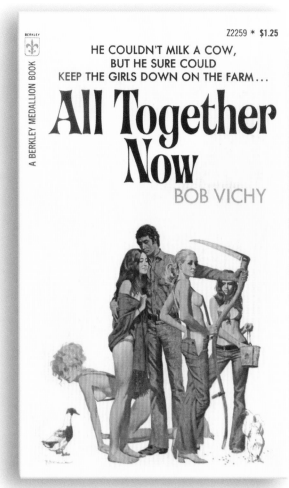

↑ *All Together Now:* 1972, Berkley paperback

↑ **Where the Red Fern Grows:** 1974, tempera; Wilson Rawls, Bantam

↑ **The Wolf and the Dove:** 1974, tempera; Kathleen E. Woodiwiss, Avon → **The Best of Everything:** 1976, tempera; Rona Jaffe, Avon

↑ **Vice Avenged:** 1972, tempera; Lolah Burford, Fawcett

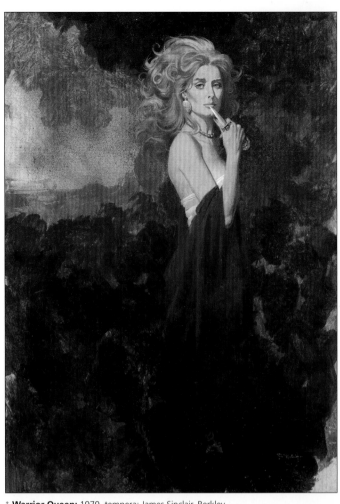

↑ **Warrior Queen:** 1979, tempera; James Sinclair, Berkley

↑ **Gallows Wedding:** 1980, tempera; Rhona Martin, Berkley

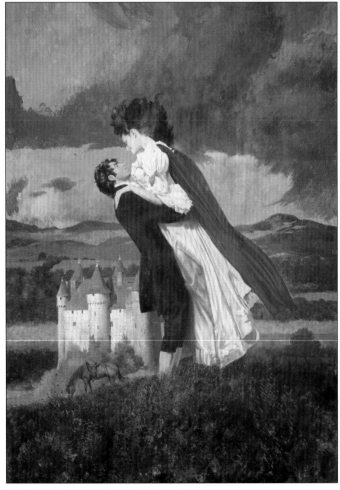

↑ **Norah:** 1978, tempera; Pamela Hill, Fawcett

→ **Judith:** 1979, tempera; Brian Cleeve, Berkley

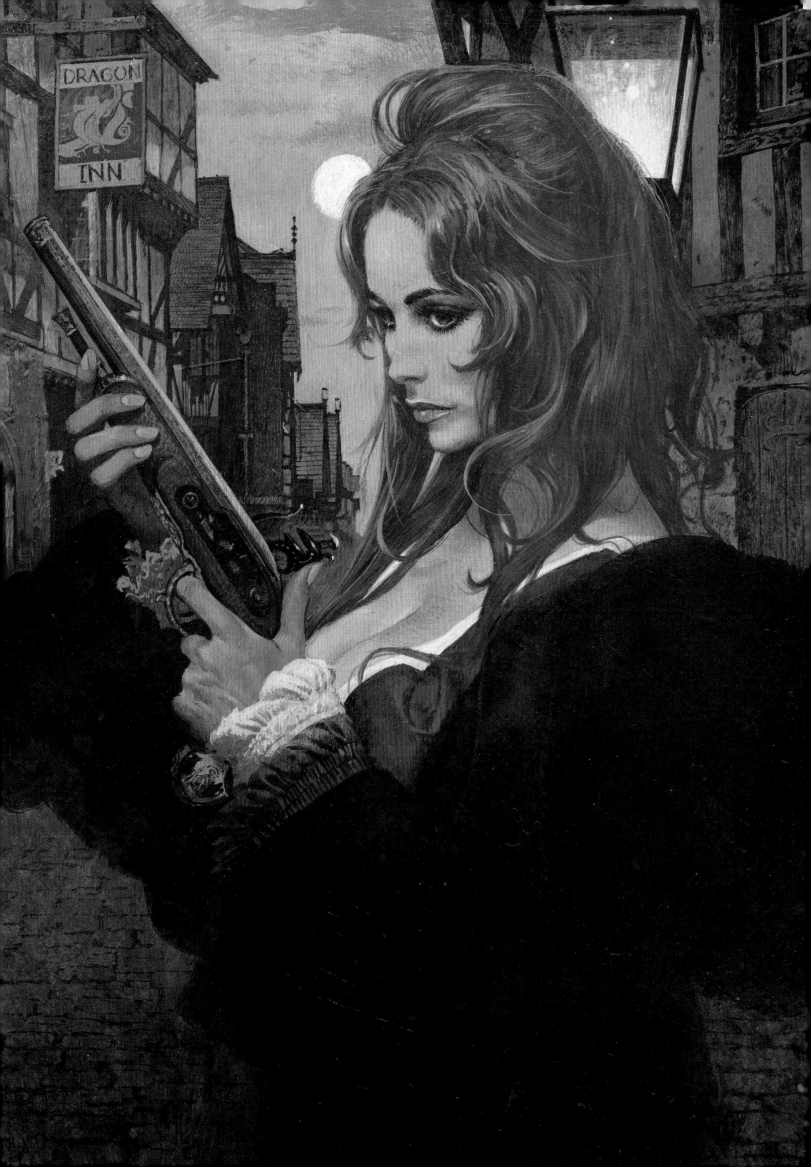

HISTORICALS AND CONTROVERSY

McGinnis's yearly total of paperback assignments began trending downward around 1976. He was hardly hurting for work, since he was established at the top of his profession, and was commanding top fees. But instead of the simple portraits that he began with, publishers wanted elaborate wraparound or fold-out covers, sometimes with embossed lettering, die cuts, and other gimmicks, especially for the huge romance market and on big bestsellers like *Princess Daisy* and *"...And Ladies of the Club"*.

These were big jobs and large paintings, requiring extensive model shoots, research into period costumes, locales, architecture, and other details.

Johanna Lindsey was Avon's top romance star, and McGinnis's dramatic and sensual covers on thirteen of her titles surely contributed to her success. One widely copied McGinnis innovation, the "naked man" cover, began with *Fires of Winter* in 1980 and sparked controversy (as well as great publicity) when

some retailers complained about excessive exposure of the hero's hindquarters on *Tender Is the Storm*. Cover-up stickers were hastily slapped on some copies.

Though historicals were the main fare through the '80s and '90s, McGinnis also produced exceptional pieces in other genres: the dramatic "crane shot" for *The Merry Adventures of Robin Hood*; *Hondo*, a smaller-scale sample of the big Western paintings he had begun painting for gallery sale; the exotic "travel poster" for *Mandalay*; and the amazing *Letters from Philippa*—one of several fine covers he did for Bantam's young readers' imprints.

Philippa is a superb example of the illustrator as *storyteller*. The intriguing picture conveys the essence of the tale—a young girl finds old letters written by a long-dead relative, whom she remarkably resembles. The usual blurbs are rendered superfluous by a master illustrator. The picture was deservedly featured in *Illustrators 35*, a publication of the Society of Illustrators.

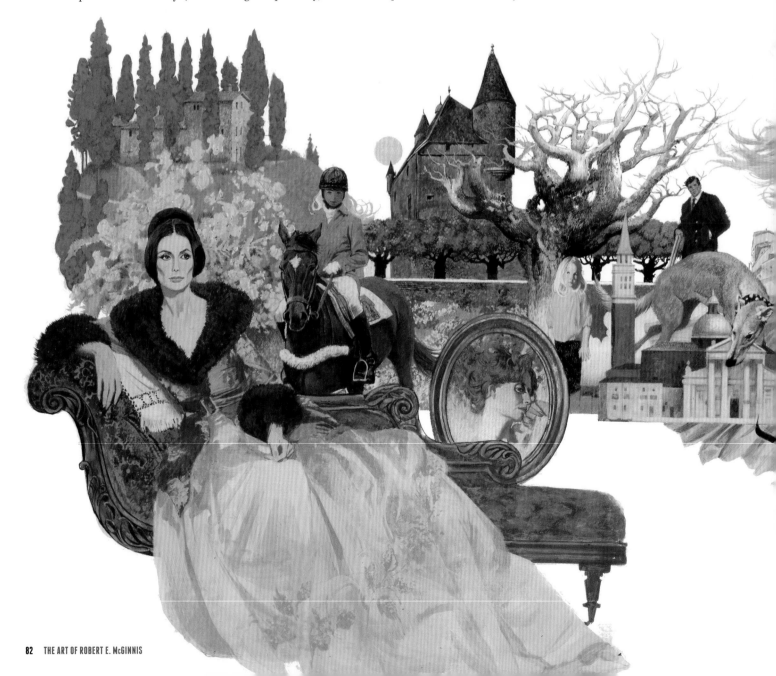

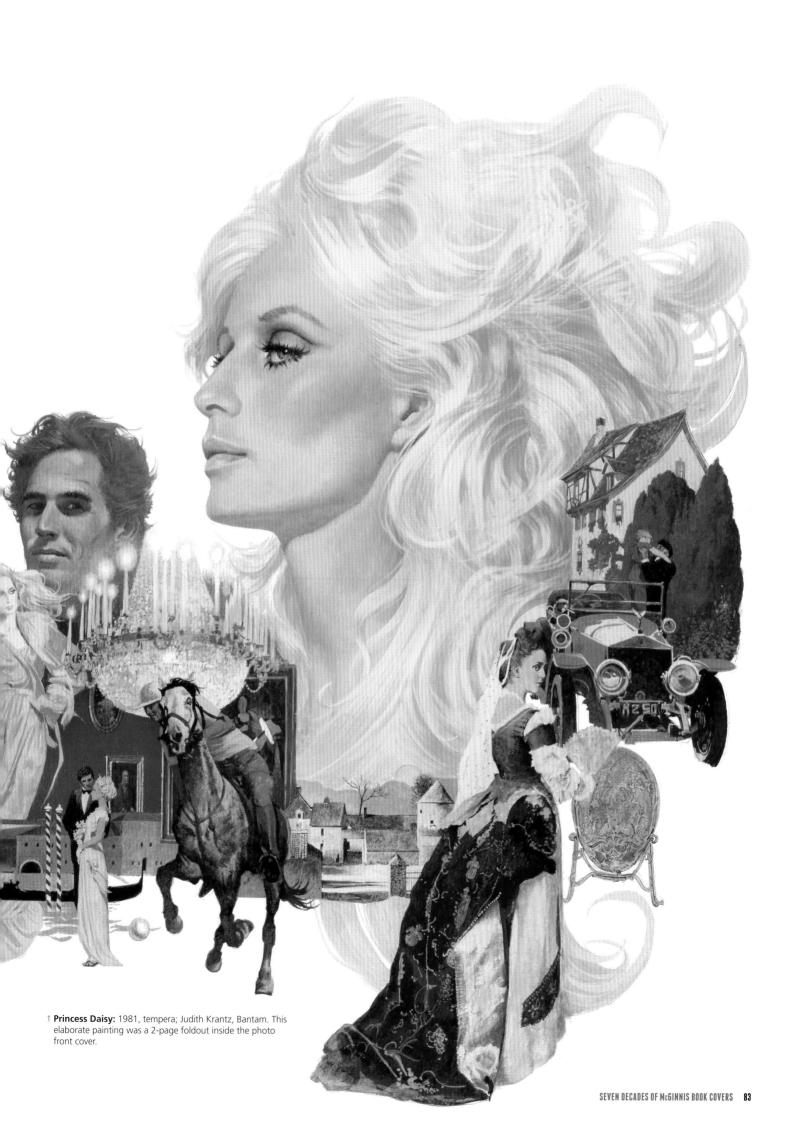

↑ **Princess Daisy:** 1981, tempera; Judith Krantz, Bantam. This elaborate painting was a 2-page foldout inside the photo front cover.

↑ **Finding Out:** 1979, tempera; Thomas Baird, Avon

↓ **"…And Ladies of the Club":** 1985, tempera; Helen Hooven Santmyer, Berkley. Back cover illustration for the massive 1433-page bestseller.

→ **The Merry Adventures of Robin Hood:** 1985, tempera; Howard Pyle, Signet

↓ **Gracie Square:** 1984, oil; Bruce Nicolaysen, Avon

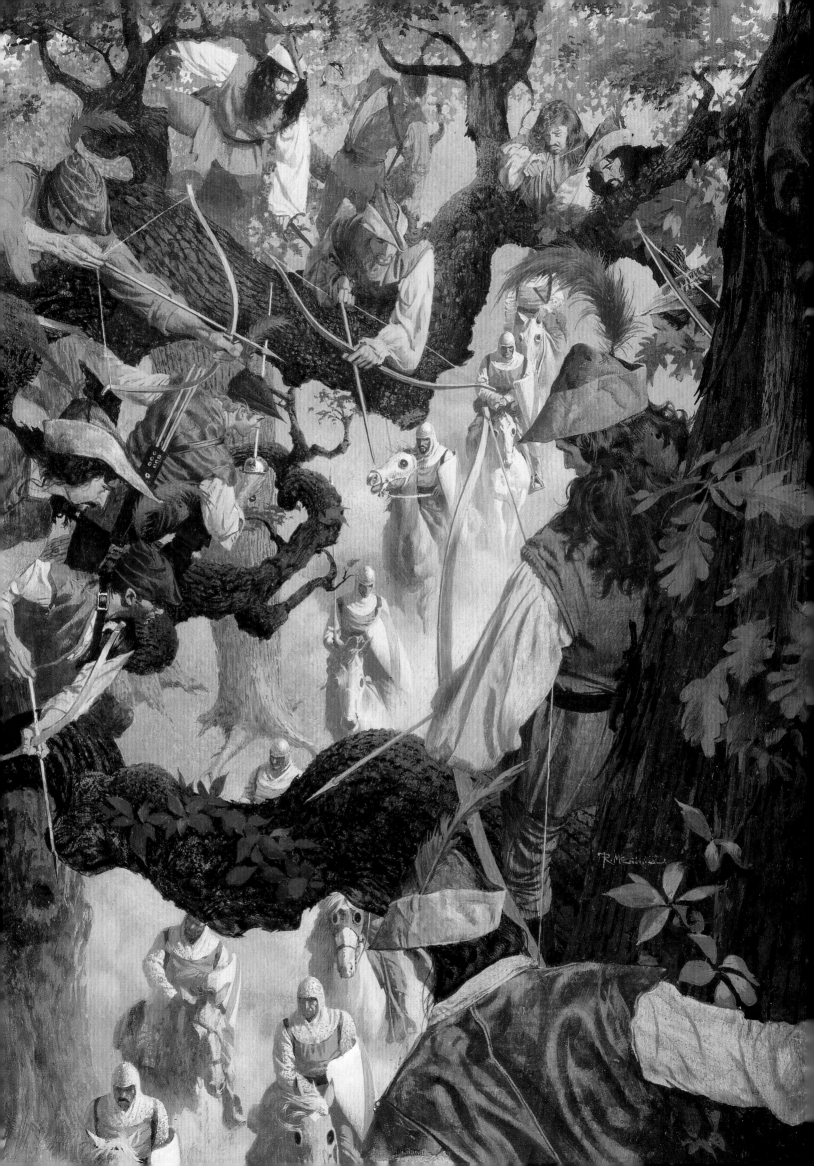

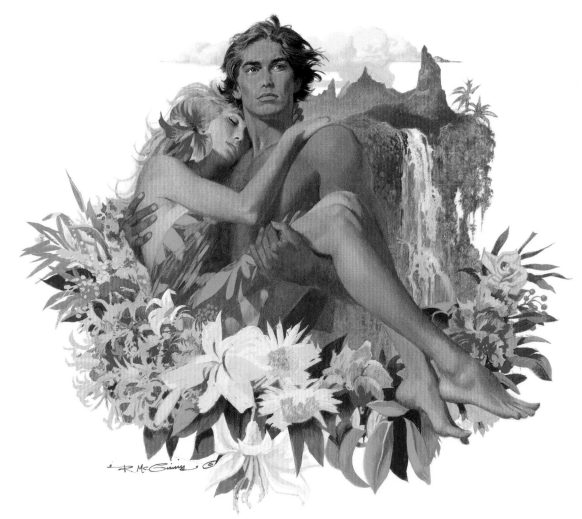

↑ **Paradise Wild:** 1981, tempera; Johanna Lindsey, Avon

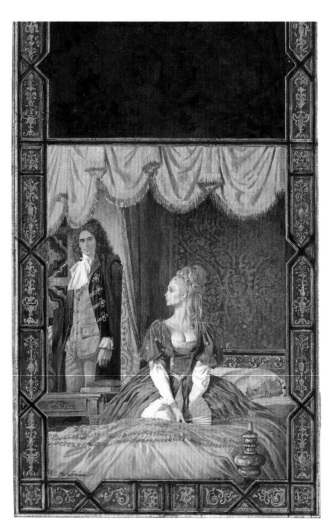

↑ **The Shadow of the Sun:** 1981, tempera; Sylvia Pell, Avon

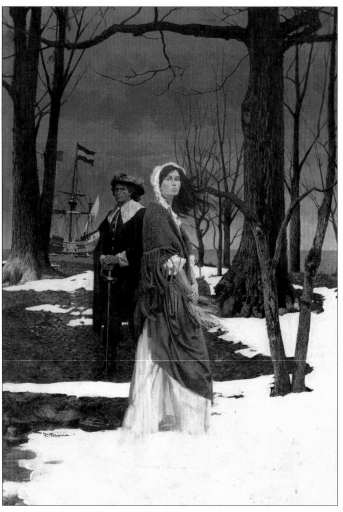

↑ **Pirate's Landing:** 1983, tempera; Mary Shura Craig, Jove

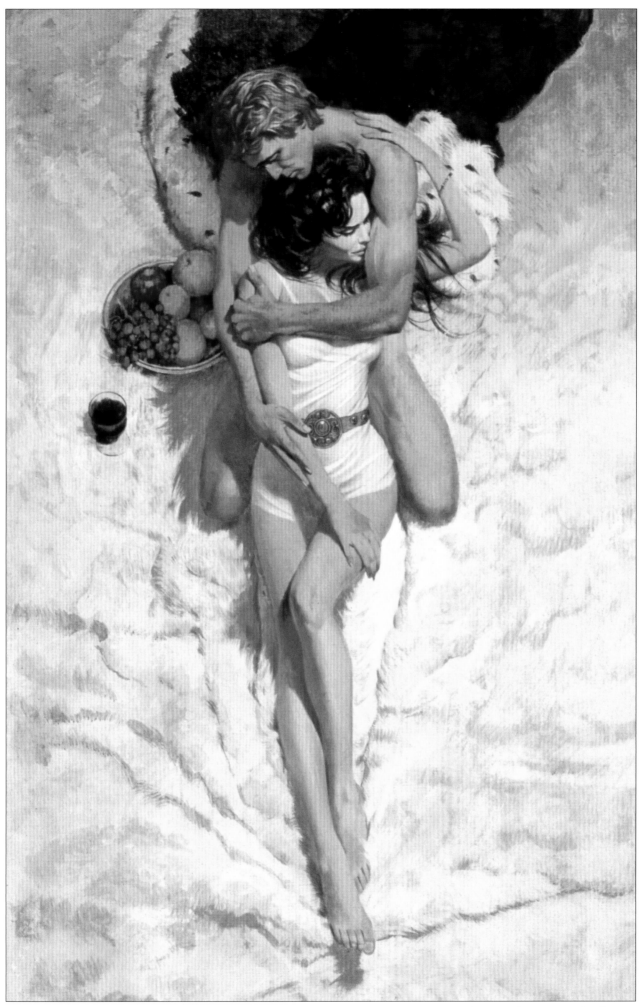

↑ **Fires of Winter:** 1980, tempera; Johanna Lindsey, Avon. The first of the Avon "naked man" covers. The woman was also nude in the painting as originally submitted, but this was vetoed and the white garment added.

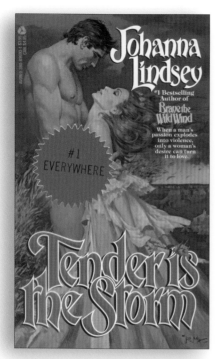

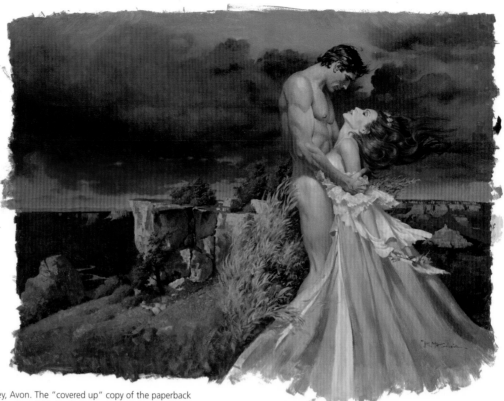

↑ **Tender Is the Storm:** 1985, tempera; Johanna Lindsey, Avon. The "covered up" copy of the paperback shows how stickers were strategically applied to some copies of this book to appease nervous retailers.

↑ **Clan of the Cave Bear:** 1981, unpublished painting, tempera; Jean M. Auel, Bantam

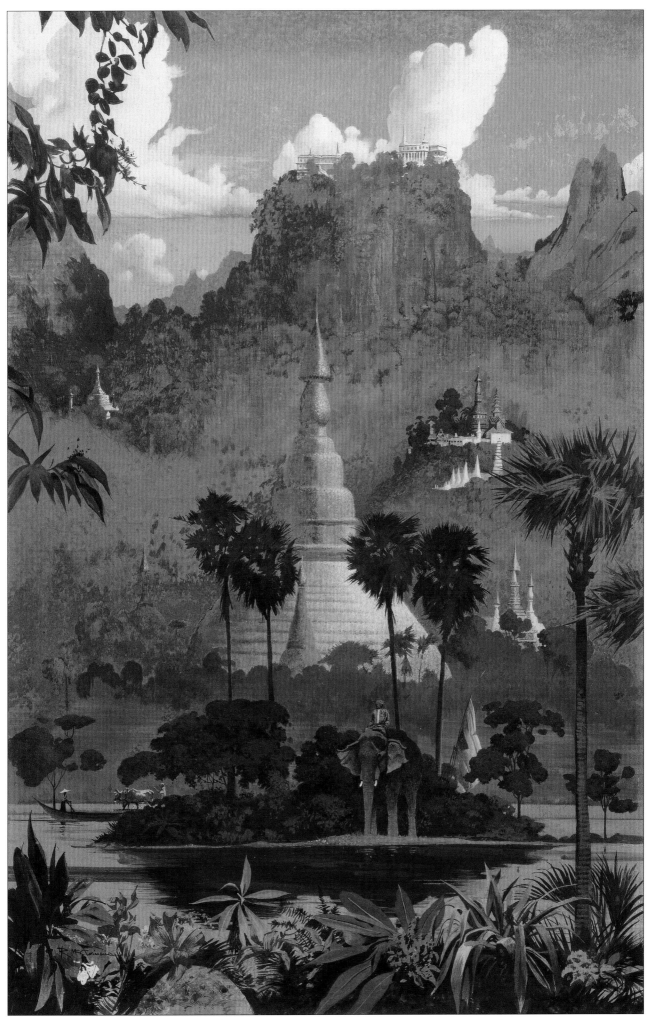

↑ **Mandalay:** 1988, tempera; Alexandra Jones, Villard. Hardcover dust jacket.

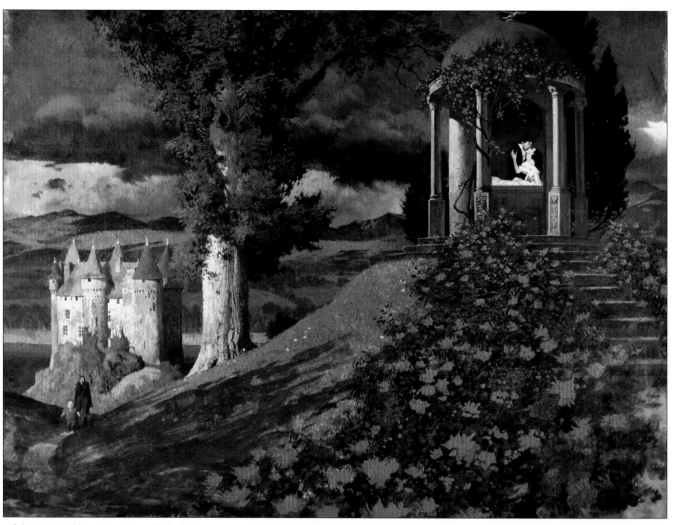

↑ **If the Reaper Ride:** 1978, tempera; Elizabeth Norman, Avon

↑ **Cathay:** 1982, tempera; Helene Thornton, Fawcett

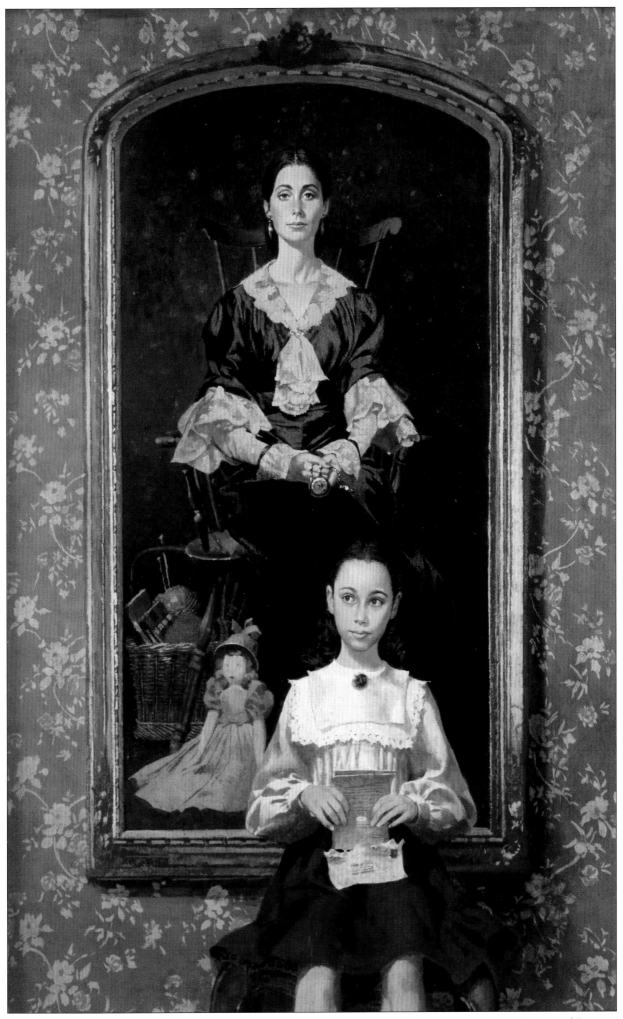

↑ **Letters from Philippa:** 1991, oil; Anne Graham Estern, Bantam. This painting was selected for inclusion in *Illustrators 35*, published by the Society of Illustrators.

HARD CASE CRIME

By the end of the century, McGinnis had essentially retired from doing book covers. Though he took on an occasional magazine or film poster assignment, he was no longer painting to the specifications of an art director. He was painting for himself: rural landscapes, the Old West, and figure studies.

However, in 2004, Charles Ardai founded Hard Case Crime, devoted to publishing noir crime fiction—new and reprint—and he wanted an old-school, retro look for the covers. So he asked illustrator Glen Orbik if he knew anybody who painted in the style of Robert McGinnis.

"Have you tried Robert McGinnis?" Orbik replied.

Ardai was amazed to learn that at age seventy-eight, McGinnis was still painting. He called him, and thus began a sort of paperback Indian summer for the artist.

As of this writing, McGinnis has done more than a dozen covers for mass-market, trade paperback, and hardcover editions, bringing back to crime fiction the iconic McGinnis Woman. Among those titles are reprints of three novels that he illustrated early in his career: Halliday's *Murder Is My Business*, Prather's *The Peddler*, and Robert Terrall's *Kill Now, Pay Later*, the latter published by Hard Case Crime *forty-seven years* after the original Dell edition, then issued under the "Robert Kyle" pseudonym. The cover painting for the 1960 paperback is the cover of this book. He has also done a rare "sideways" cover (for *Losers Live Longer*), a pair of dustjacket paintings for a Lawrence Block double novel, and a dustjacket and interior pencil illustrations for the limited edition of Stephen King's *Joyland*.

Sometimes you *can* go home again.

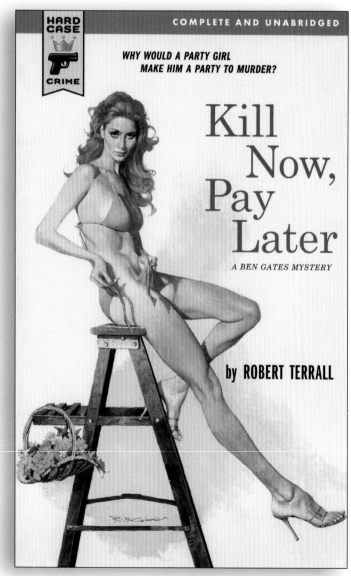

↑ *Kill Now, Pay Later*: 2007, Hard Case Crime paperback. McGinnis did the cover for this same novel when first published by Dell in 1960. That painting serves as the cover of this book.

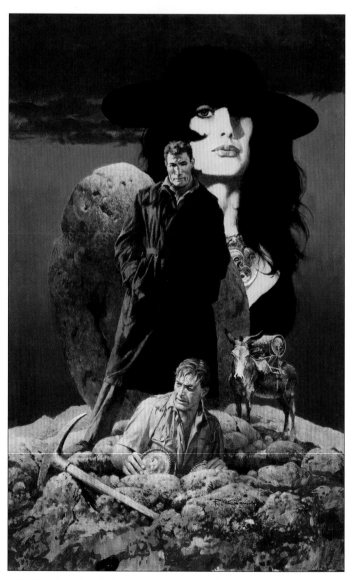

↑ **Plunder of the Sun**: 2005, egg tempera; David Dodge, Hard Case Crime

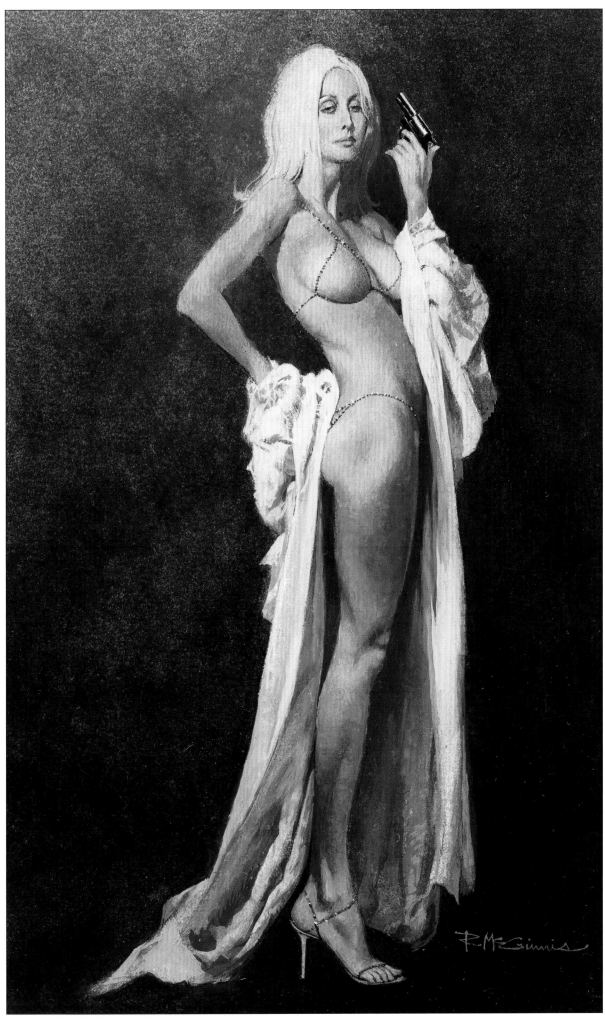

↑ **Baby Moll:** 2008, egg tempera; John Farris, Hard Case Crime

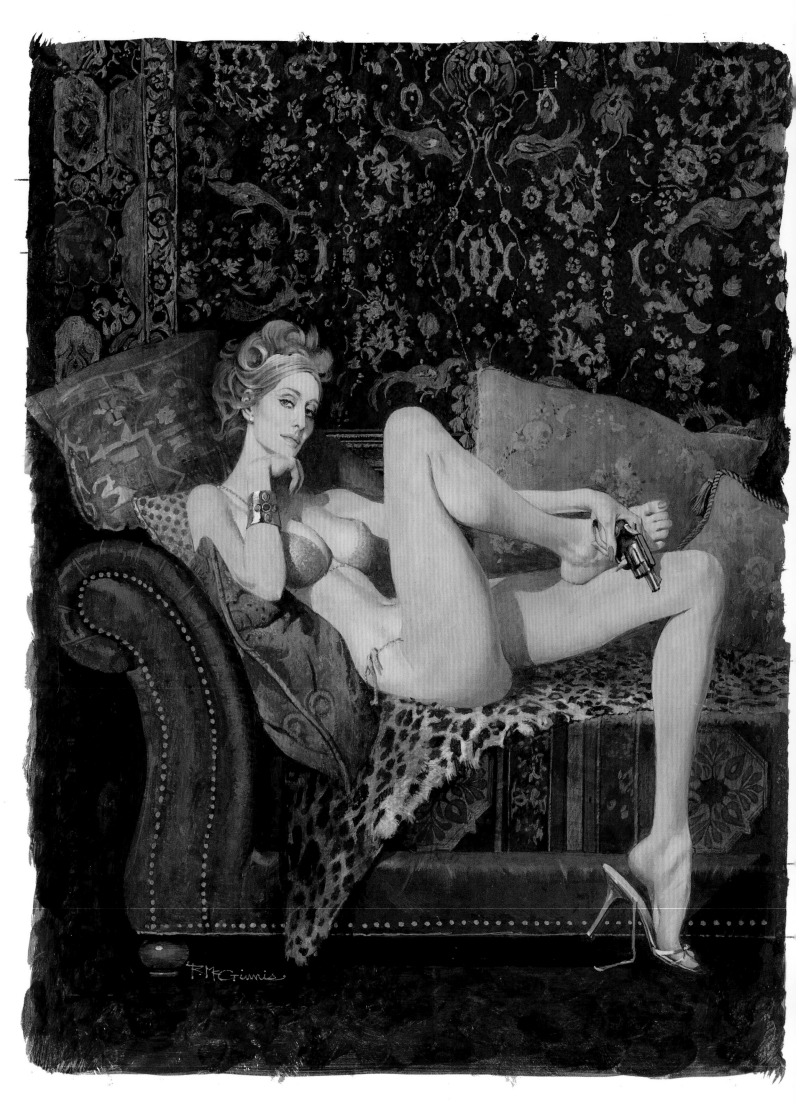

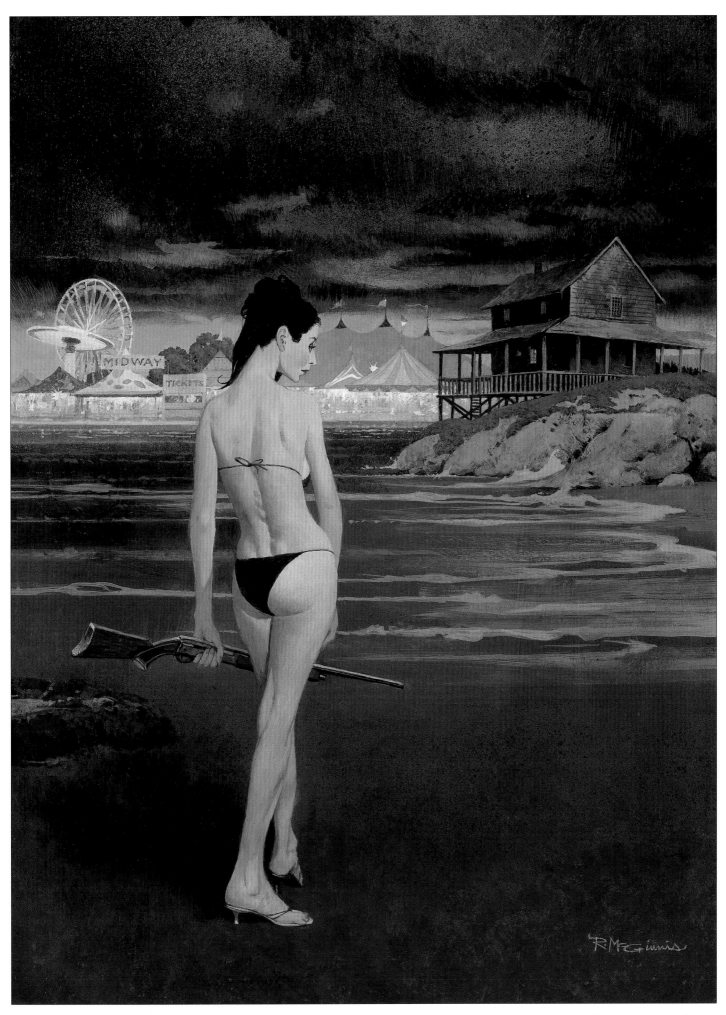

← **The Consummata:** 2011, egg tempera; Mickey Spillane & Max Allan Collins, Hard Case Crime

↑ **Joyland:** 2013, egg tempera; Stephen King, Hard Case Crime. Dust jacket for the hardcover limited edition.

THE MOVIES

Illustrators working on poster art projects for Hollywood studios have to deal with a much more complicated situation than if they were doing paperback or magazine art. Instead of working to a specific format, like a book cover or magazine page, they must prepare illustrations than can be adapted to a variety of formats—not only the classic 27" x 41" one-sheet poster, but also the three-sheet, the six-sheet, the half-sheet, the insert, the soundtrack LP jacket... Everything from a small newspaper ad to a gigantic billboard looming over Sunset Boulevard.

In addition, instead of only dealing with an art director, they must also satisfy the producer, the director, assorted suits from the studio and the distributor, talent agents, and the stars themselves—who will be carefully monitoring the proofs to make sure their images properly reflect their star status.

Nevertheless, sometimes the subject, the design, and the artist's talent combine to produce a poster image that is iconic. That is what happened with Robert McGinnis's very first poster, for *Breakfast at Tiffany's*, released in 1961. As McGinnis recounts:

"I did it, not thinking very much at all about it, because it was very simple—only one figure with a cat on her shoulder. I had a cat at home and my wife put a cat on her shoulder. Then I grafted that onto a movie still of Audrey Hepburn, making little exaggerations here and there, trimmed the figure. You didn't have to do much with her, she's so perfect. It was just one more job along the way and I didn't think much of it. But I see it everywhere!"

In 1965 he worked on *Thunderball*, and became the principal poster artist for the James Bond films for the next ten years, maintaining the look and style of the franchise through the difficult transition from Sean Connery to George Lazenby to Roger Moore. His poster introducing Moore as 007 in *Live and Let Die* is a masterpiece of imagination and design, certainly one of his finest.

In all, McGinnis art has appeared on posters for more than sixty films—action films, Westerns, comedies, dramas—and he has worked on at least another dozen where his art was not used. In this century, he still takes on an occasional movie assignment, such as a poster for the animated hit *The Incredibles*, or the faux paperback covers he created for Shane Black's private eye film, *Kiss Kiss Bang Bang*.

Another iconic poster was for *Cotton Comes to Harlem*, described by art director Don Smolen as "his best poster art ever." As McGinnis recalls:

"It was the first black movie from United Artists. They didn't know what to do with it, they didn't know if it would make any money, or have any draw, or how to promote it. Smolen said, 'Let's have Bob do some of his women, and guns and stuff, and see how it turns out.' Well, that's what we did, and it became the number one movie of the year for United Artists as far as income. It was astounding what happened. It was just the concept, women and guns, I guess."

A shortlist of "iconic" McGinnis posters would also have to include, at minimum, *The Odd Couple*, *Barbarella*, *Semi-Tough*, and *The Private Life of Sherlock Holmes*. Not iconic, in fact practically unknown, are the seven posters he did for the Group 1 organization. One suspects that many serious McGinnis collectors will be amazed to see these. Group 1 apparently took soft-core European sex films, added dubbed English soundtracks, and released them to drive-ins

and the like. There's no mistaking them as McGinnis—there's Shere Hite, there's Walter Matthau, and for *The Teasers Go to Paris*, there's a self-parody of his *Semi-Tough* poster!

We have noted McGinnis's talent for cartoon and caricature, and it's his poster work that showcases it best, as seen in *Sleeper* and *Serial*.

"I think the best movie poster I did was *The Odd Couple*. It was a loosely done thing with a lot of spirit; it went back to my cartooning beginnings. I wanted to be a cartoonist, and I think cartooning is important. To a small degree, Norman Rockwell had cartooning ability. He would exaggerate just the right places to give it the zest and release from the photo. He was so good. A lot of artists have that cartooning ability, and it pays off down the road."

↓ ***Breakfast at Tiffany's:*** 1961, poster; Paramount

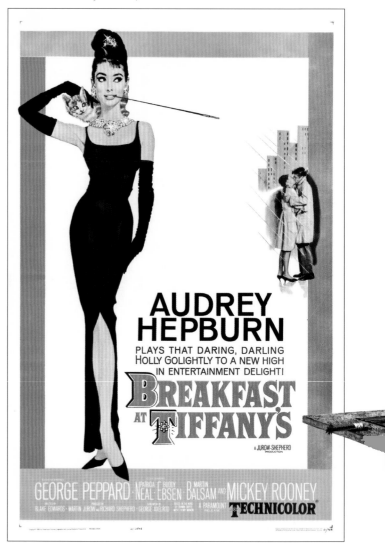

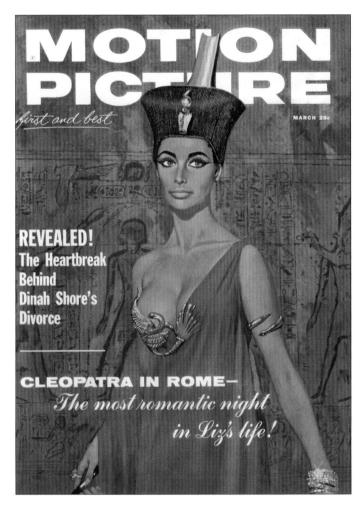

↑ **Liz Taylor as Cleopatra, *Motion Picture Magazine*:** 1962. The cover painting was given away to the winner of a write-in contest.

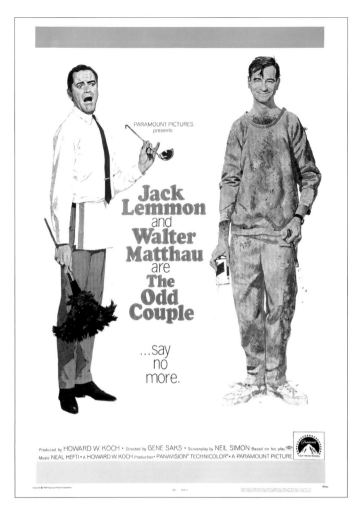

↑ ***The Odd Couple:*** 1968, poster; Paramount

← **The Odd Couple, Jack Lemmon and Walter Matthau:** 1968, pencil studies

↓ **The Odd Couple, Walter Matthau:** 1968, tempera

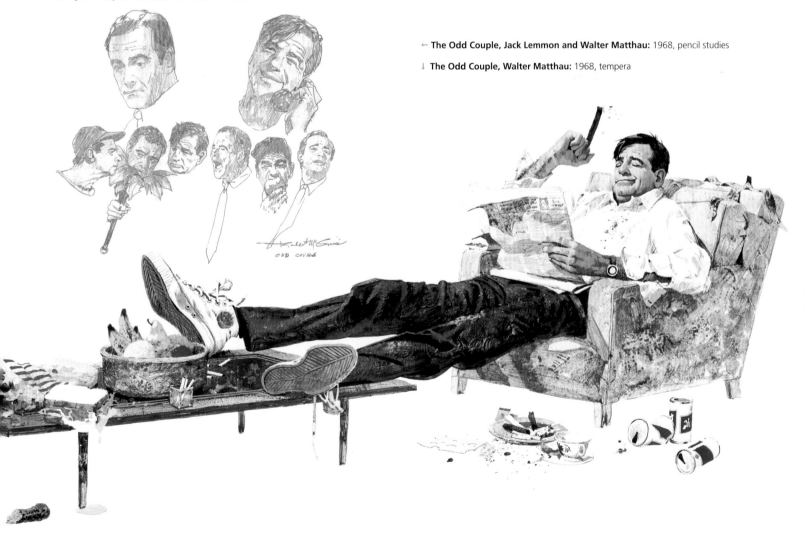

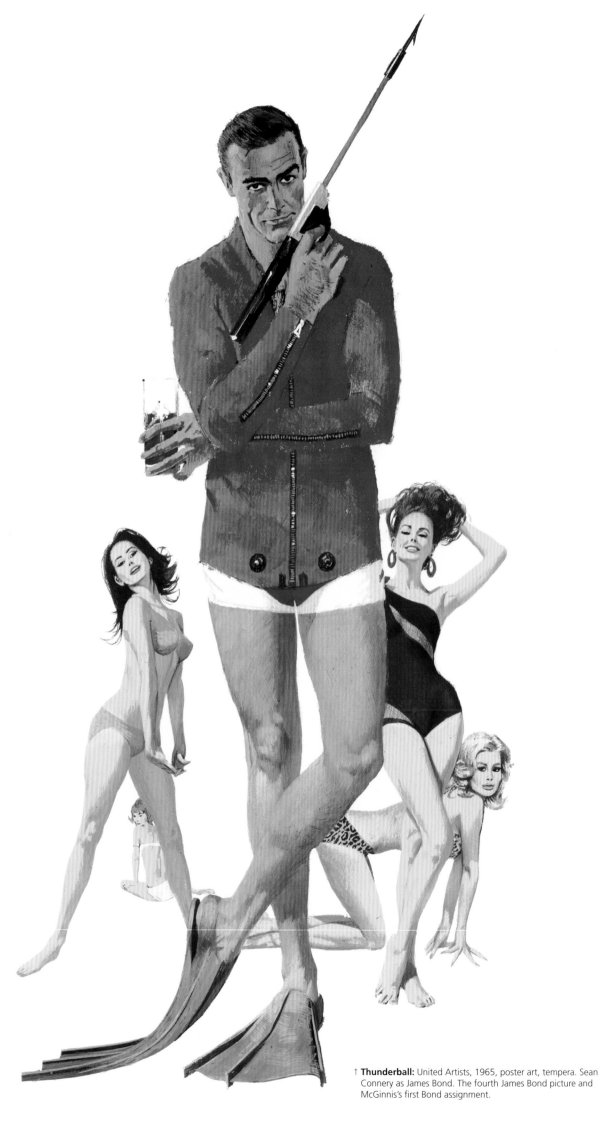

↑ **Thunderball:** United Artists, 1965, poster art, tempera. Sean Connery as James Bond. The fourth James Bond picture and McGinnis's first Bond assignment.

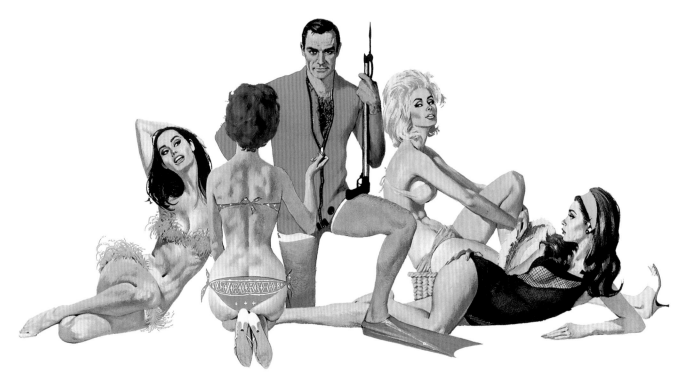

↑ **Thunderball:** 1965, poster art, tempera

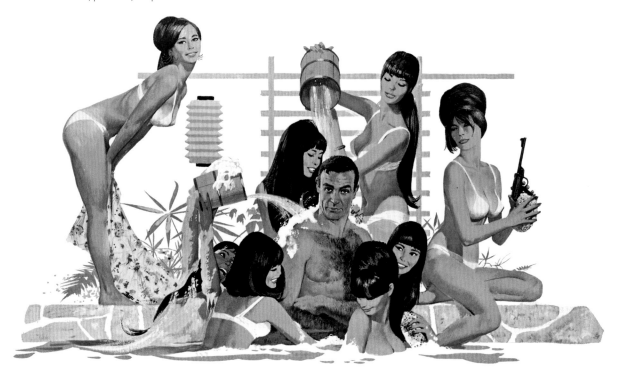

↑ **You Only Live Twice:** 1967, poster art, tempera

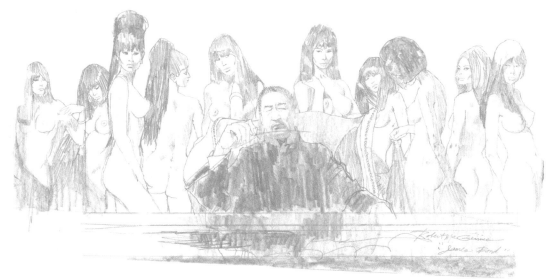

↑ **Asian man and nude women:** 1967, pencil study. Probably for *You Only Live Twice*.

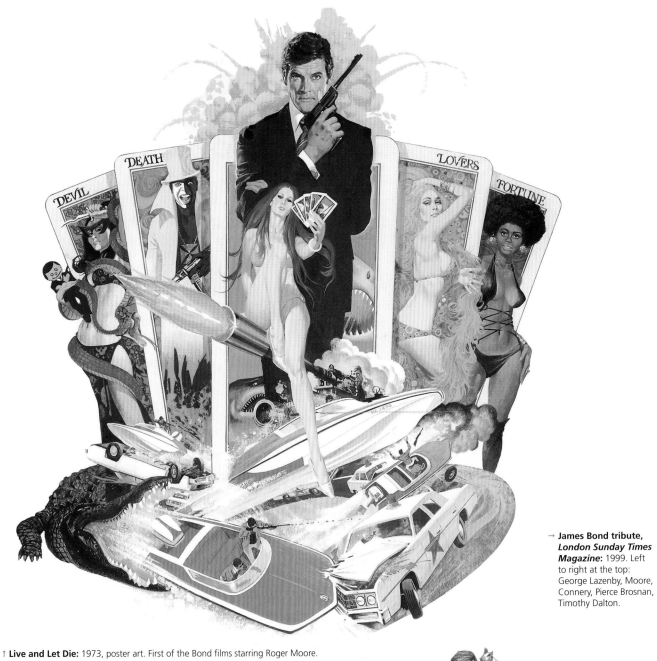

→ **James Bond tribute,**
London Sunday Times
Magazine: 1999. Left
to right at the top:
George Lazenby, Moore,
Connery, Pierce Brosnan,
Timothy Dalton.

↑ **Live and Let Die:** 1973, poster art. First of the Bond films starring Roger Moore.

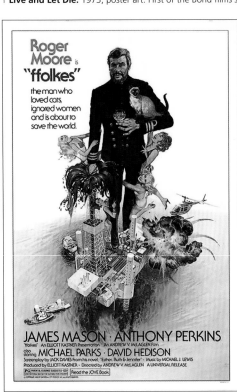

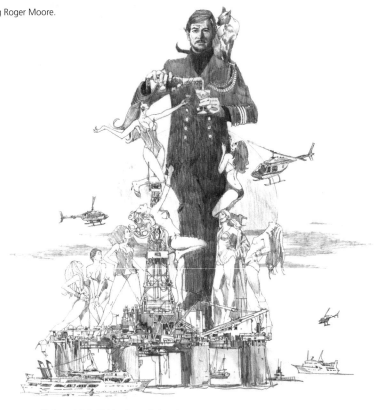

↑ ***ffolkes*** **(aka *North Sea Hijack*):** 1979, poster; Universal. A
non-Bond adventure film starring Roger Moore. The studio
insisted on "ffolkes," with no initial capital letter.

↑ ***ffolkes:*** 1979, finished pencil drawing

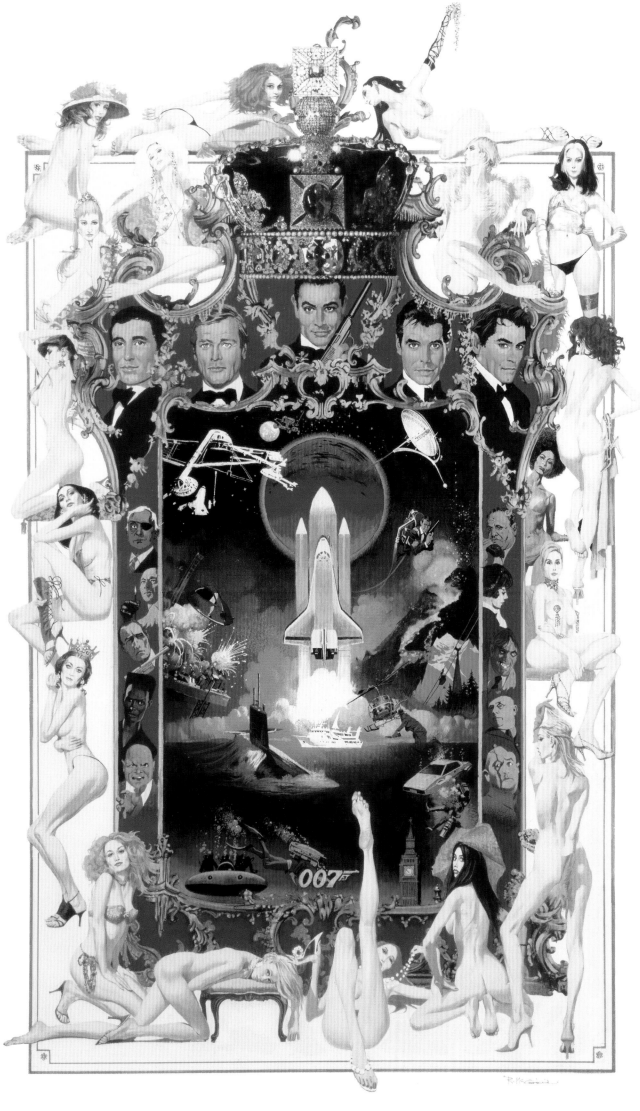

THE HALLELUJAH TRAIL

McGinnis's most unusual Hollywood job was to produce the artwork for the title sequence of John Sturges's 1965 film *The Hallelujah Trail*, a big-budget comedy Western starring Burt Lancaster and Lee Remick. The art once again showcases McGinnis the cartoonist:

"Sturges gave me full freedom to do what I wanted. He told me, 'You've done the cartoons for the poster, why not do the title treatment?' And he liked them all... I developed a style that worked, and they were unlike anything I did before or since. I would make a drawing; I had a big projector and I would project it on the studio wall about ten feet high to simulate a movie screen. I had to make them bold; I used black magic marker and casein opaques over that. They were some of the most original things I did, I think."

In addition to having to adapt his work to show best as projected, rather than as printed, McGinnis also had to design for the unfamiliar 2.5:1 Ultra Panavision format. Years later, he returned to similar panoramas in his Western and landscape gallery paintings.

Twenty-five paintings were used in the credit sequence, and we present here a mixture of three finished title cards: Art Director (bubbling pool), Lee Remick, and the final card for producer-director John Sturges (the Indian in the wagon); and five color roughs, done in pastel chalk. Some of the latter are quite close to the finished versions—Lancaster with the cigar, the cuddling couple of Jim Hutton and Pamela Tiffin, the Indian bopping a tribesman. Others were significantly altered, or didn't make the final cut. Most notably, the one with the naked women by the wagon.

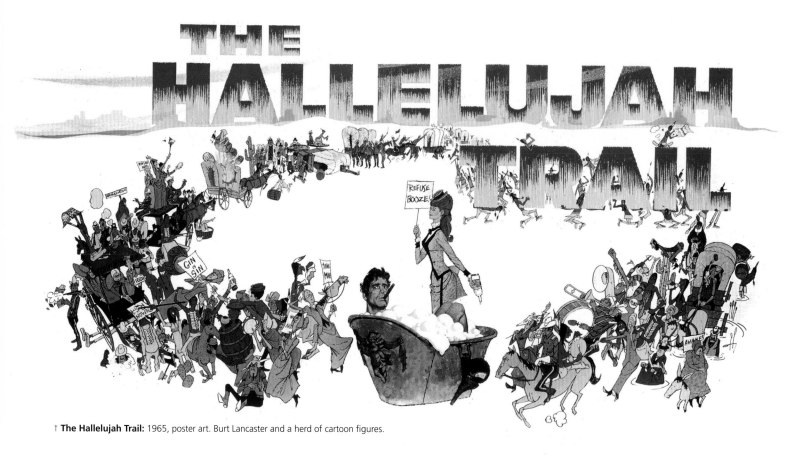

↑ **The Hallelujah Trail:** 1965, poster art. Burt Lancaster and a herd of cartoon figures.

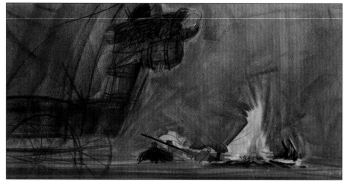

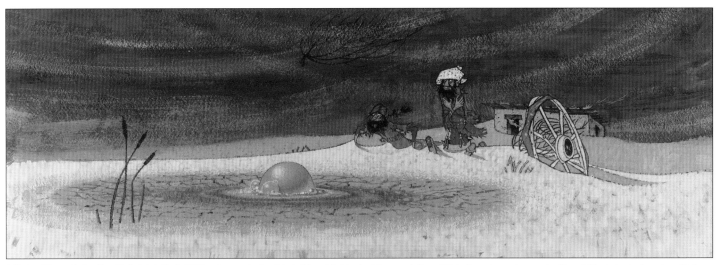

↑ **Eight title cards for _The Hallelujah Trail_:** 1965, color roughs (pastel chalk) and finished art (tempera). Page 102 *bottom:* two color roughs; Page 103, clockwise from top: "Art Director Cary Odell" title card; "Burt Lancaster" title card color rough; "Produced and Directed by John Sturges" title card; unused color rough; "Jim Hutton" title card color rough; "Lee Remick" title card

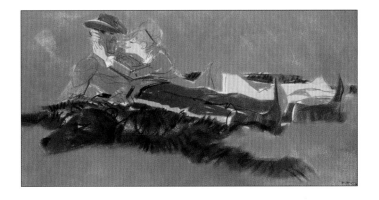

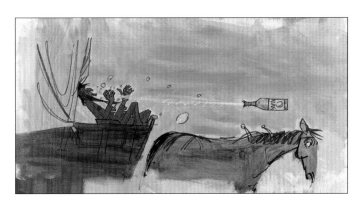

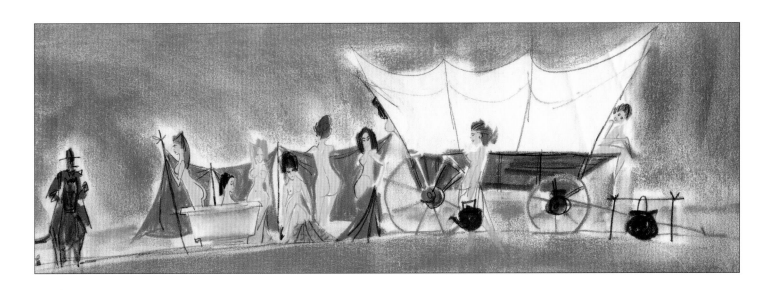

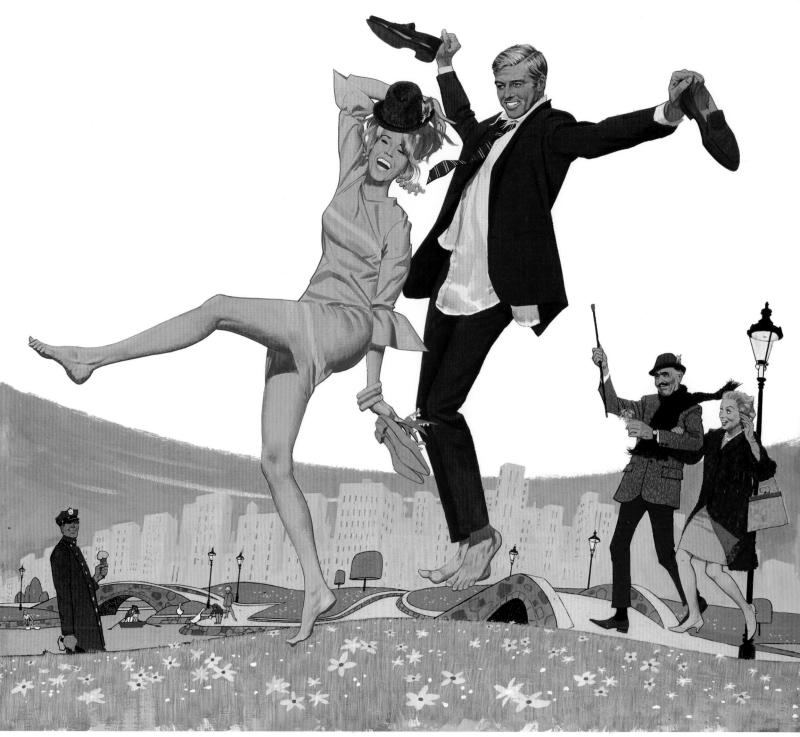

↑ **Barefoot in the Park:** 1967, poster art, tempera. Jane Fonda, Robert Redford, Charles Boyer and Mildred Natwick.

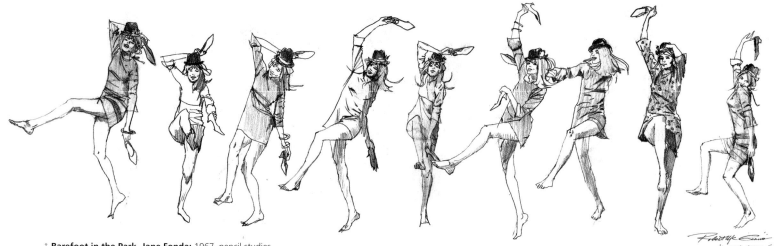

↑ **Barefoot in the Park, Jane Fonda:** 1967, pencil studies

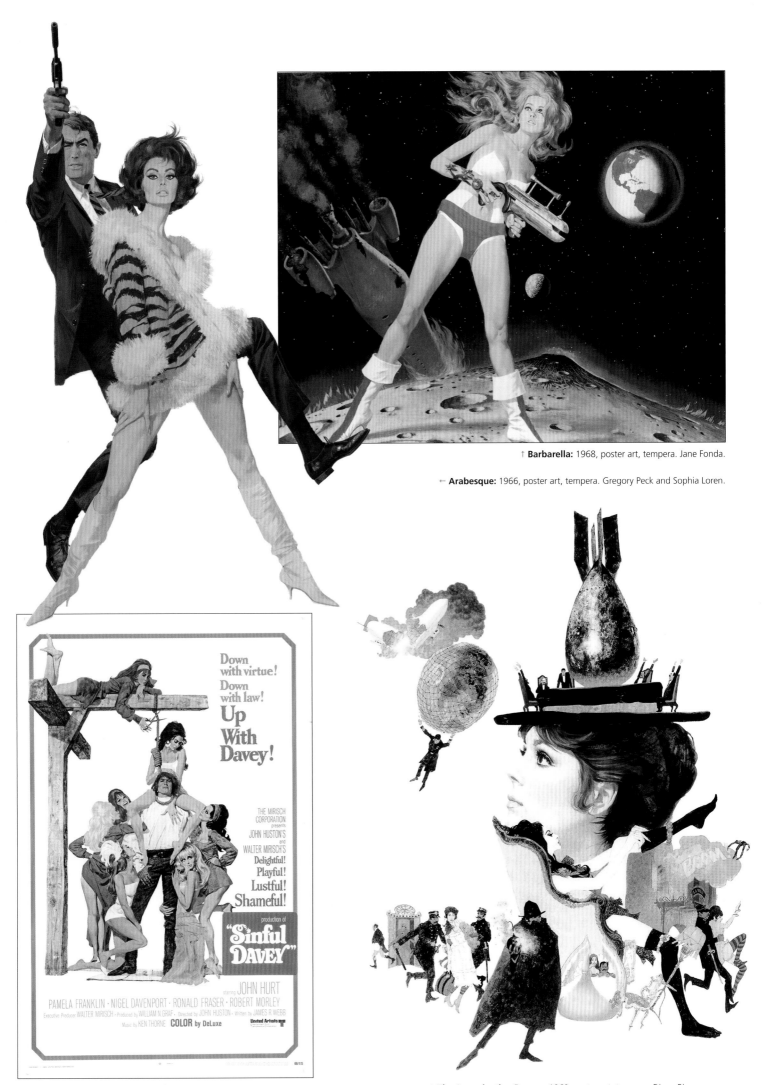

↑ **Barbarella:** 1968, poster art, tempera. Jane Fonda.

← **Arabesque:** 1966, poster art, tempera. Gregory Peck and Sophia Loren.

↑ *Sinful Davey:* 1969, poster; United Artists

↑ **The Assassination Bureau:** 1969, poster art, tempera. Diana Rigg.

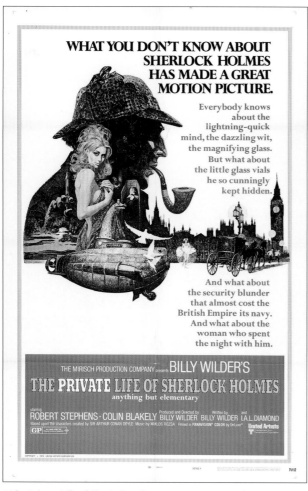

↑ *The Private Life of Sherlock Holmes:* 1970, poster; United Artists

↑ **Duck, You Sucker (aka *A Fistful of Dynamite*):** 1971, poster art, tempera. James

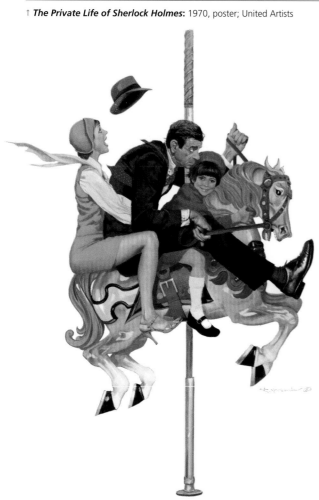

↑ **Little Miss Marker:** 1980, poster art, tempera. Julie Andrews and Walter Matthau.

↑ **The Bingo Long Traveling All-Stars & Motor Kings:** 1976, poster art, tempera. Billy Dee Williams, James Earl Jones, Richard Pryor. This artwork was apparently never used.

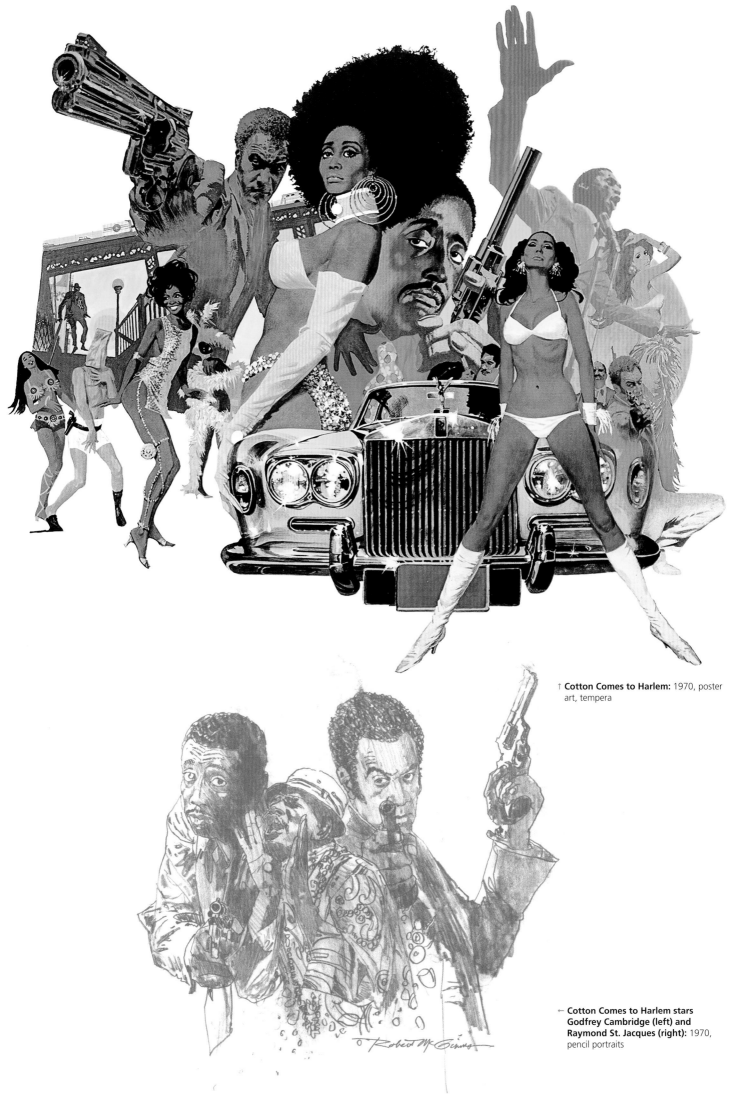

↑ **Cotton Comes to Harlem:** 1970, poster art, tempera

← **Cotton Comes to Harlem stars Godfrey Cambridge (left) and Raymond St. Jacques (right):** 1970, pencil portraits

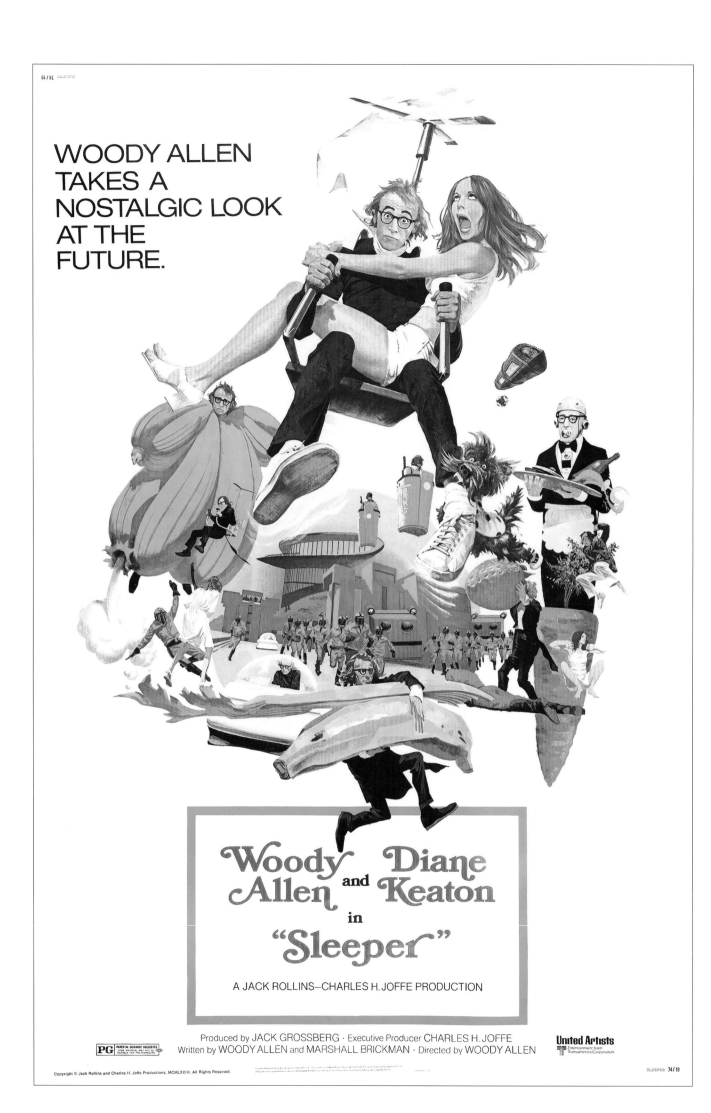

WOODY ALLEN TAKES A NOSTALGIC LOOK AT THE FUTURE.

Woody Allen and Diane Keaton in "Sleeper"

A JACK ROLLINS—CHARLES H. JOFFE PRODUCTION

Produced by JACK GROSSBERG · Executive Producer CHARLES H. JOFFE
Written by WOODY ALLEN and MARSHALL BRICKMAN · Directed by WOODY ALLEN

PG PARENTAL GUIDANCE SUGGESTED
SOME MATERIAL MAY NOT BE
SUITABLE FOR PRE-TEENAGERS

United Artists
Entertainment from
Transamerica Corporation

SLEEPER 74/19

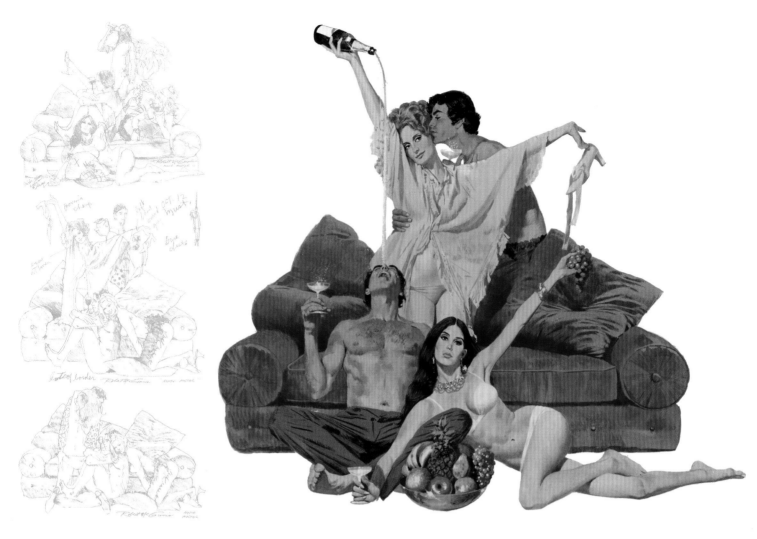

← **Sleeper:** 1973, poster; United Artists

↑ **The Four of Us:** 1974, poster art, tempera, and pencil sketches

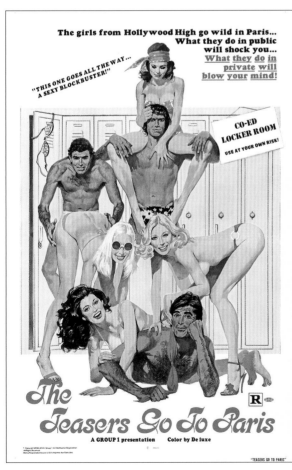

↑ **The Teasers Go to Paris:** 1977, poster; Group 1. McGinnis parodies his own *Semi-Tough* poster.

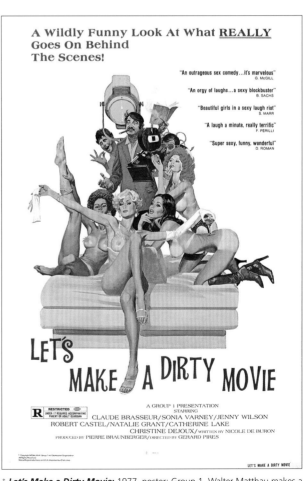

↑ **Let's Make a Dirty Movie:** 1977, poster; Group 1. Walter Matthau makes a "cameo appearance" on the poster for a movie he certainly did not appear in!

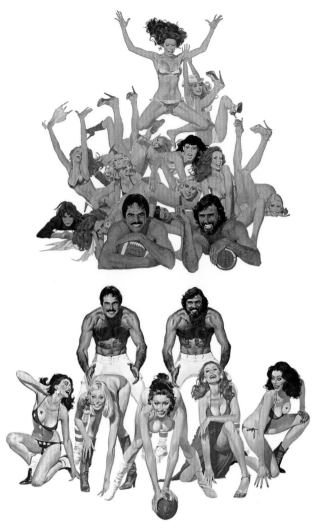

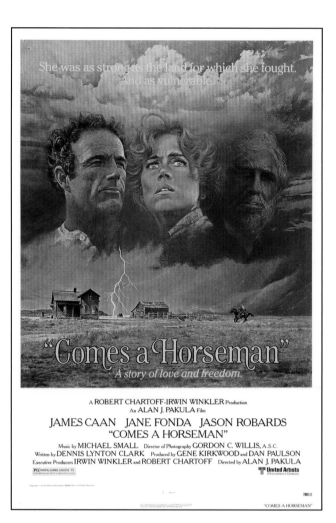

↑ **Semi-Tough:** 1977, poster art. For two versions. The top, "Pile On!" version was primarily used in print ads and for European release. Burt Reynolds' and Kris Kristofferson's agents objected to their being on the bottom rather than the top of the pile.

↓ **Comes a Horseman:** 1978, poster art, tempera

↑ **Comes a Horseman:** 1978, poster; United Artists. The three heads in the original art were rearranged by the studio art department, and Jason Robards' face is now in shadow. Apparently it was felt that as a supporting player, not a Star, Robards' face was too prominent in the original artwork.

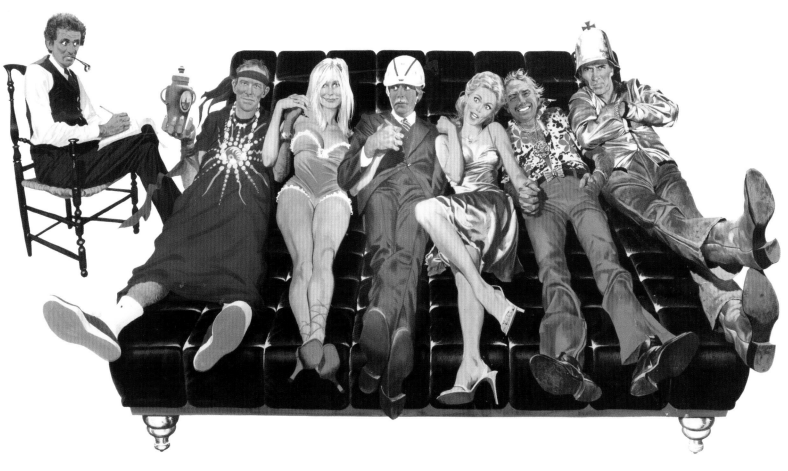

↑ **Serial:** 1980, poster art. Caricatures of Peter Bonerz, Tom Smothers, Sally Kellerman, Martin Mull, Tuesday Weld, John Ritter, Dick Smothers. The artwork was never used.

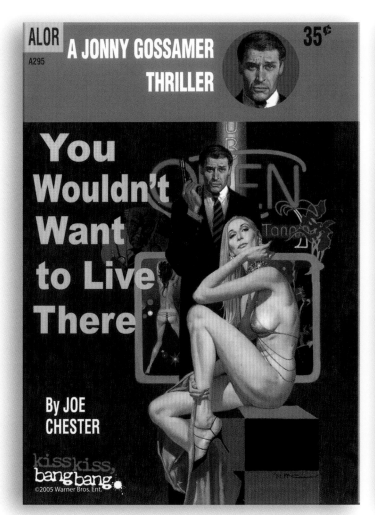

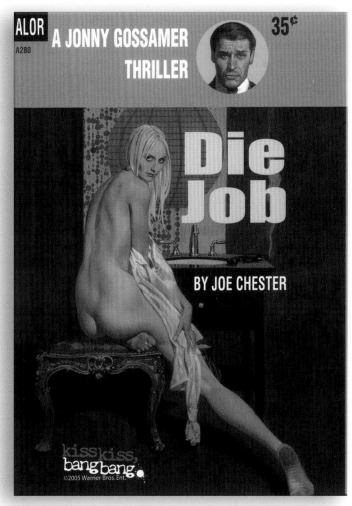

↑ *Kiss Kiss Bang Bang* **promotional postcards:** 2005. These faux paperback covers in Mike Shayne retro style were used in the movie.

MAGAZINE ILLUSTRATION

From the nineteenth century to the mid-point of the twentieth century, magazines were the main stage upon which America's finest illustrators performed—especially the weekly or monthly general-interest magazines such as *Harper's*, *Scribner's*, *McCall's*, *The American Magazine*, *Liberty*, *Collier's*, and *The Saturday Evening Post*. These publications were familiar fixtures in literate American homes, and an important source of entertainment before the television became ubiquitous. They presented current fiction by popular authors, short stories and serialized novels, and it was the illustrator's role to provide faces for the characters and visualize key incidents in the stories.

The roll call of artists who were prominent contributors to these magazines encompasses the finest American illustrators. For the span 1900-1950, we find the likes of Pyle, Gibson, Remington, Coll, Parrish, Wyeth, Schoonover, Booth, Christy, Flagg, Leyendecker, Cornwell, Rockwell, Schaeffer, Whitcomb, and Dohanos—all inductees to the Society of Illustrators' Hall of Fame, as is McGinnis. Such men and women were more than distinguished and influential artists, they were also *celebrities*, as familiar to the readers as the best-selling authors whose stories they illustrated. They also painted the covers, produced portraits of historical figures, newsmakers, and film stars, and provided the artwork for full-page advertisements for major corporations.

These magazines were known in the trade as "the slicks," printed on slick, glossy paper capable of quality color reproduction, as distinguished from "the pulps." After World War Two the pulps faded quickly in popularity, and by the time McGinnis arrived in New York in the late 1950s, the slicks were in decline as well. *Liberty* folded in 1950, *The American Magazine* in 1956, *Collier's* in 1957. The weekly *Saturday Evening Post*—then the top market for illustrators—was also losing subscribers. In 1963 they cut back to bi-weekly publication, before shuttering in 1969.

Paperback books had vanquished the pulps, and along with television were now eroding the circulation of the fiction magazines. Even so, in 1960 the slicks were still a prestige market for illustrators, and not all magazine categories were declining. Women's magazines and men's magazines were flourishing. McGinnis looked to break into that market, since magazines presented a wide range of subjects to illustrate. The magazines would give him a larger "canvas" upon which to work, as well. A double-page spread in the *Post* could run as large as 20" x 10"— quite a step up from the 4" x 7" paperback cover.

In January 1960, McGinnis's first illustration assignment for *The Saturday Evening Post* appeared, a mere four years after his first *Master Detective* cover, and two years after his first paperback. In 1960 and 1961, he did, in all, a dozen jobs for them, one of them a six-part serial. Over the next forty years he maintained a steady pace of about five magazine jobs per year, even in the years of especially heavy paperback and movie work. In all, he has done paintings and occasional drawings for at least 250 magazine issues.

His two mainstays were *Good Housekeeping*, with fifty-plus assignments over more than twenty years, beginning in 1964, and *Guideposts*, for more than a hundred issues from 1957 to 1999. His work has appeared in men's magazines like *Argosy*, *True*, and *Cavalier*; and women's magazines, including *McCall's* and *Cosmopolitan*. He has contributed to *Reader's Digest*, *National Geographic*, *Field & Stream*, and many more.

For all but the most dedicated McGinnis fans and collectors, his magazine work is *terra incognita*. There has always been a ready marketplace for used books. Once someone who has an eye for art and a collector's bent discovered the McGinnis Shell Scotts or Carter Browns, it was easy to head to the local paperback exchange to find more of the same. However, few used bookstores carried back-issue magazines. They were bulky, difficult to organize and display, and for most titles there was scant demand. There was and still is no definitive listing of McGinnis's magazine illustrations. It is unfortunate that this body of work has been so hard to locate, because some of his most extraordinary art has appeared in periodicals.

→ **The Magic Lane:** 1960, tempera; *The Saturday Evening Post*

→ **Make Up Your Mind:** 1960, tempera; *The Saturday Evening Post*

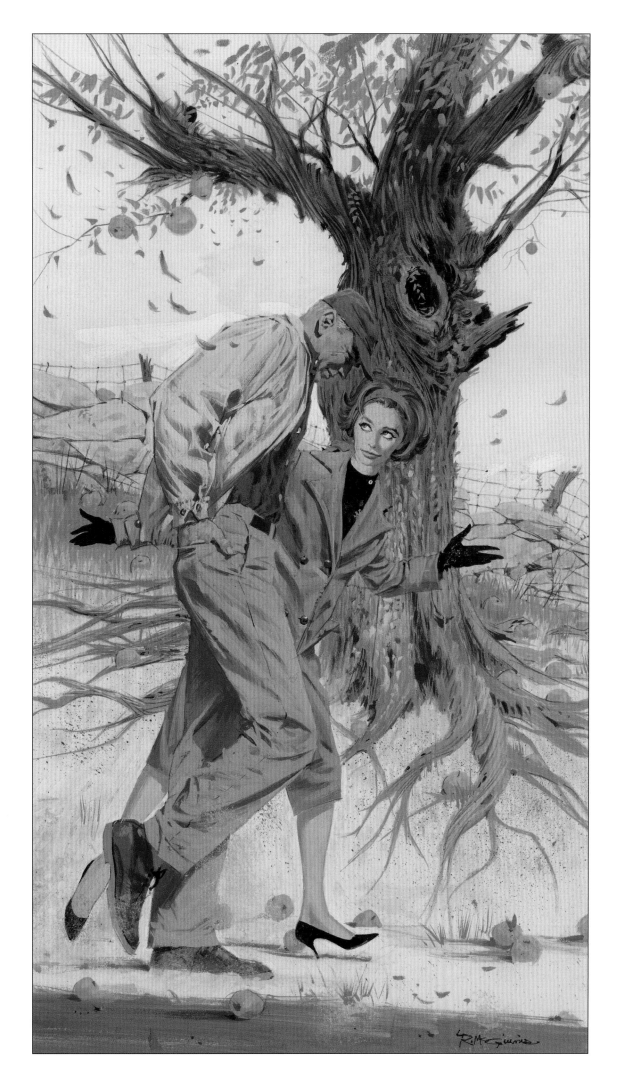

THE SATURDAY EVENING POST

McGinnis made his debut in the premiere illustrators' showcase with the January 1960 issue, just two years after his first paperback covers, with a story entitled "The Other Wife." He recounts the thrill of being invited to paint for *The Saturday Evening Post*:

"That was it, the ultimate. It was a huge compliment, and I worked as hard as I could on those, made many sketches, and struggled, to tell you the truth. There's *The Girl on the Tower*—I did two of them; and the trampoline thing, I worked on that a lot."

Regrettably, the *Post* was failing, and his work only appeared in seventeen issues in 1960 and 1961. One of his last assignments was the amazing *Kitten on a Trampoline* (April 8, 1962). Here we present the two finished versions that were *not* published—the published version was a reworking of the multiple-image version, with one fewer pose, the pennants absent, and a lone man at the rail. The second version, with the six poses of the girl jumping, will remind some of the pioneering stop-motion photography of Eadweard Muybridge, but McGinnis relates that his inspiration was the model who posed for him, Olga Nicholas:

"In no time at all she would go through all these emotions, jumping up in the air, and all I had to do was press the camera release. She did all of that. I think the single was the first one I did. Then I thought, I had all these poses, why not have the sequence of her jumping on a trampoline? But I think the first one was with all the banners. And then the final one was better. I had more fun painting Olga, to tell you the truth."

← **The Girl on the Tower:** 1960, tempera; *The Saturday Evening Post*

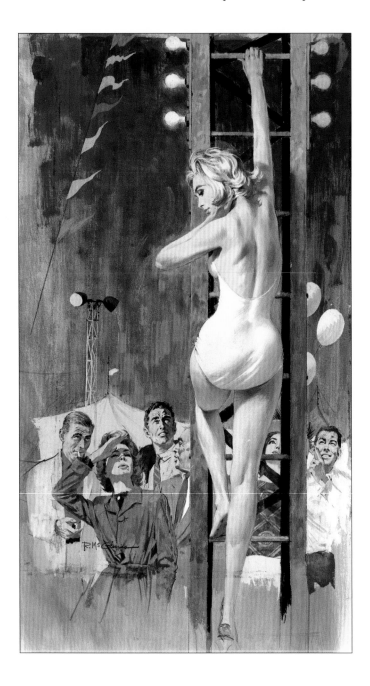

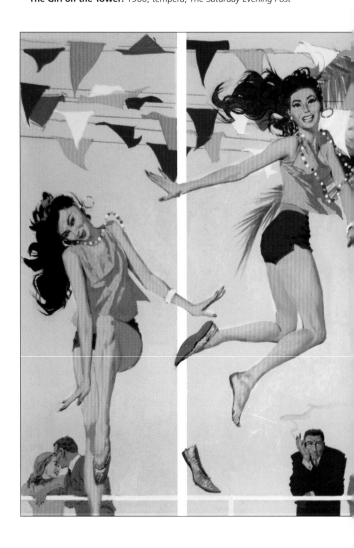

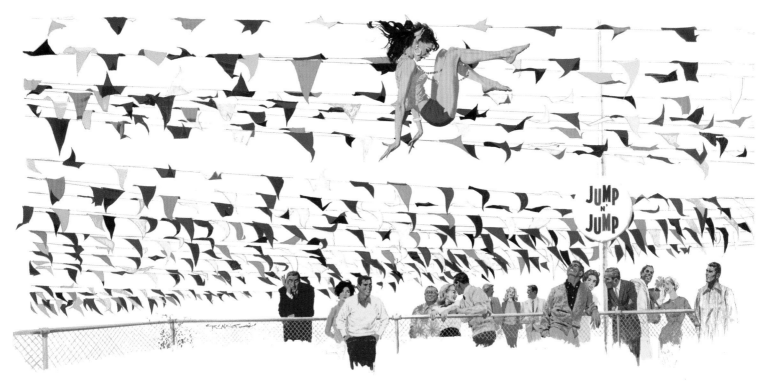

↑ **Kitten on a Trampoline:** 1961, unpublished 1st version, tempera; *The Saturday Evening Post*

↓ **Kitten on a Trampoline:** 1961, unpublished 2nd version, tempera; *The Saturday Evening Post*. The published version was a modification of this one, with five poses of the girl, no pennants, and the man at the rail the only figure in the background.

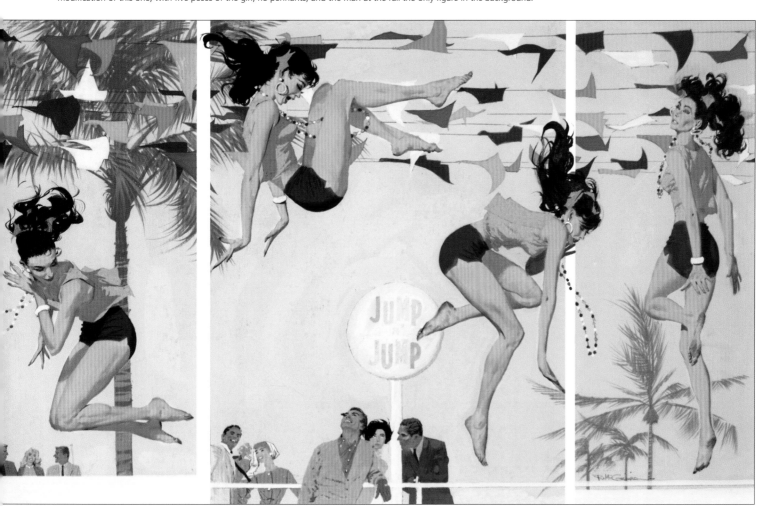

THE MEN'S MAGAZINES

McGinnis had noteworthy pieces in several men's magazines, including *True*, *Argosy*, and *Saga*, but his nudes for *Cavalier* are the ones every McGinnis fan knows about and seeks out. At the time, 1964-65, the magazine was trying to upgrade its image and jump on the *Playboy* bandwagon, and the McGinnis pieces—unsigned and uncredited—were their answer to *Playboy*'s Vargas pinups. There were twelve paintings in all, and one woman was fully clothed.

"I was amazed that they would allow it, to tell you the truth. I just couldn't believe it. But I didn't sign it, because I was ashamed of doing them. I grew up in the Midwest, and I don't think my mother and father would want their name associated with it, with nudity, so I didn't want to sign them.

"I wanted to do them—there's nothing more interesting than painting women, it's the greatest subject that can be—but I didn't want it to be known. I didn't want to broadcast it. But everybody seems to like those and go back to them.

"I guess I didn't keep it a secret, did I?"

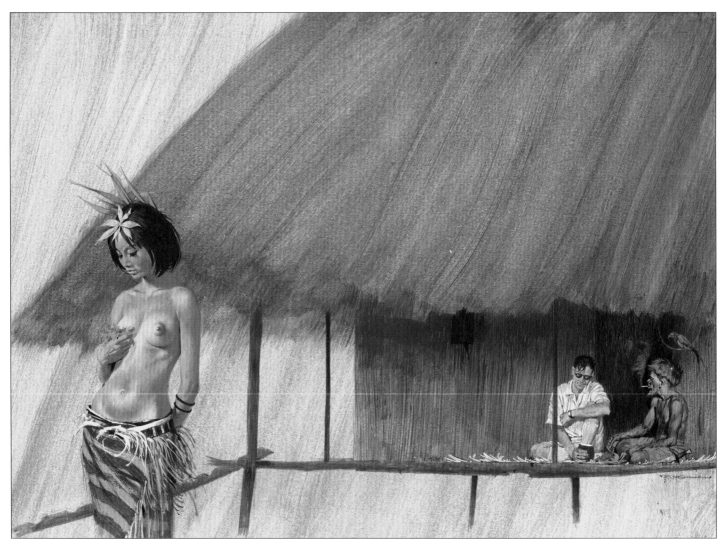

↑ **A Girl for Your Bed, A Man for Your Fields:** 1964, tempera; *True*

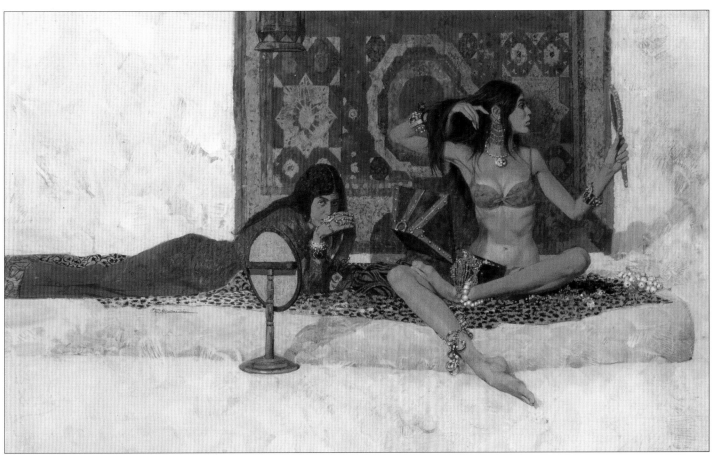

↑ **The Housewife:** 1971, tempera; *Cosmopolitan*

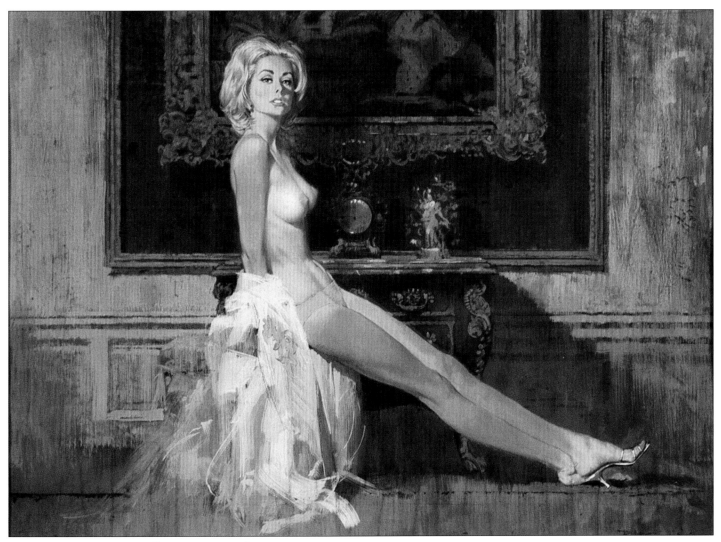

↑ **Arnold Freedman, The Lucky Stiff:** 1964, tempera; *Cavalier*

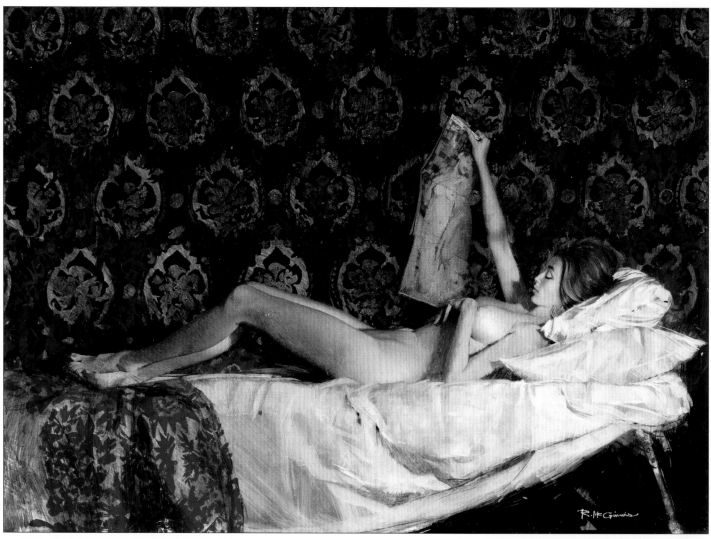

↑ **Jepson's Last Motto:** 1965, tempera; *Cavalier*

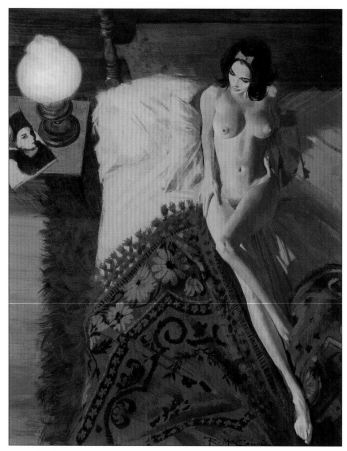

↑ **Weekends Are the Happy Time:** 1965, tempera; *Cavalier*

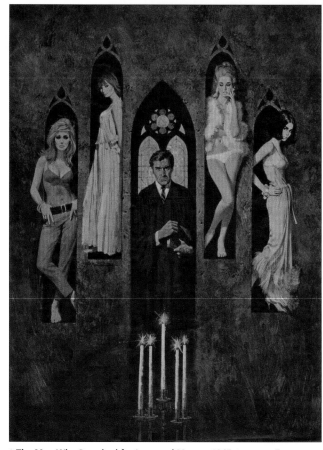

↑ **The Man Who Preached for Love and Money:** 1967, tempera; *True*

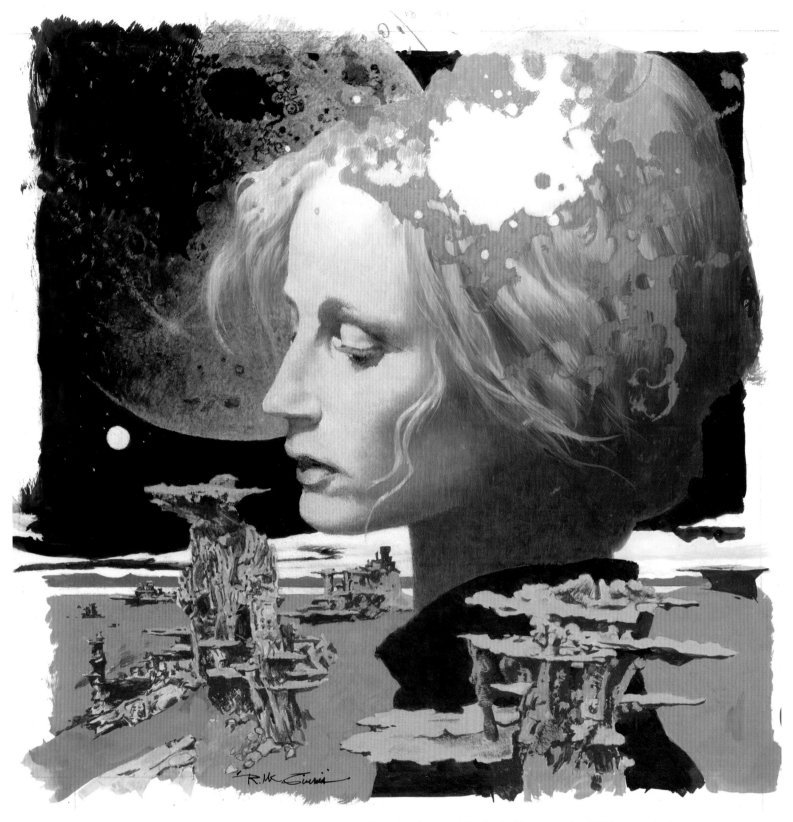

↑ **Untitled study of woman's head in surreal landscape:** 2001, egg tempera. A finished version was published as the February page in a 2002 Japanese calendar.

GOOD HOUSEKEEPING

McGinnis's debut for *Good Housekeeping*, October 1964, was auspicious. He submitted four paintings to illustrate "And All the Days to Come," and the editors were so impressed they ran them all, as "a pictorial ode to the season, a tribute to rural America with its whispering grass, its infinite skies, and beautiful old houses that stand like sentries on hilltops," along with a brief biography and photo of the artist. It was a fruitful twenty-year partnership. The magazine continued to run fiction throughout the '70s and '80s, and McGinnis illustrated a lot of it.

Many of the stories were contemporary romances, and his portrayals of ordinary couples in Middle-America settings were a marked contrast to the highly stylized covers—the passionate embrace, the golden tresses blowing in the wind—he was doing for the steamy romance novels over on the paperback side.

He had space to paint people in evocative landscapes, as in *With a Change of Season* and *Shadow River*; images charged with emotion and sentiment, as in *Come Home With Me* and *Love Is for Sharing*; and simply gorgeous compositions, as in *Oh, Heavenly Day*.

McGinnis said this about his experience with the magazine:

"I understood that it was for Middle America—wholesome stories, wholesome people—and I slanted it that way. It was wonderful. I could incorporate settings, backgrounds. My first one was that scene in the field with the hawk up in the air. They used all four [that I submitted]. That was the kick-off, and I worked for three art directors there... I really liked 'Good House.'"

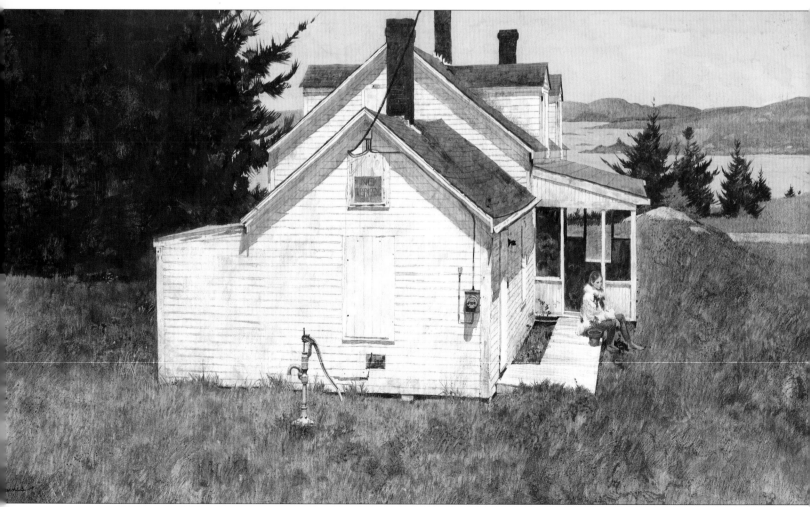

↑ **With a Change of Season:** 1968, tempera; *Good Housekeeping*

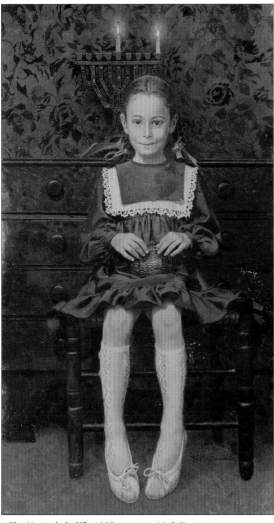

↑ **The Hannukah Gift:** 1985, tempera; *McCall's*

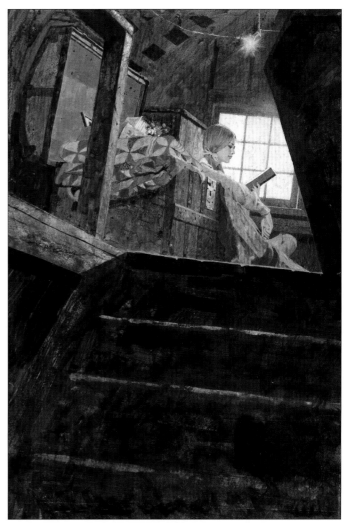

↑ **To Be a Girl:** 1965, tempera; *Good Housekeeping*

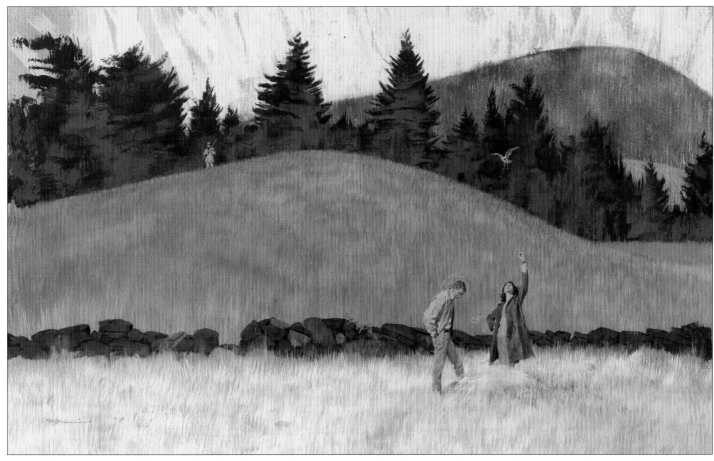

↑ **And All the Days to Come:** 1964, tempera; *Good Housekeeping*. McGinnis's first assignment for "*Good House*;" he submitted four paintings, and they used all four.

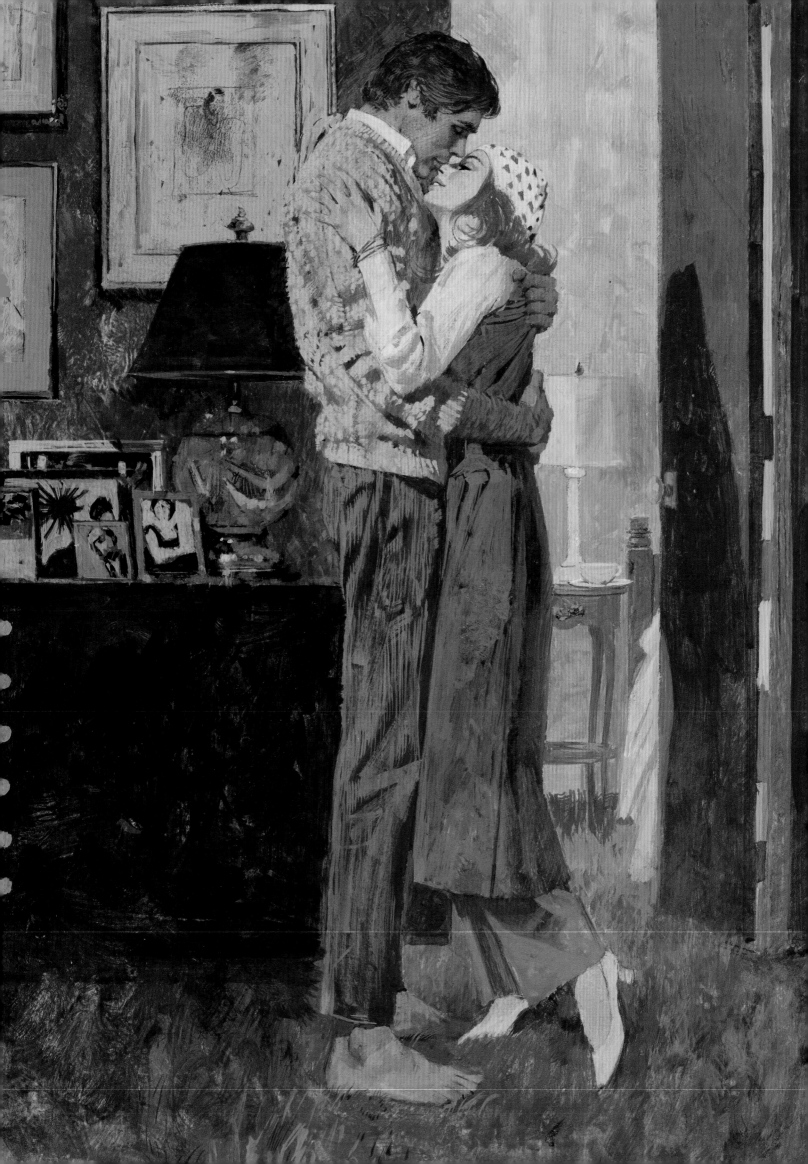

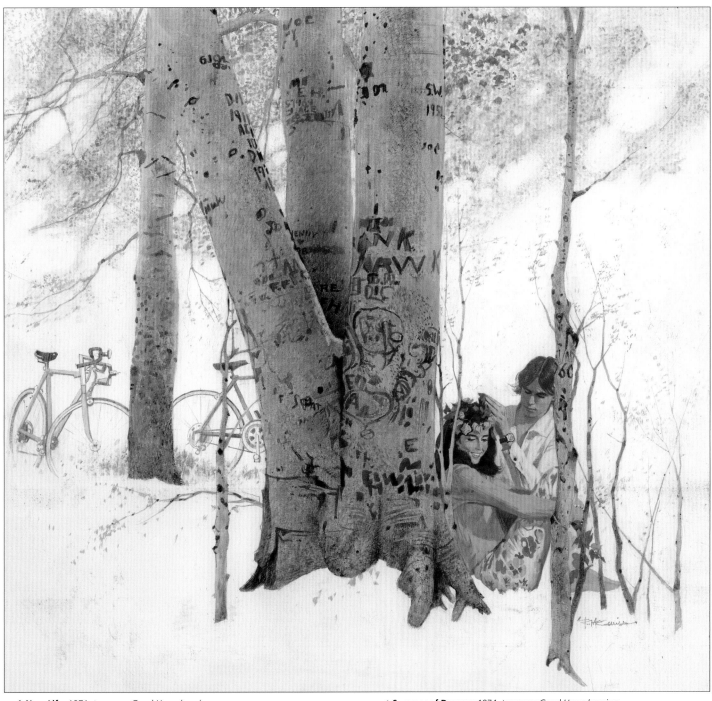

← **A New Life:** 1971, tempera; *Good Housekeeping* ↑ **Summer of Dreams:** 1974, tempera; *Good Housekeeping*

← **Betrayal:** 1972, tempera and pencil sketches; *Good Housekeeping*

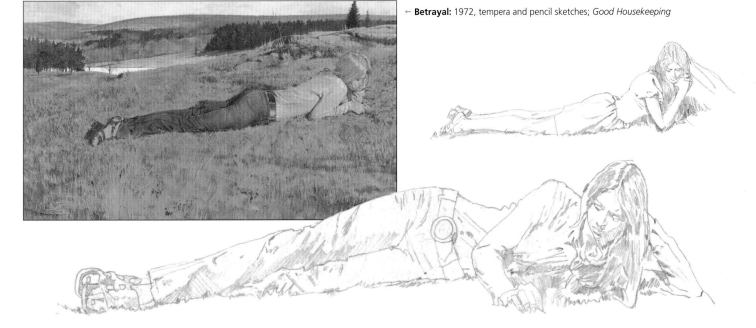

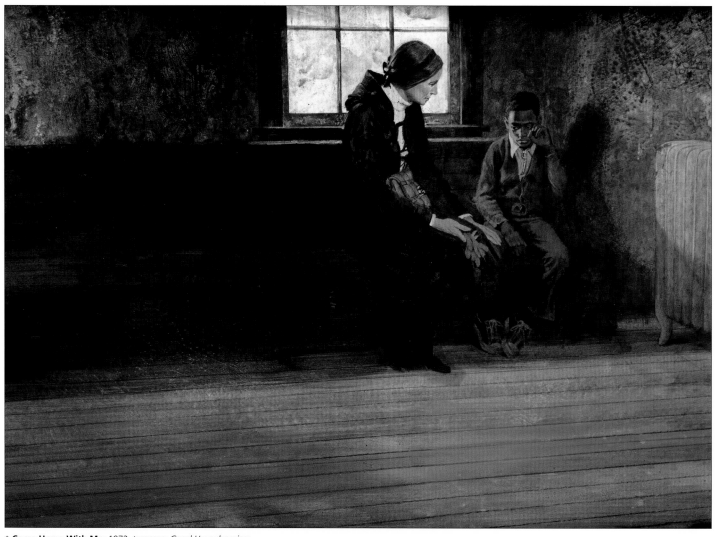

↑ **Come Home With Me:** 1972, tempera; *Good Housekeeping*

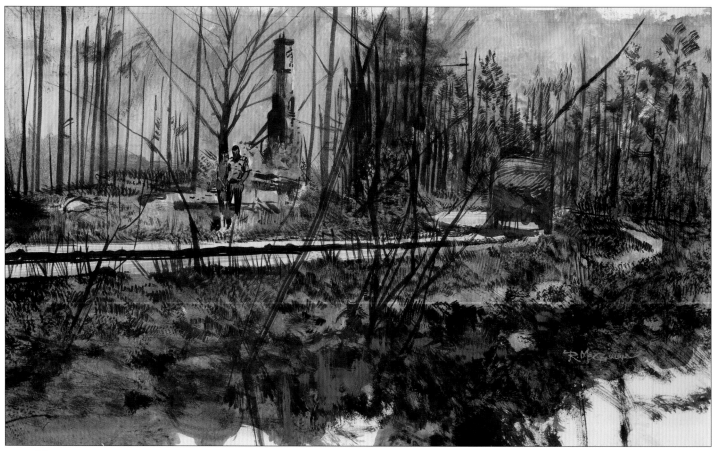

↑ **To Build a Dream:** 1972, unpublished color study, tempera; *Good Housekeeping*

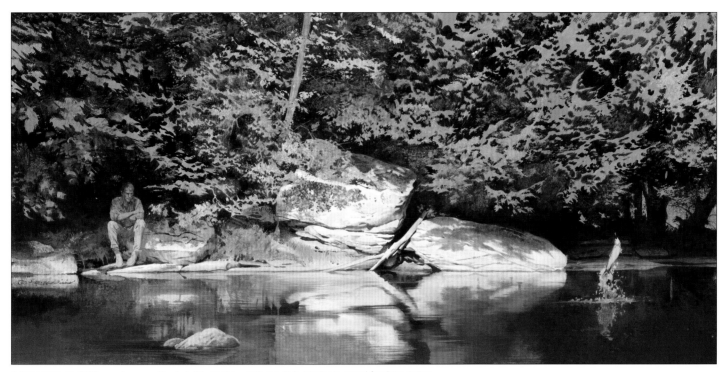

↑ **Roger's River:** 1990, egg tempera; *Reader's Digest*. The artist's son, Kyle McGinnis, posed for this painting.

↑ **Untitled woman in blue and blue bird:** date uncertain, believed unpublished, egg tempera

↑ **Love is for Sharing:** 1978; *Good Housekeeping*

← **Shadow River:** 1974, tempera; *Good Housekeeping*

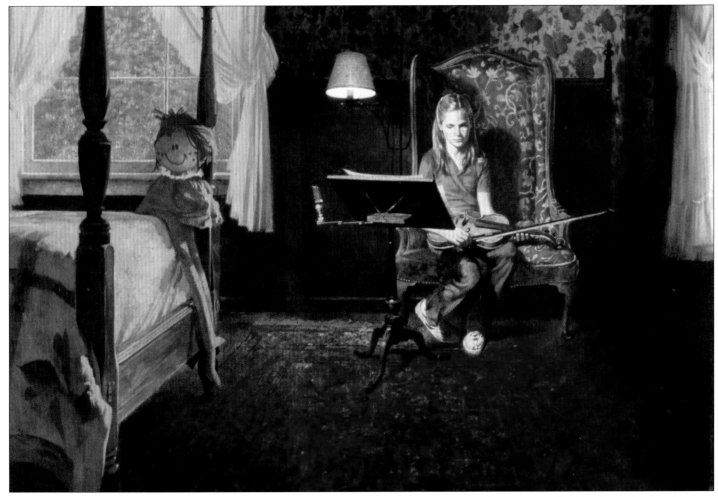

↑ **Title of article unknown, young girl with violin:** 1982, tempera; *Ladies Home Journal*. This painting was selected for inclusion in *Illustrators 24*, published by the Society of Illustrators.

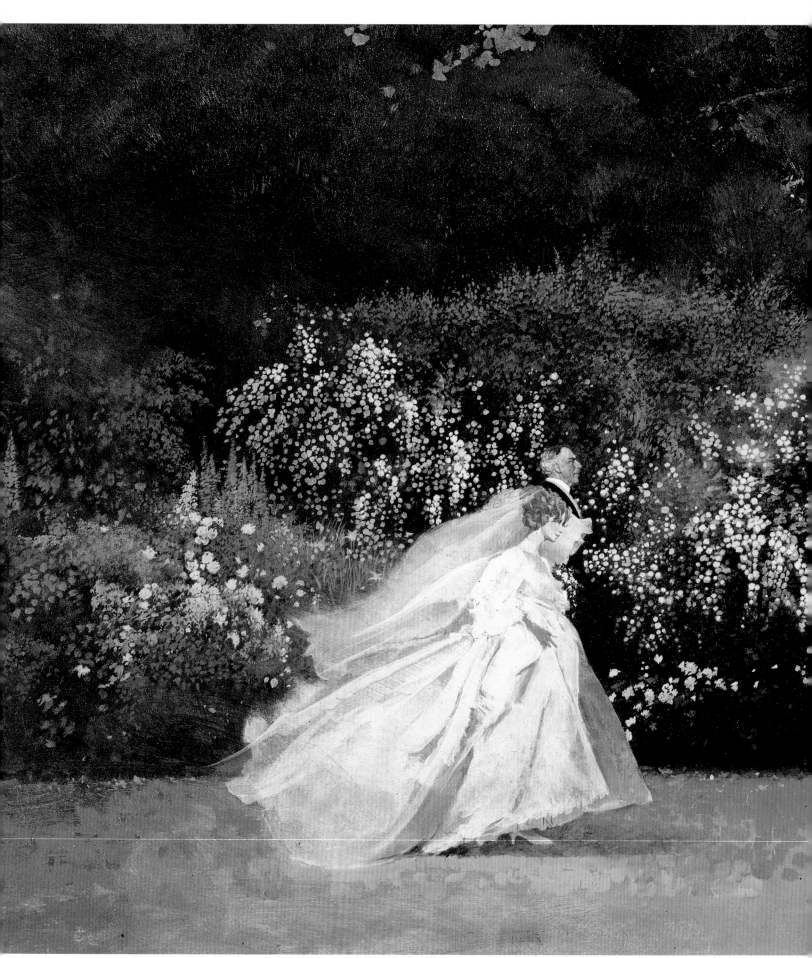

↑ **Oh, Heavenly Day:** 1982, egg tempera; *Good Housekeeping*

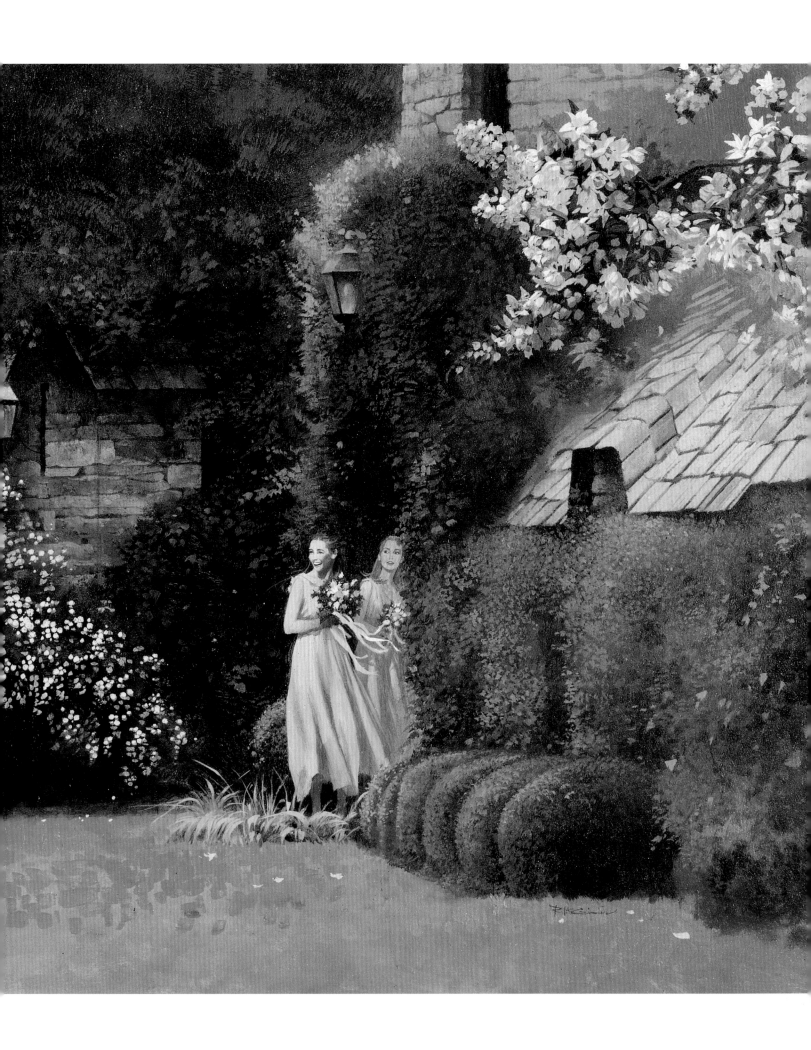

GUIDEPOSTS

The magazine for which Robert McGinnis did the most work, over the longest span, is the one least known to his admirers.

Guideposts is a small-format, subscription-only monthly magazine published by Guideposts Publications, an organization founded by noted clergyman and author Norman Vincent Peale. Though rooted in the Christian faith, the magazine's content is non-denominational and free of overt religiosity and proselytizing. Its stories are inspirational, supplied by its readers, who submit their own true accounts about the power of faith and prayer in dealing with life's challenges, people who helped or inspired them, how they survived dangerous situations, and the like.

McGinnis has illustrated approximately one hundred such stories, beginning in 1957. The images he has painted for *Guideposts* are, as you'd expect, worlds away from the dangerous dames and romantic idylls of his paperback covers. This is McGinnis in "Rockwell country"—small-town America, farms and fields, children, animals, interesting characters, and nostalgia. It is just as certainly McGinnis in "McGinnis country," for this world is close to the heart of the man who grew up in rural southern Ohio. Many of his finest paintings are here, including one of four cats in a barn (*Cat With No Name*), about which McGinnis had this to say:

"There's one that is probably the best painting I ever made... It's a bunch of cats in a barn... I stand in front of it, and I can't believe I did it. I can always find fault, and failure, and something wrong with my paintings. I look at that and I can't find one stroke wrong anywhere to improve it or change it. It's as close to [Andrew] Wyeth as I'll ever get."

→ **Untitled steeple cross overlooks Fourth of July parade:** July 1993 issue, egg tempera; *Guideposts*. Cover inset.

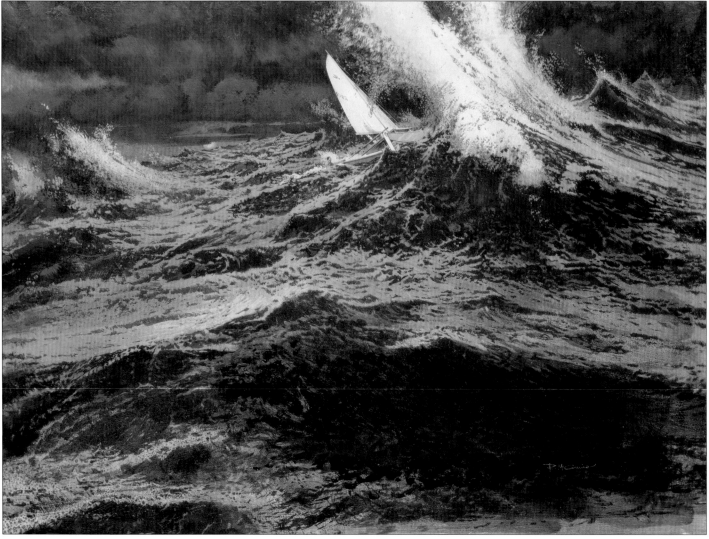

↑ **Ordeal at Sunset:** 1975, tempera; *Guideposts*

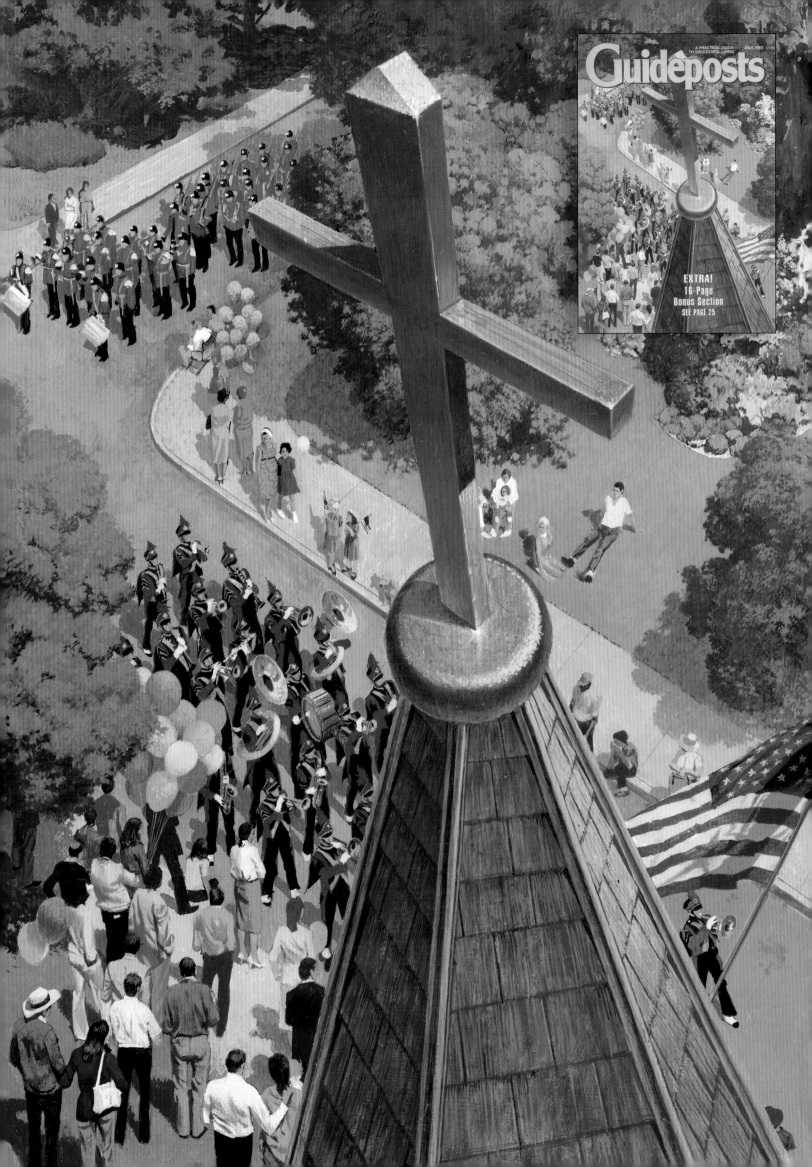

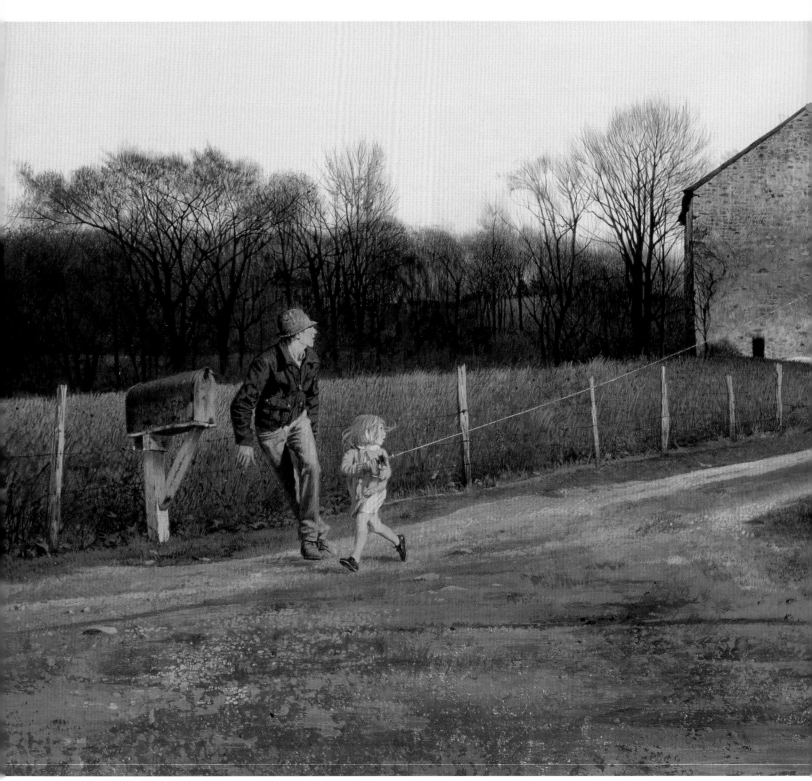

↑ **The Coming of Spring:** 1982, egg tempera; *Guideposts*

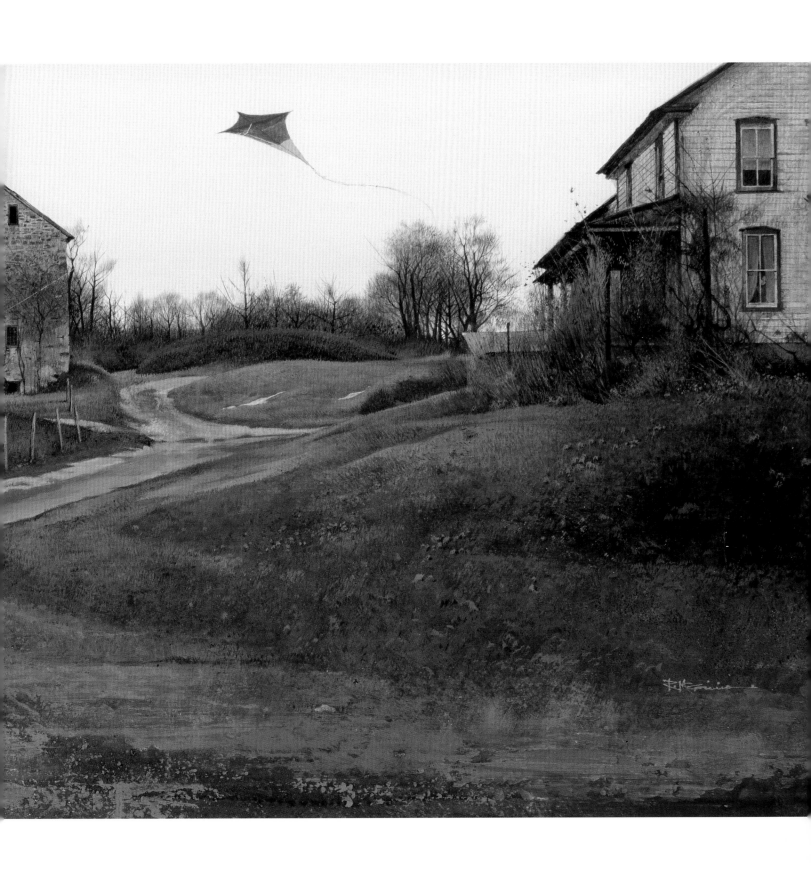

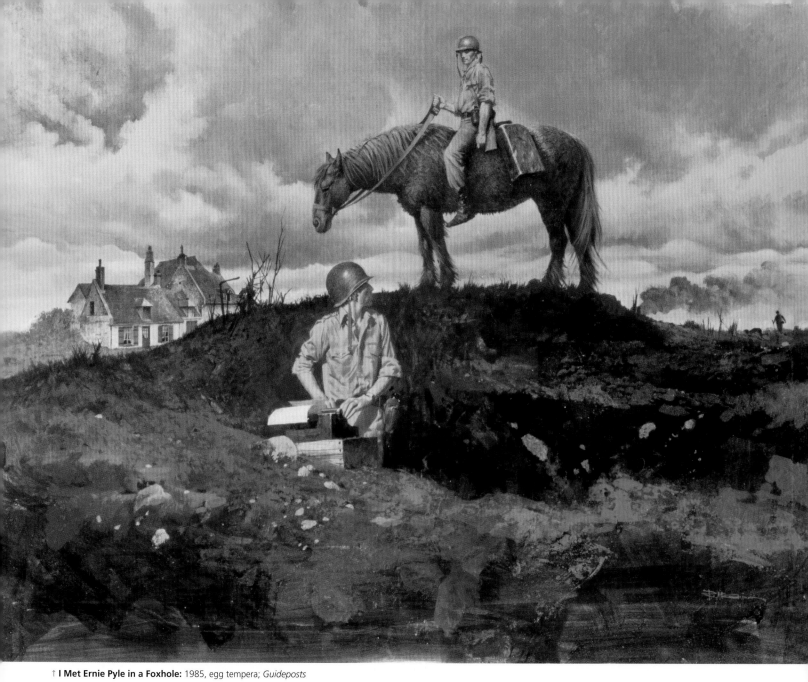

↑ **I Met Ernie Pyle in a Foxhole:** 1985, egg tempera; *Guideposts*

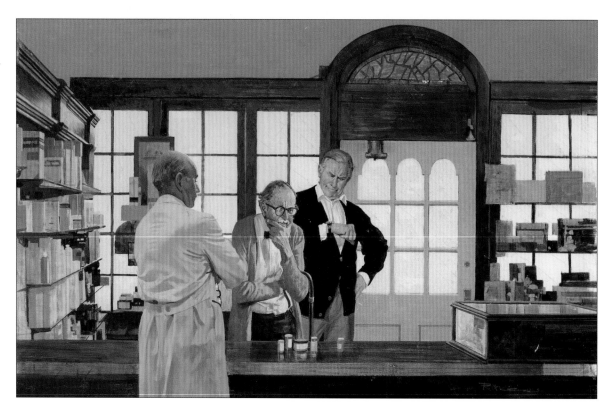

→ **What's the Rush?:**
1991, egg tempera;
Guideposts. McGinnis
makes a rare appearance
as a model, looking at
his watch.

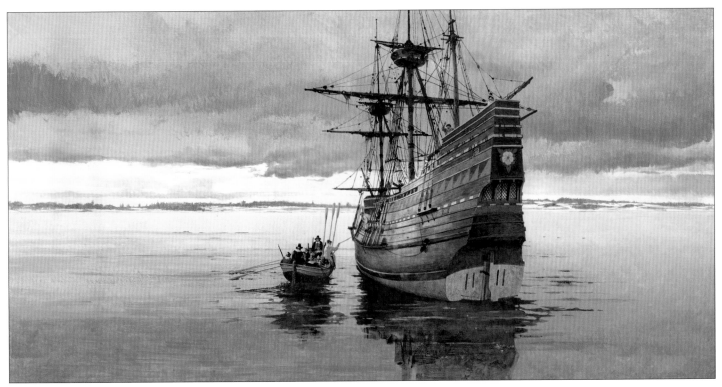

↑ **One Small Candle:** 1995, egg tempera; *Guideposts*. The Pilgrims disembark from the *Mayflower*.

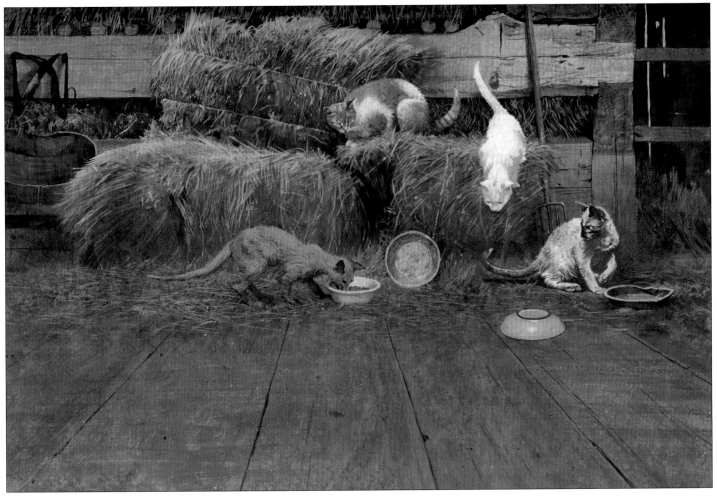

↑ **Cat With No Name:** 1998, egg tempera; *Guideposts*. In the Interview, McGinnis states that this is "probably the best painting I ever made."

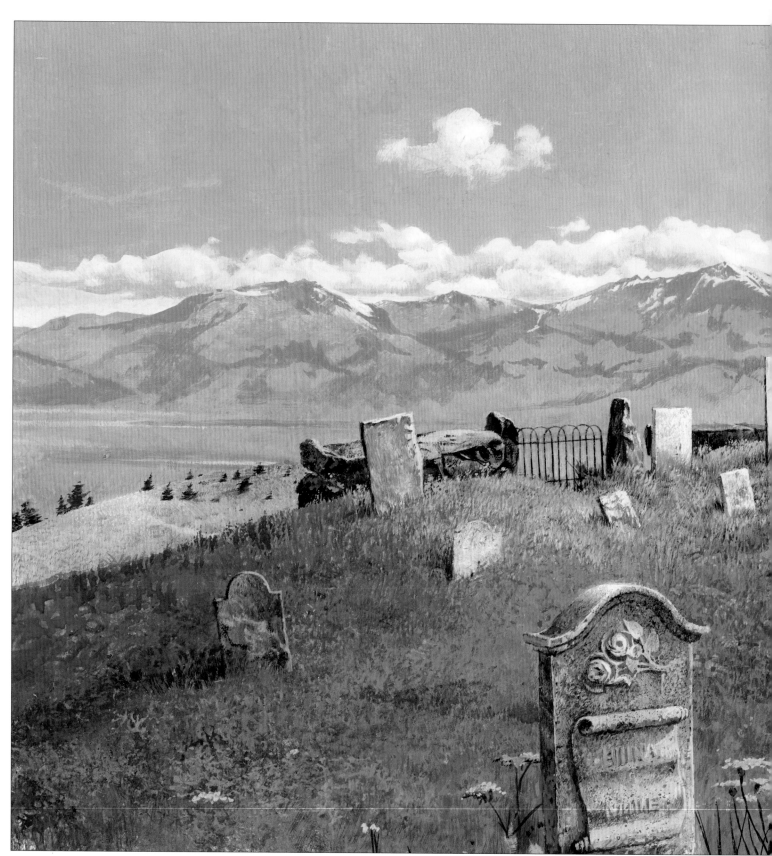

↑ **Memorial Day:** 1992, egg tempera; *Guideposts*

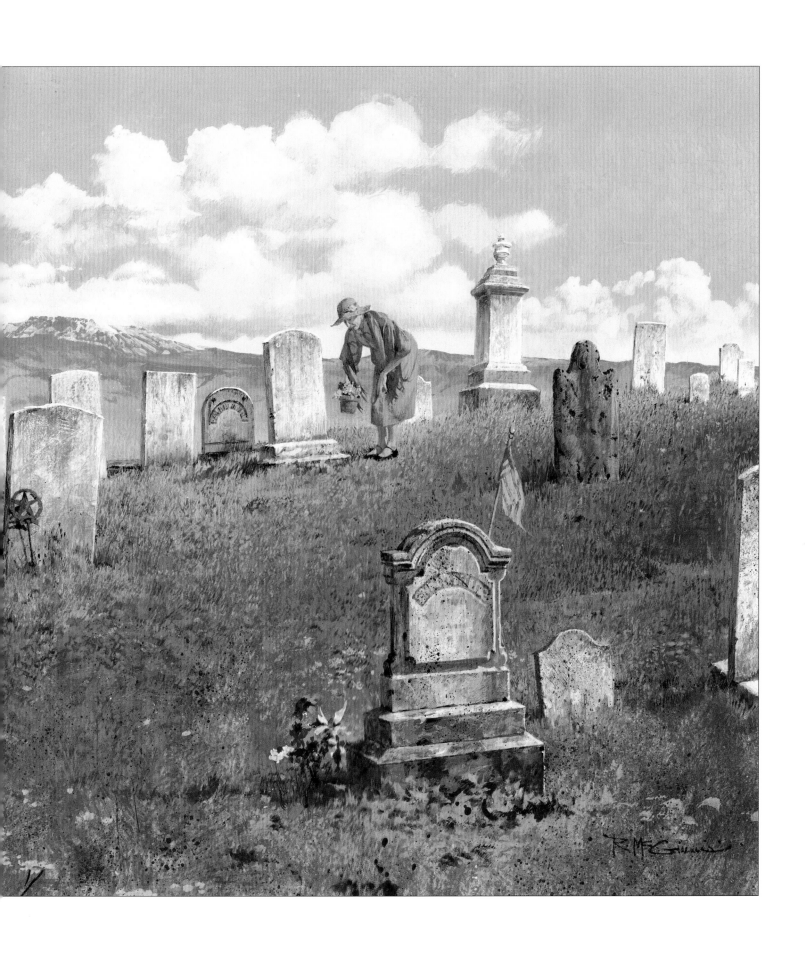

↑ **Tempering Tool:** 1997, egg tempera;
Guideposts. A portrait of the artist's father,
Nolan "Dutch" McGinnis.

↑ **Ruth Layton, You Changed My Life:** 1996, unpublished alternative version, egg tempera; *Guidepost*

↑ **My Irascible Aunt Alice:** 1995, egg tempera; *Guideposts*

↑ **Nothing But the Truth:** 1998, egg tempera; *Guideposts*

↑ **Doing What's Best for Suhana:** 1998, egg tempera; *Guideposts*

NATIONAL GEOGRAPHIC

For the September 1990 issue of *National Geographic* magazine, McGinnis prepared four paintings for a long article, "Track of the Manila Galleons." A large assignment like this for the *Geographic* necessitated extensive and careful research into locales, period costumes, artifacts, and architecture—in this case, the architecture of sailing galleons of the period. It required multiple pencil sketches and color studies to try possible layouts, particularly for a complex crowd scene like the painting of the Acapulco harbor marketplace.

Here we present finished art for a storm at sea, and pencil sketches and color studies for the marketplace scene. The sketch for the latter—only a portion of the whole picture—is particularly

interesting for its marginal notes, documenting the dialogue between McGinnis and the art director at the National Geographic Society. Many changes were made between this sketch and the final product.

Another major assignment for the Society was to produce four panoramic battle scenes for the huge—424 pages, 12" x 18"— hardcover coffee-table book *Peoples and Places of the Past*, published in 1983. The paintings depict the Roman army storming a Romanian fortress; canoe-borne Khmer warriors fighting in the Mekong River; Chinese warriors defending the Great Wall; and Inca soldiers battling tribesmen in the Andes, as seen in the painting included here.

↓ **The Inca Wars:** 1983, egg tempera; *Peoples and Places of the Past,* National Geographic Society

↑ **Track of the Manila Galleons, a galleon runs aground:** 1990, egg tempera; *National Geographic*. One of four paintings done for this magazine article.

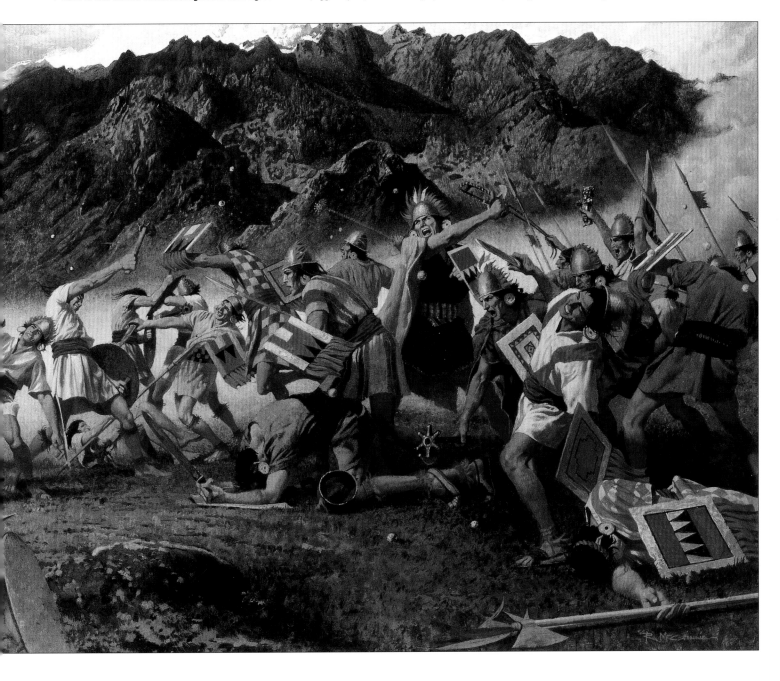

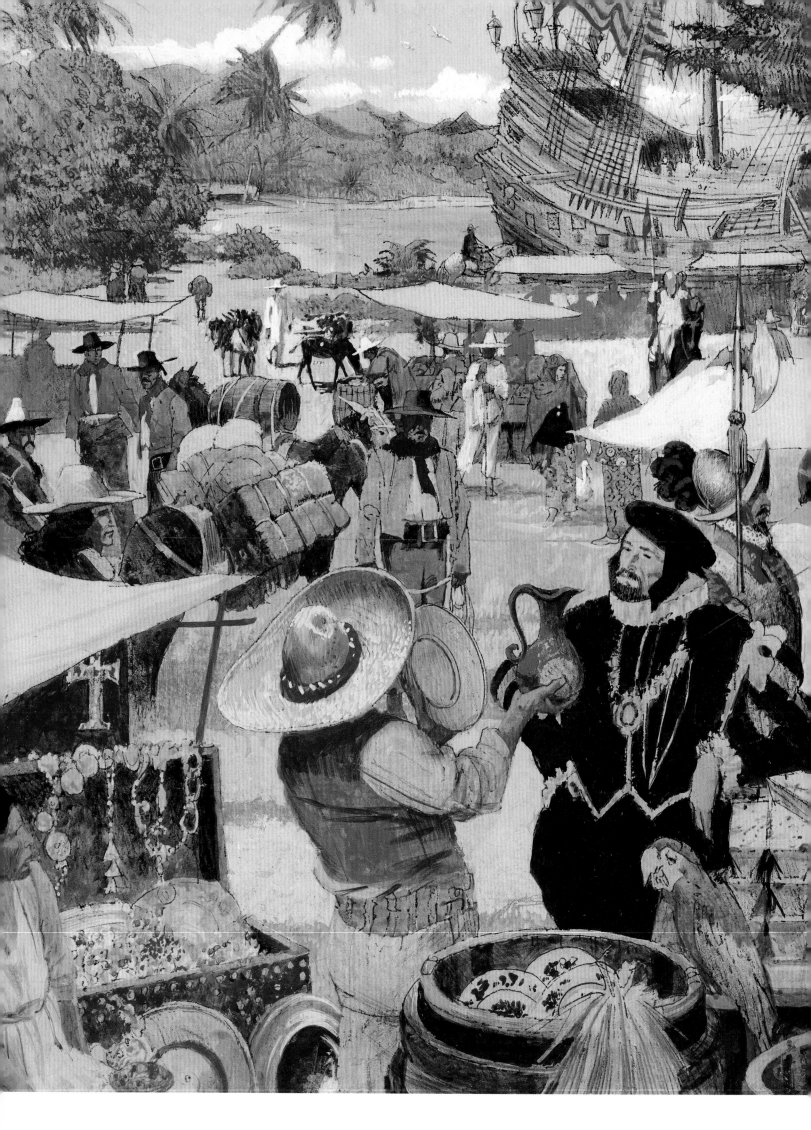

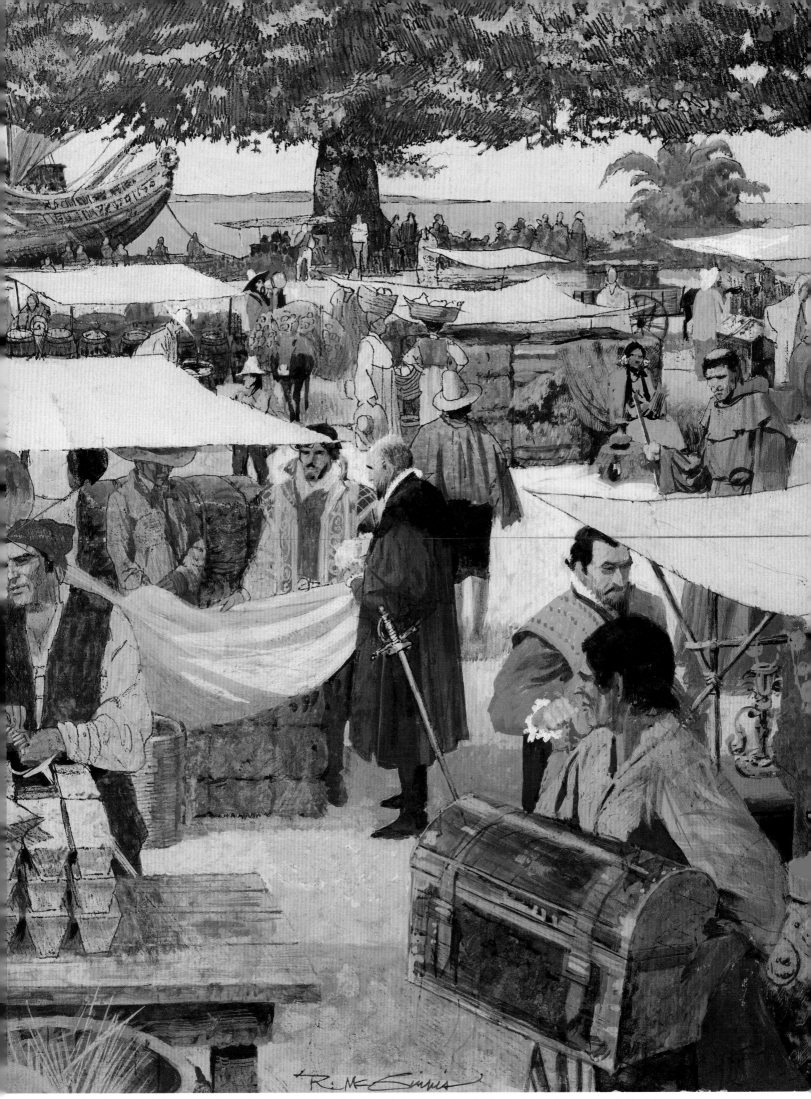

↑ **Track of the Manila Galleons, Acapulco marketplace scene:** 1990, full color study, tempera. This was the final preliminary stage before the finished picture was painted.

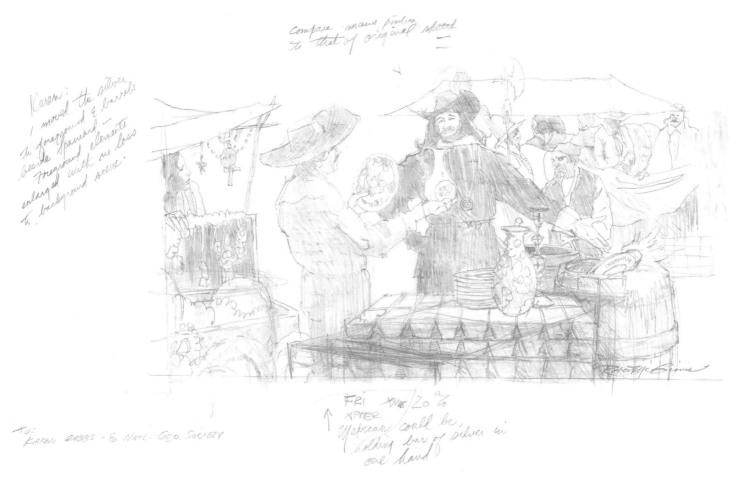

↑ **Track of the Manila Galleons, Acapulco marketplace scene:** 1990, preliminary pencil sketch. Marginal notes inform *National Geographic*'s art director of changes made in this work-in-progress.

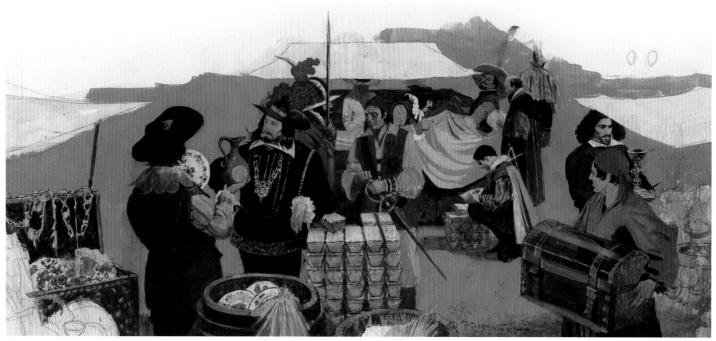

↑ **Track of the Manila Galleons, Acapulco marketplace scene:** 1990, color rough, tempera. This piece documents an intermediate stage in development of the picture, between the pencil rough and the full color study on the previous page.

The 17th Annual Amelia Island

Concours d'Elegance

Sunday, March 11, 2012
The Ritz-Carlton, Amelia Island
The Golf Club of Amelia Island
Summer Beach

to Benefit Community Hospice of Northeast Florida, Inc.

↑ **Portrait of Vic Elford:** 2012, egg tempera; *Amelia Island Concours d'Elegance* program book

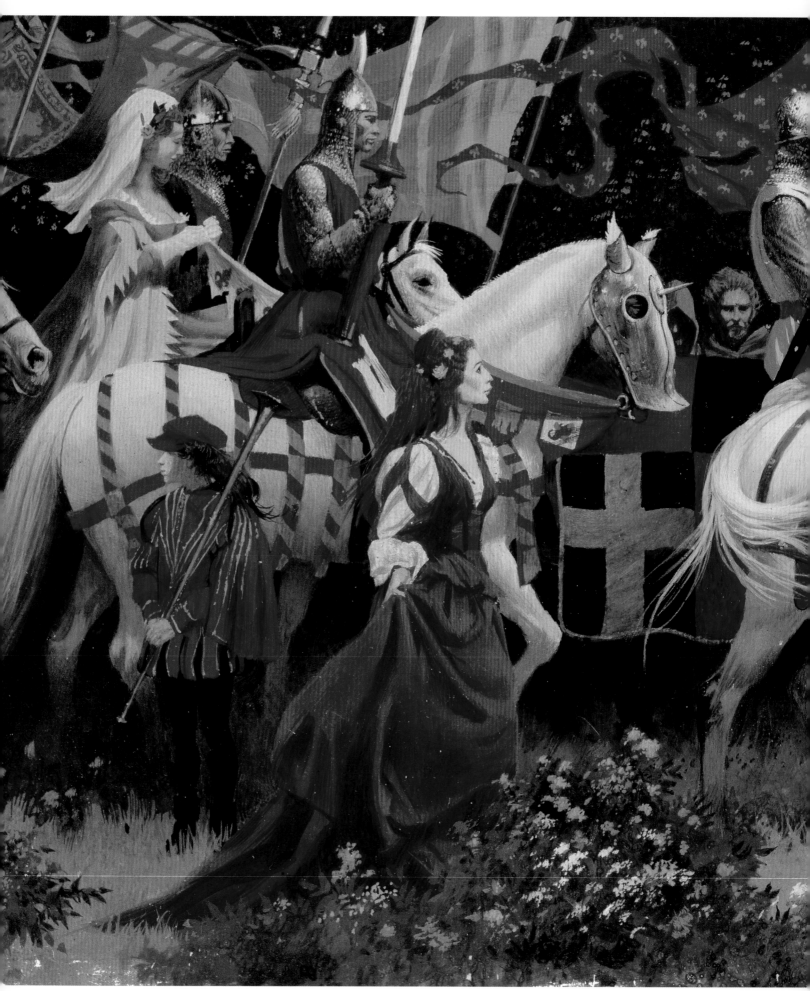

↑ **To Camelot:** c.1998, believed unpublished, tempera; possibly a magazine commission

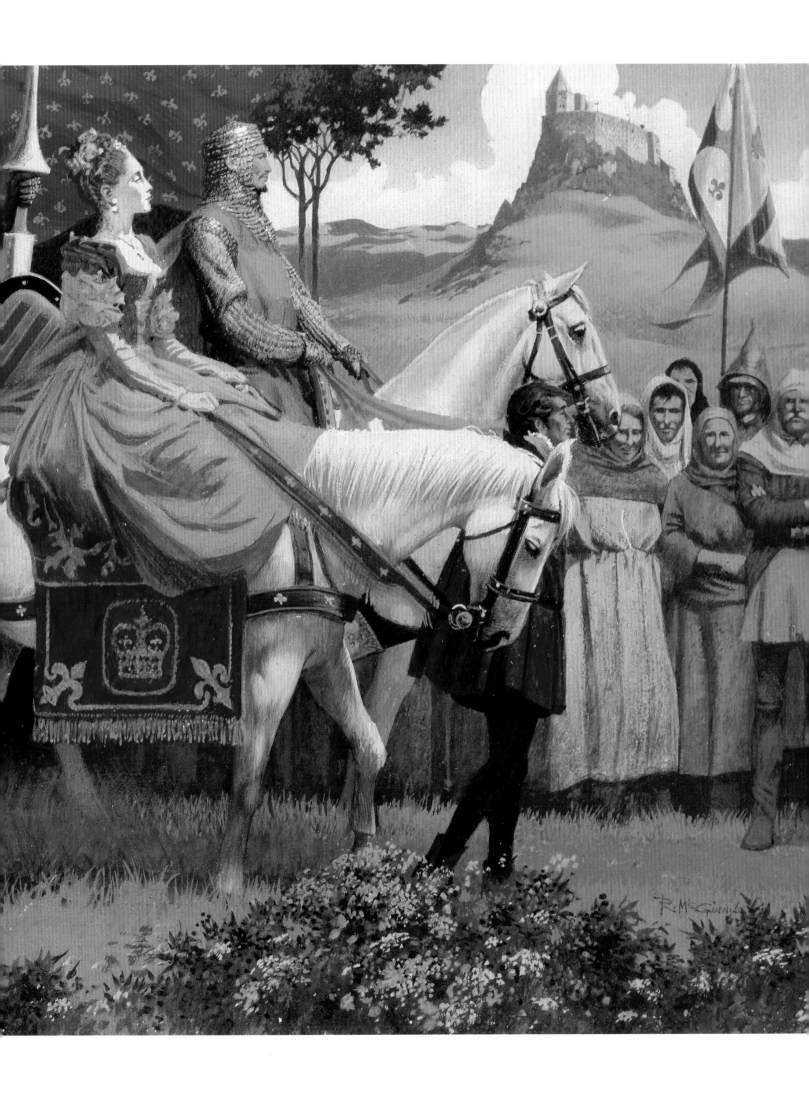

GALLERY ART

In the late 1970s, Robert McGinnis—by then a prosperous and acclaimed artist, still in demand for commercial assignments—began to set aside time to paint pictures as his own muse dictated, rather than to the specifications of an art director. In a profile for The Greenwich Workshop newsletter, he said of this new direction, "My eventual goal is pure self-expression."

These paintings were and are exhibited for sale in galleries and at auction. Some have been reproduced and sold as signed-and-limited prints. To this day, McGinnis continues to paint as he chooses.

His gallery work falls into three general categories:

1) Portraits of women, mostly but not exclusively nudes.

2) Scenes of the American West.

3) Contemporary landscapes, especially rural scenes, many of the Ohio farmland that he knew as a boy.

At this point in our survey of McGinnis's art, it hardly needs explaining why he chooses to continue to paint beautiful women. His talent for depicting them seems to be innate, in the blood. Exercising the freedom to paint frank nudes is an obvious step in augmenting his legacy in this genre. These portraits are more than mere figure studies—he likes to add interest and complexity by incorporating ornate backgrounds (*Renee Streim*) and unusual props (*Tiffany*). For a change of pace, there's *Gallery Show*, a witty, sophisticated take on the one-line-gag pinup calendars of an earlier era. Nude or clothed, these paintings always communicate the intriguing personality of the subject as well as her physical allure—just as the brunette on *The Red Scarf* cover did in 1958.

Many noted American illustrators have felt the pull of the West

and taken up Western painting as a second career. Frank McCarthy, Howard Terpning, and James Bama are notable examples. There is an established market for realistic paintings of the American West, well served by specialist galleries and magazines. Many of the New York-based artists moved out west, although McGinnis chose to remain in Connecticut.

Nevertheless, his affection for the Old West is strong, fueled by his love of Western films, and by memories of his grandfather, who told stories of his days as a cavalryman in the pioneer West, and of seeing "Wild Bill" Hickok in Durango. "I'm not a 'Western artist,' but I share the fascination for that brief period of history termed the 'Wild West,'" McGinnis says. "Having been born too late to experience it first-hand, I've lived it all vicariously and enjoyed every moment."

In an essay entitled "Musings of a Transplanted Midwesterner," he speaks eloquently of the Ohio landscapes that he loves to paint, saying, "scenes of midwestern farm country hold special meaning to me. Like a salmon I keep returning to my origins, both in fancy and in fact... It spreads out before me—the land just as it appeared to me as a child, on the way to Grandmother's house... Here is a place where time has stood still."

Though these landscapes frequently depict autumn and winter scenes in the Andrew Wyeth-like earth tones that McGinnis strives to capture in his own work, he will sometimes give us bright sun and green grass, as in *Lowville Lady*. Or a riot of blazing fall color, in the spectacular *Poverty Hill Pond*, one of the newest paintings in this book, which depicts a back-road site near Newtown, Connecticut.

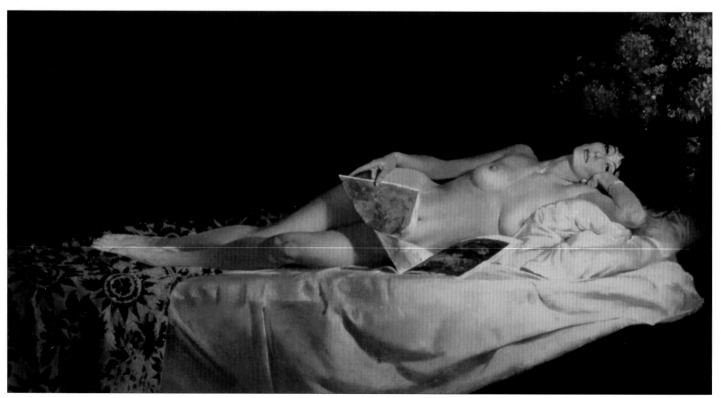

↑ **Blue Flax:** c.1997, oil

→ **Between Poses:** c.2003, oil

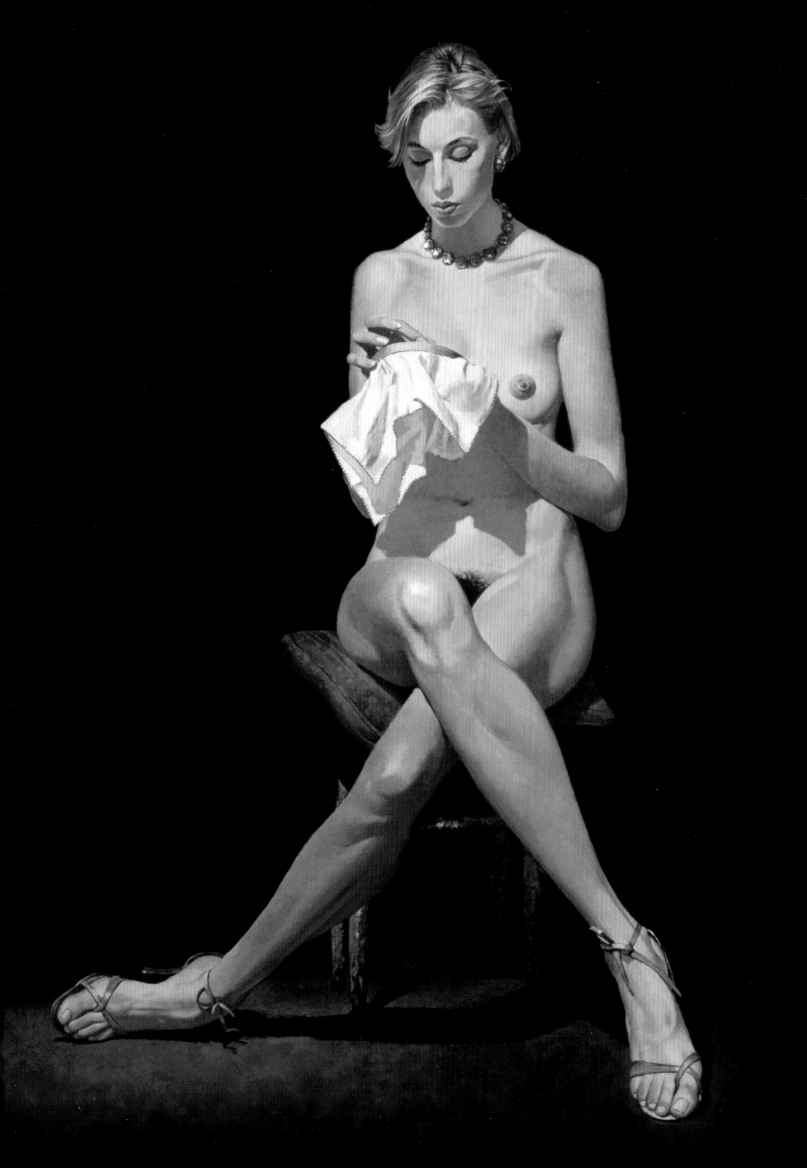

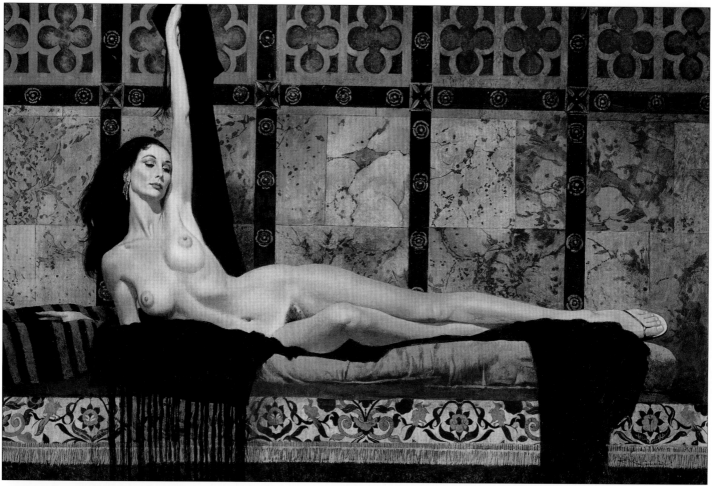

↑ **Renee Streim:** c.1998, oil

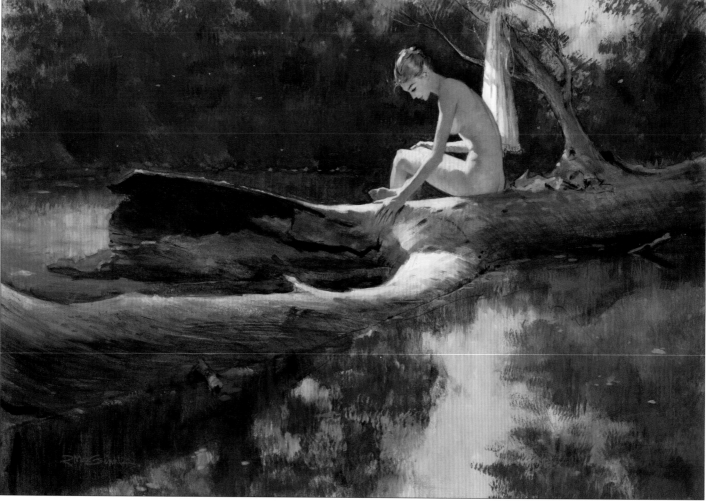

↑ **Talawanda Creek:** c.1950, tempera. Early gallery painting.

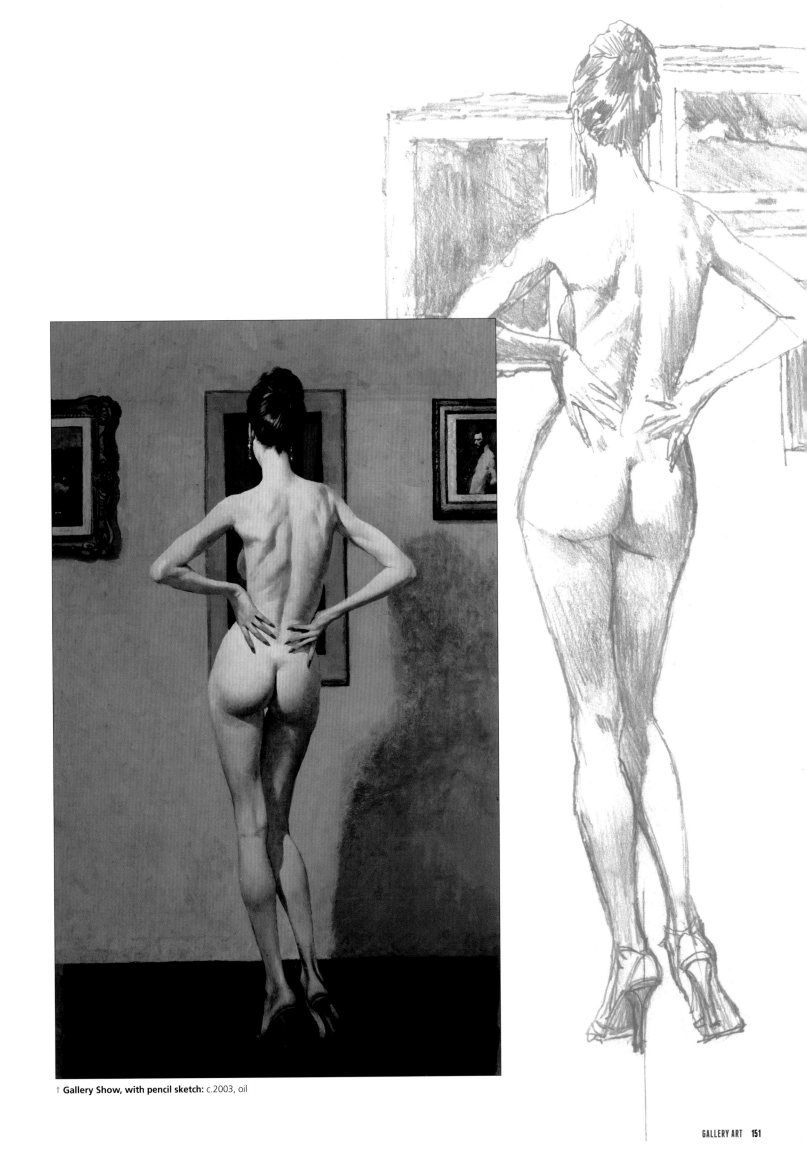

↑ **Gallery Show, with pencil sketch:** c.2003, oil

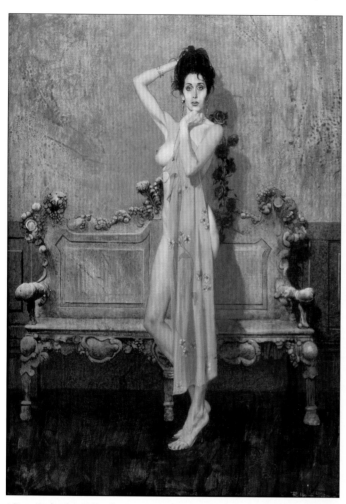

↑ **Rose Garland:** c.2002, oil

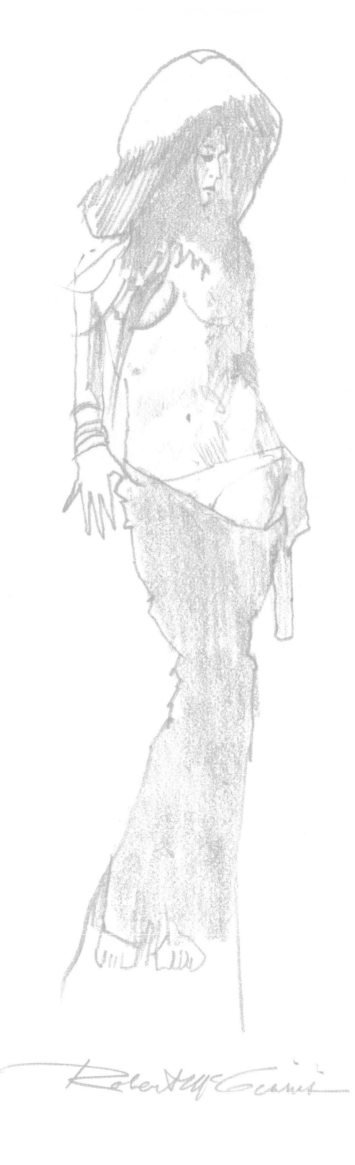

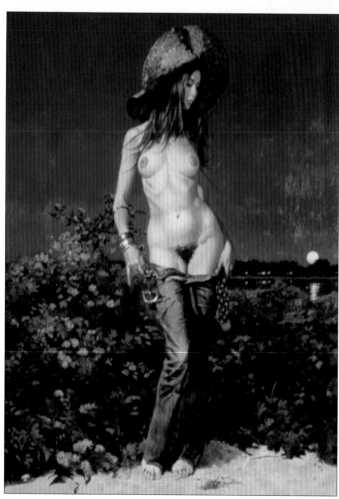

↑ **Rose Hips, with pencil sketch:** c.2001, oil

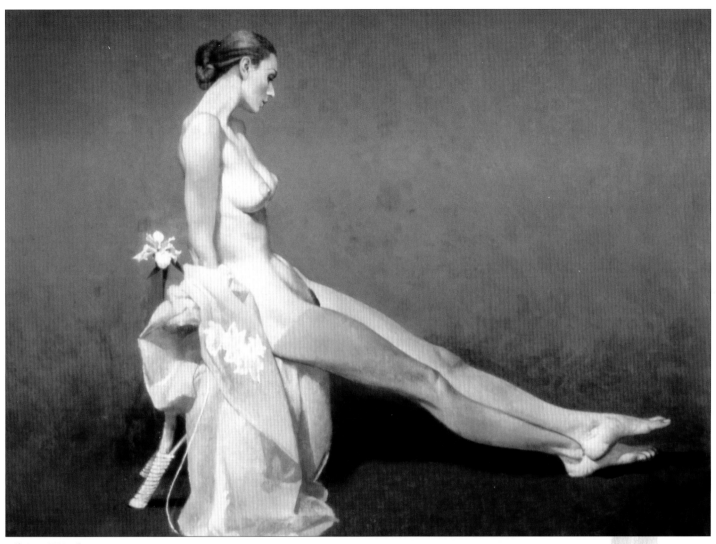

↑ **Slava:** c.2000, oil

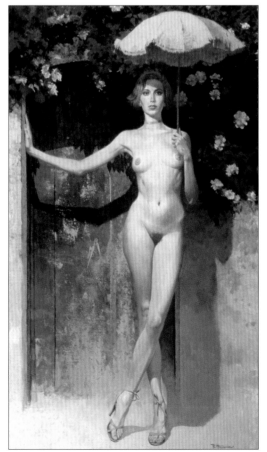

↑ **Fair Nina:** 1997, oil

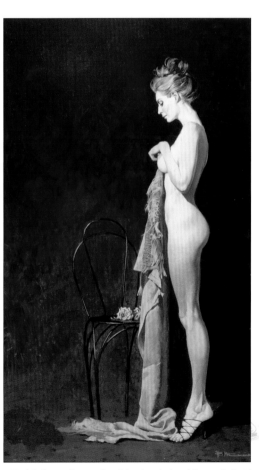

↑ **Untitled standing nude with wire chair, with pencil sketch:** c.2000, oil

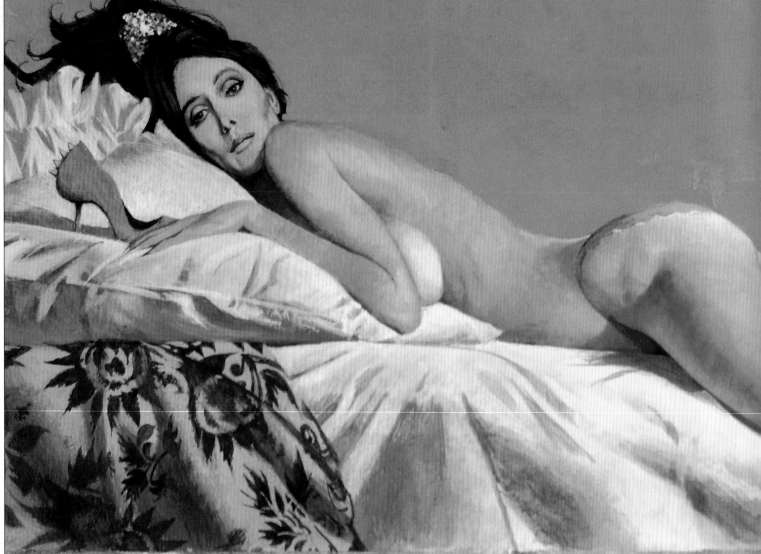

† **Riviera:** 2013, oil. Painted for a Brazilian shoe manufacturer fashion advertisement; not used.

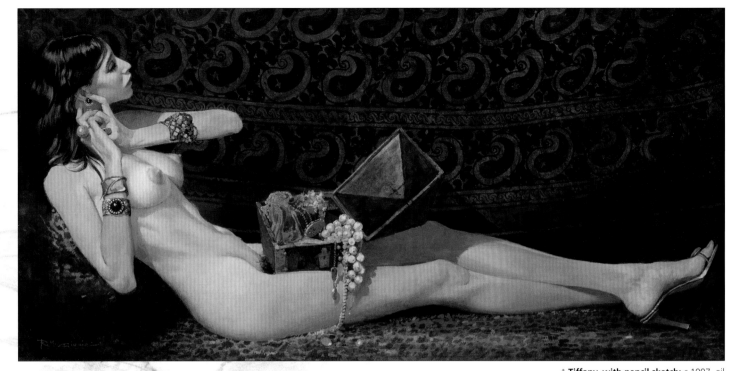

↑ **Tiffany, with pencil sketch:** c.1997, oil

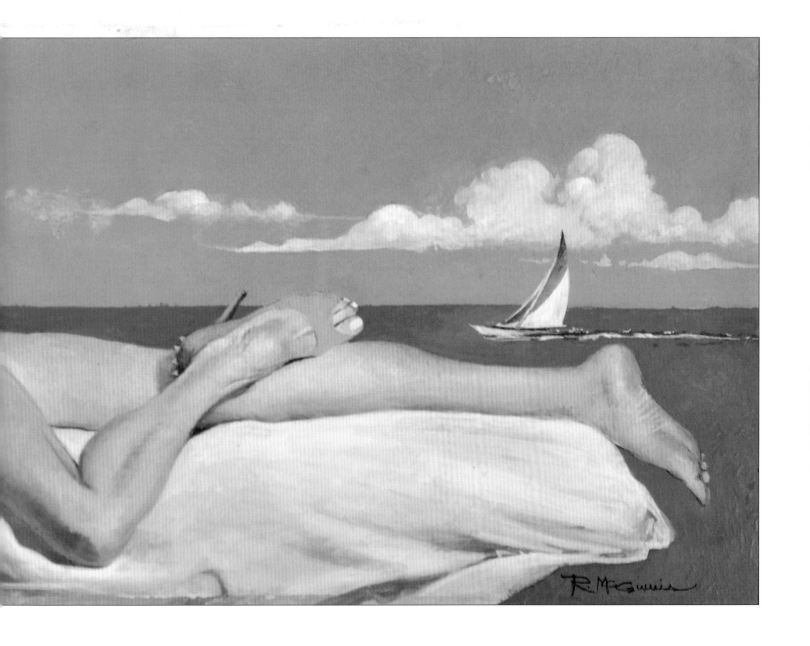

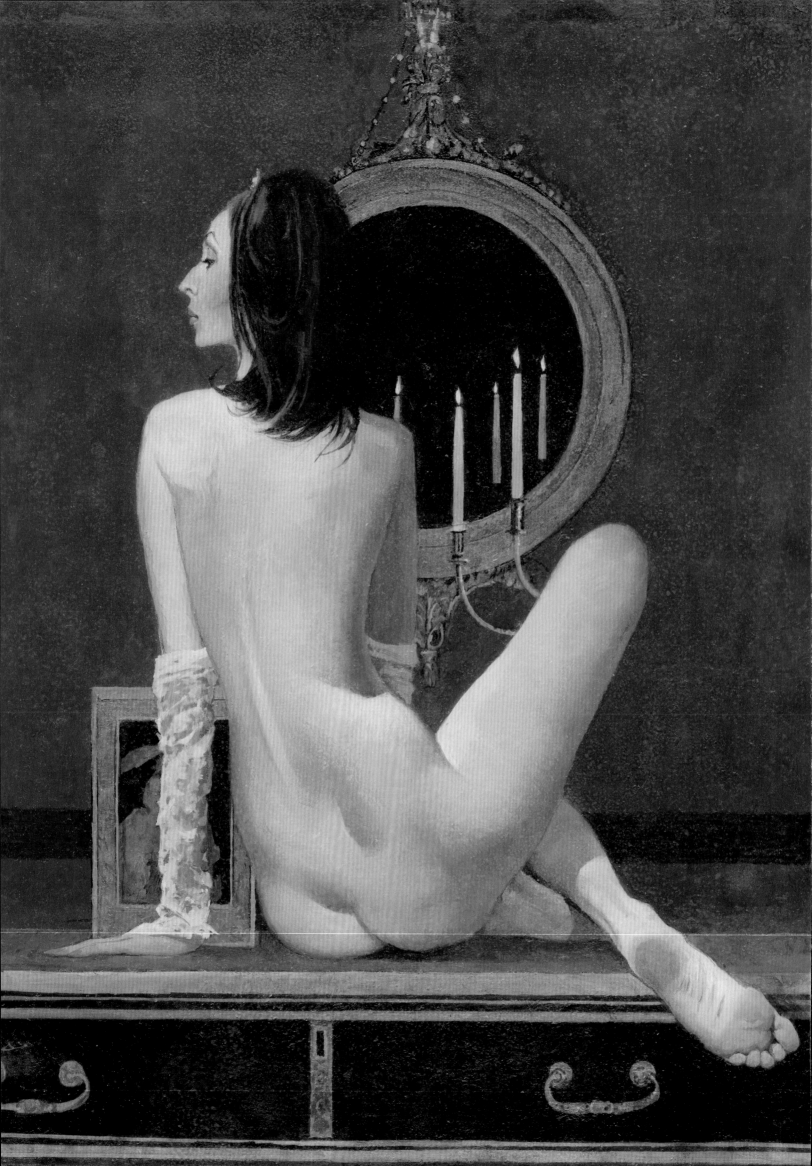

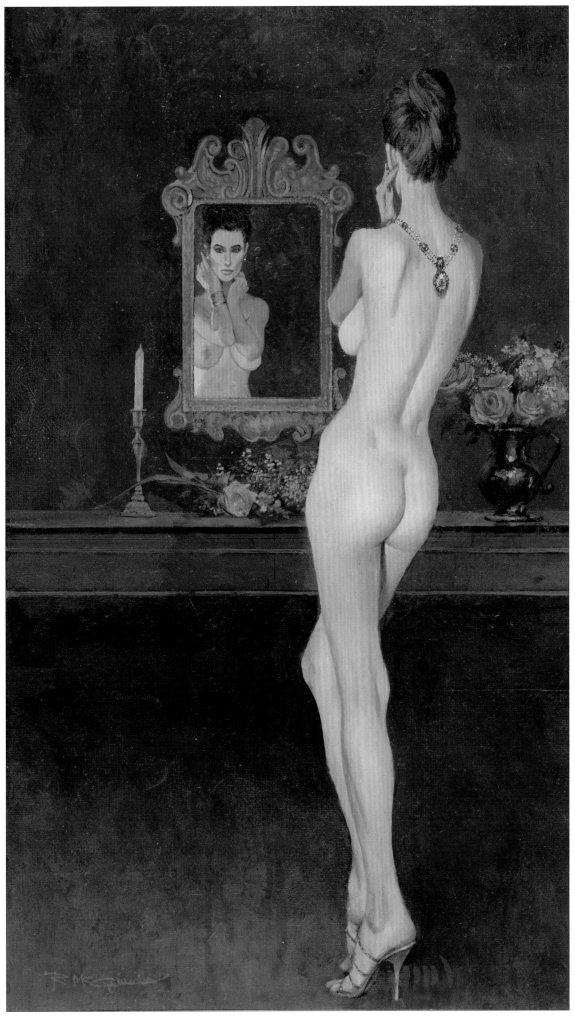

← **Candlelit:** 2014, oil

↑ **Reflection:** 2013, oil

McGINNIS'S WEST

obert McGinnis's Western paintings seem to come in three flavors: spectacular landscape, furious action, and "There's a story here."

His eye for Western scenery dates back to his first trip to California: "I hitchhiked out there out of high school to go to Disney. Couldn't afford the bus trip, so I hitchhiked out on Route 66, and slept in the desert a few nights. I went to the Grand Canyon, Capitol Reef, and all those places out there. It was just so thrilling that you just can't stand it—it's unbearable, the beauty of the West."

Eye-popping desert vistas dominate paintings like *Capitol Reef*, *The Sharp Eye*, and *Stampede!*, with John Wayne galloping through Monument Valley, home to the John Ford Western films McGinnis greatly enjoys.

Action is the dominant note of *Jack Lloyd's Freight Office* and *The Range Wars*. It's amusing—and rather surprising—to realize that although he painted hundreds of covers for private eye and spy novels, there's just a handful that depict someone firing a gun. McGinnis must have saved his ammunition for the Old West, where gunplay often was a necessity.

Some of his paintings more subtly tell a story—the gifted illustrator's stock in trade. Though it might be more appropriate to say, "There's a story here—what do you think has happened or is going to happen?" *Apache Wells* and *Not Alone*, for example, convey imminent danger. *A Cup of Cold Water* and *Red River Valley*, however, focus on the back story, asking us, "What brought these people together at this moment?" Even the contemplative portraits, like *The Lonely Sounds of Night* and *Clementine*, invite the viewer to imagine what's on the mind of the cowpuncher on his horse, or the woman in white on the porch.

Whichever the category, these are very personal favorites of the artist.

A comment here about the size of the paintings is appropriate. In the Interview, it was noted that when McGinnis is doing artwork intended for publication in books or magazines, his paintings are relatively small, generally from 2 to 2.5 times the printed dimensions. Thus the original art for a typical paperback front cover would be no larger than about 17" x 10". This is smaller than many illustrators work, but McGinnis finds that size comfortable to his eye and hand. However, when doing gallery pieces, destined for framing and wall display, he paints on a larger scale, especially the panoramic Western scenes and landscapes. Those paintings typically measure in the range 15" to 18" high by 32" to 36" wide.

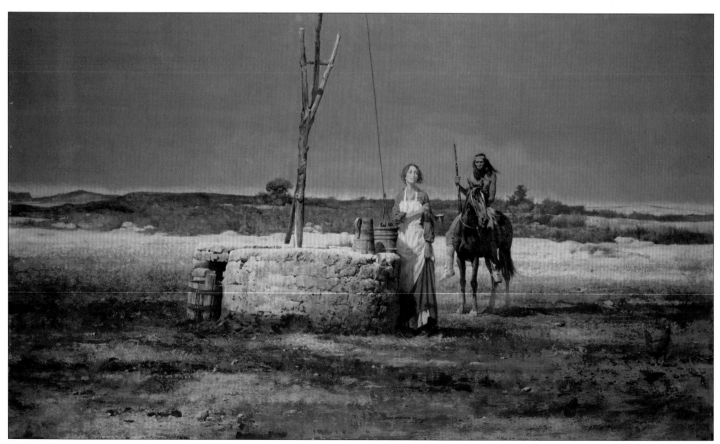

↑ **A Cup of Cold Water:** c.1982, egg tempera

→ **Not Alone:** c.1993, egg tempera

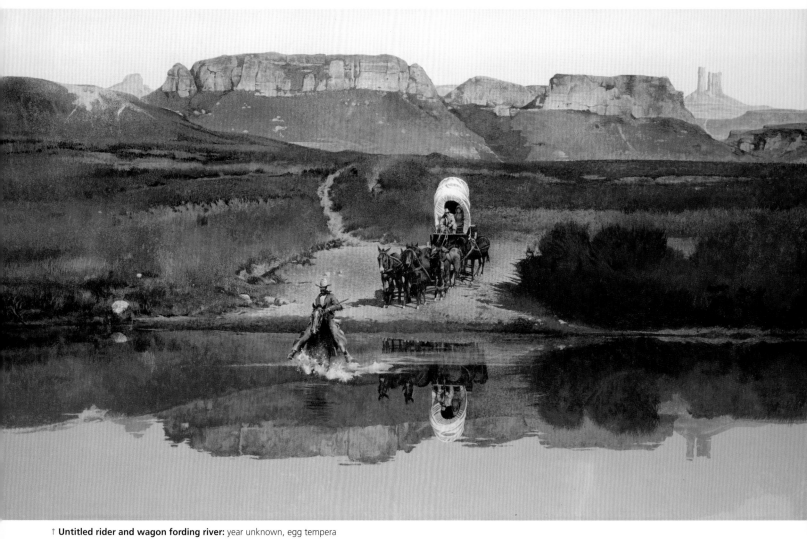

↑ **Untitled rider and wagon fording river:** year unknown, egg tempera

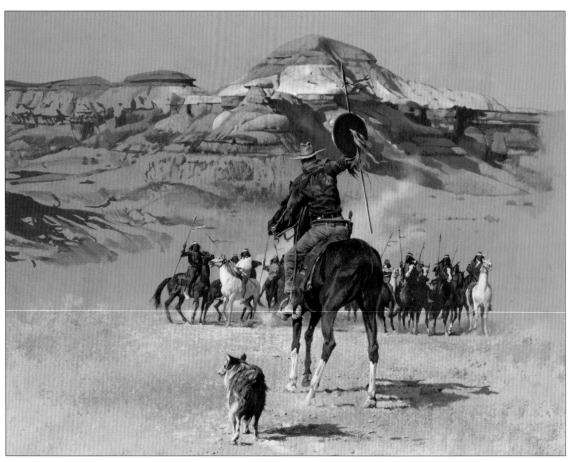

↑ **Hondo:** 1987, egg tempera; Louis L'Amour, Bantam

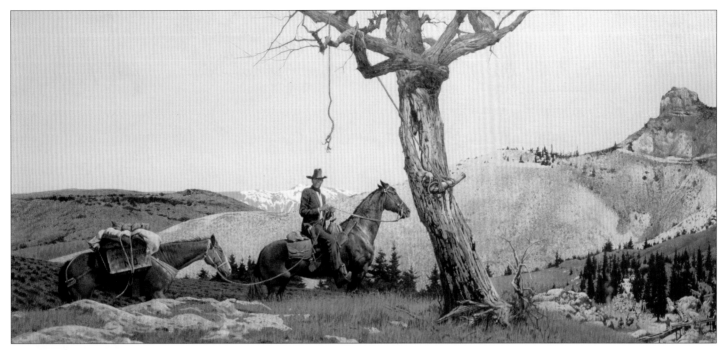

↑ **Hanging Tree:** c.1996, egg tempera

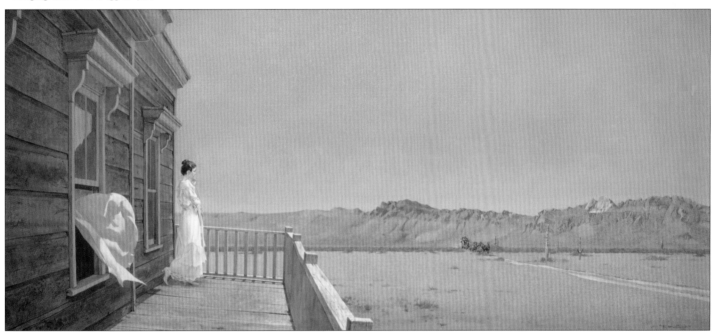

↑ **Clementine:** 2008, egg tempera

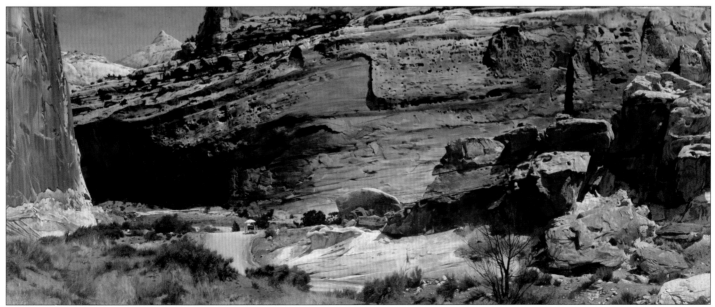

↑ **Capitol Reef:** 1992, egg tempera. This painting won an award from the Art in the Parks program of the National Parks Service.

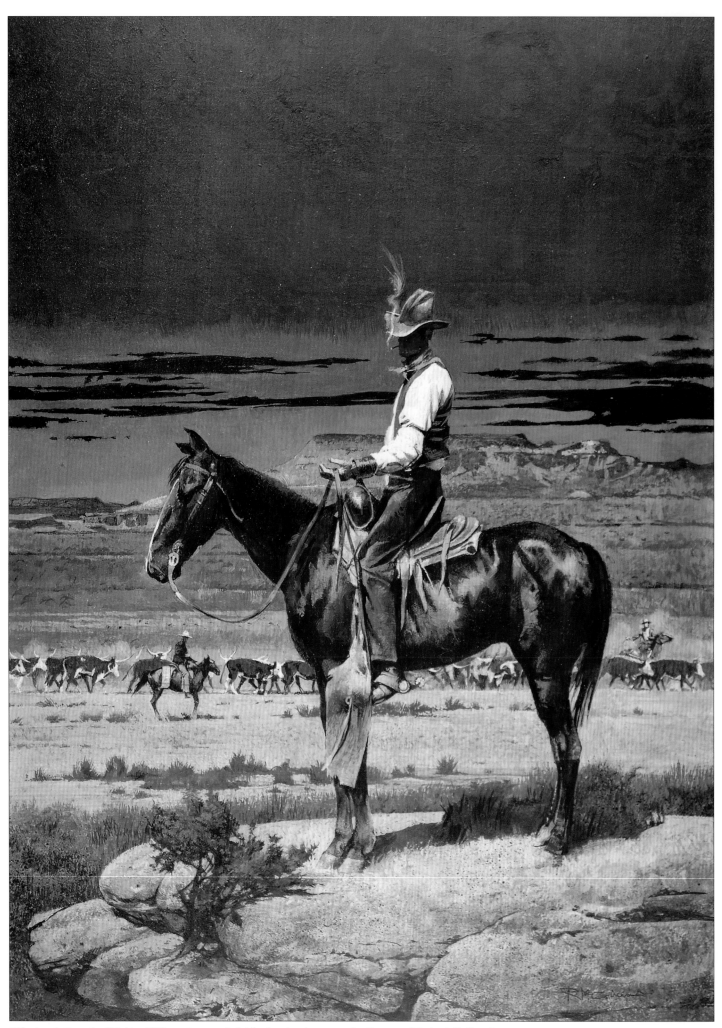

↑ **The Lonely Sounds of Night:** c.1995, egg tempera. A slightly altered version was used as the cover of the book *Six Bits a Day*.

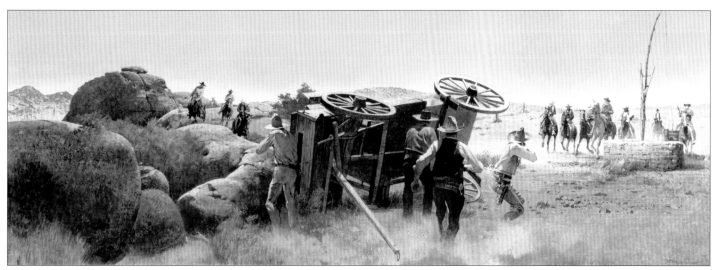

↑ **Range Wars:** c.1996, egg tempera. Appeared on the cover of a book of the same title, but commission unconfirmed.

↑ **Jack Lloyd's Freight Office:** c.1993, egg tempera

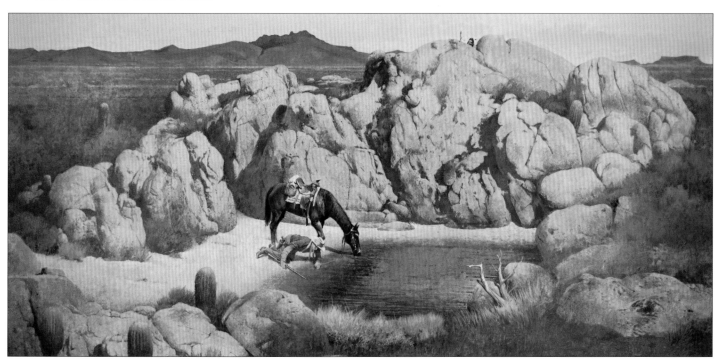

↑ **Apache Wells:** 2011, egg tempera

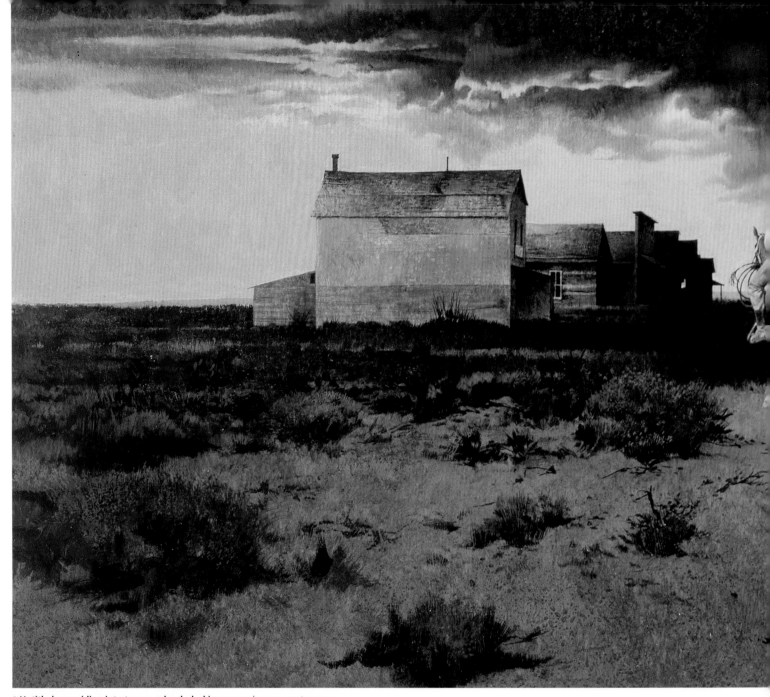

↑ **Untitled men riding into town under dark skies:** year unknown, egg tempera

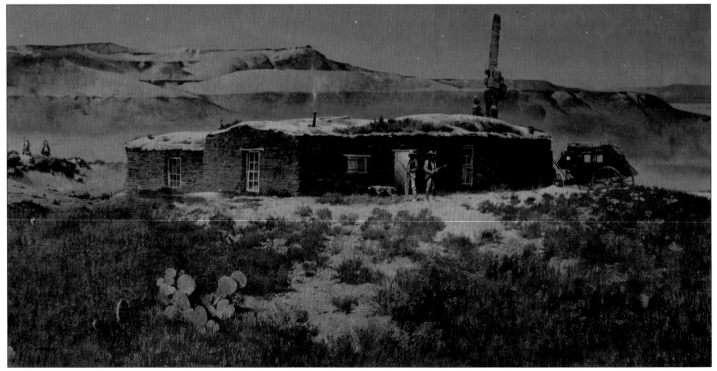

↑ **The Scent of Danger:** c.1997, egg tempera

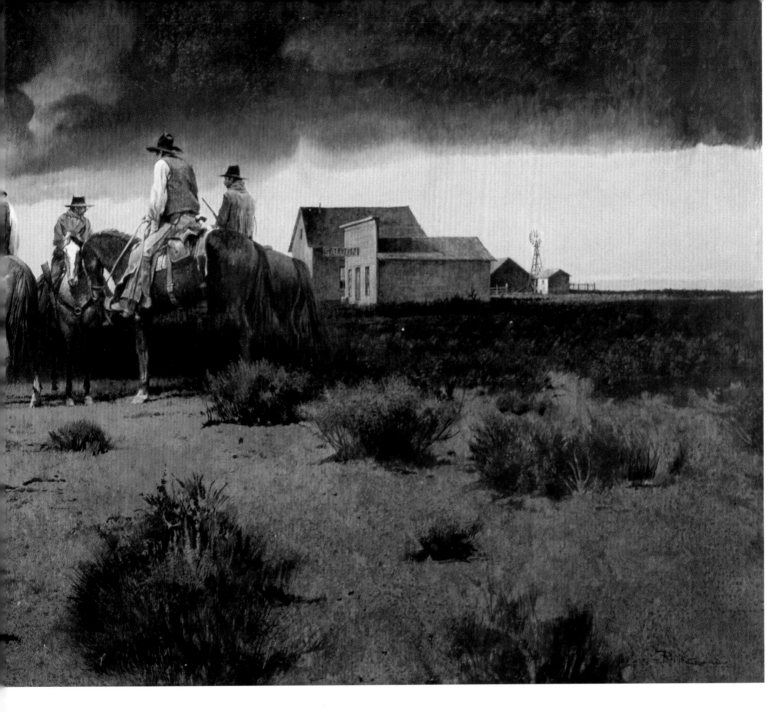

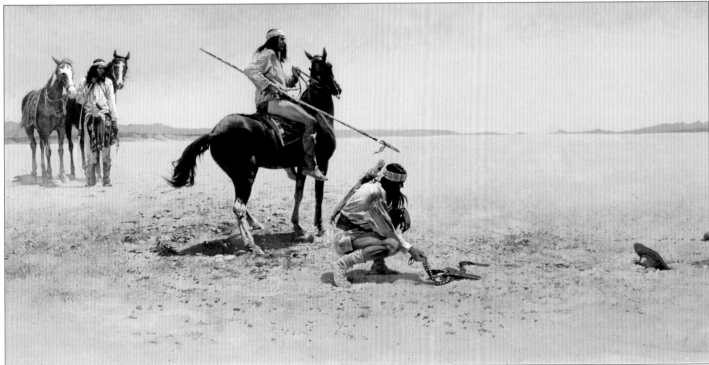

↑ **Apache Pursuit:** year unknown, egg tempera

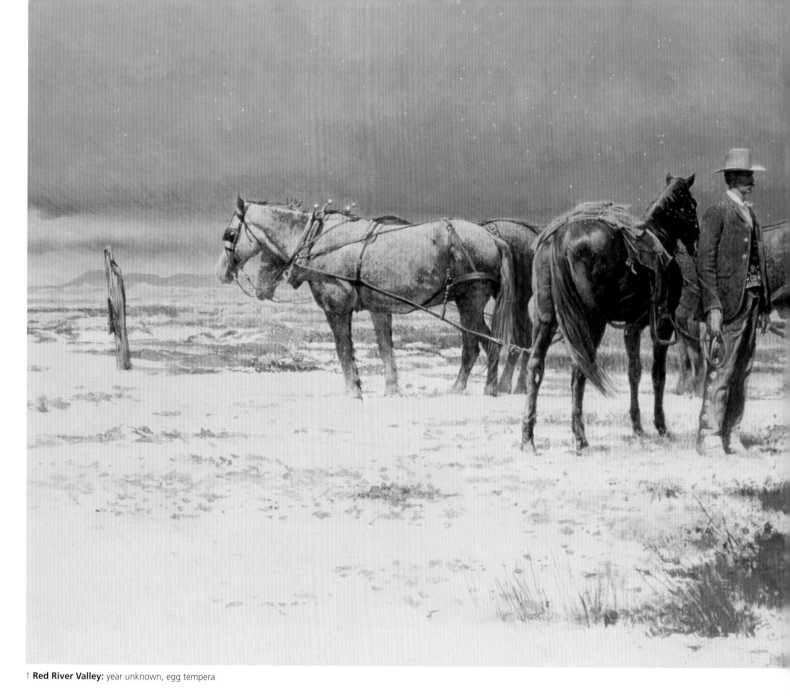

↑ **Red River Valley:** year unknown, egg tempera

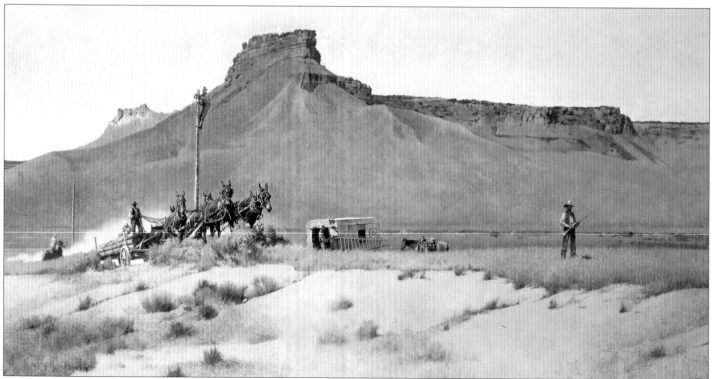

↑ **The Sharp Eye:** c.2000, egg tempera

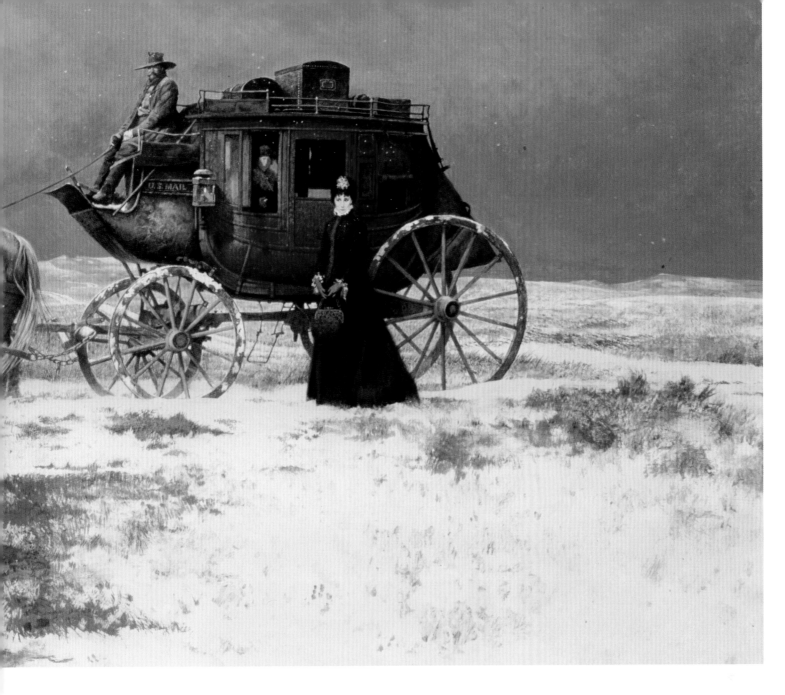

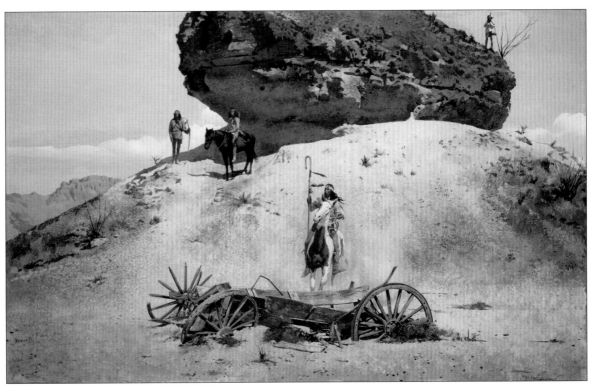

→ **Wagon Wheels:**
1994, egg tempera

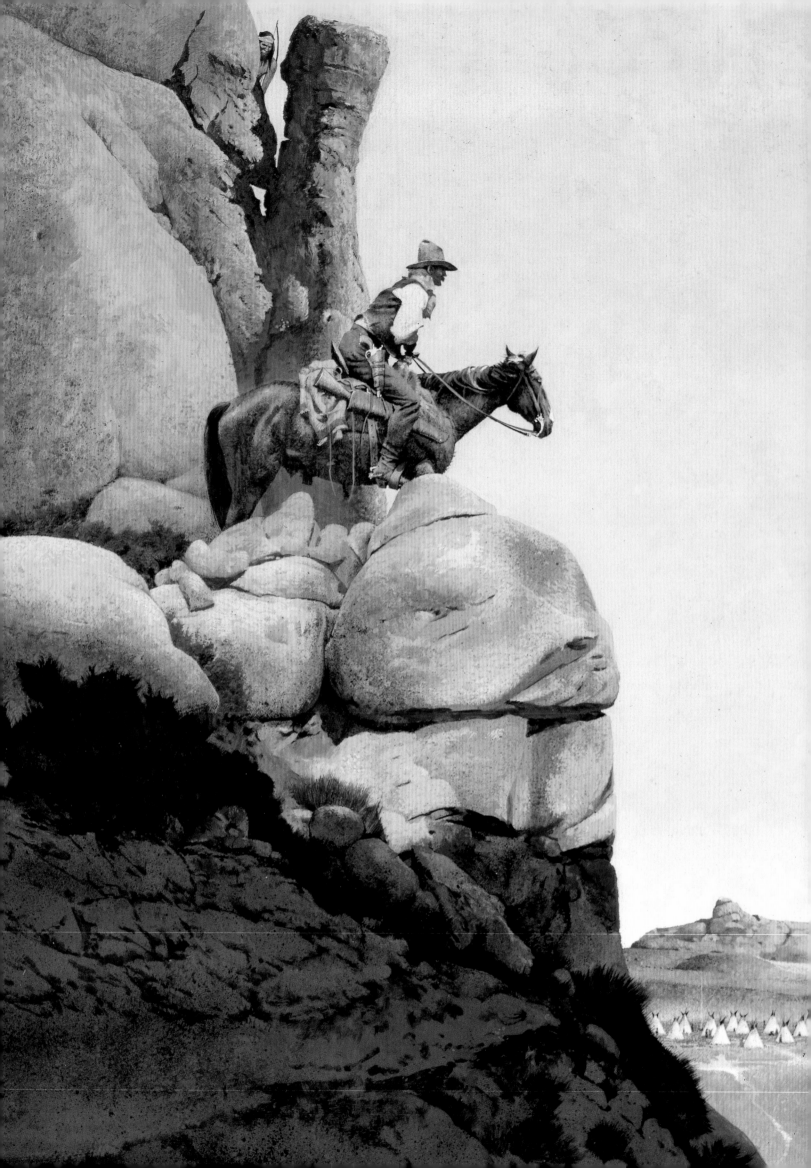

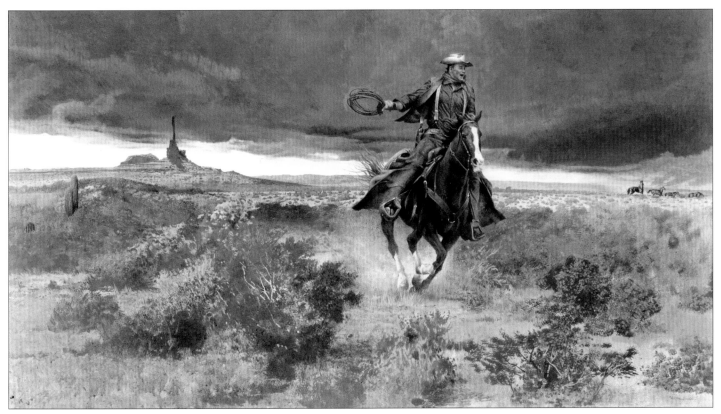

↑ **Stampede!:** c.1994, egg tempera

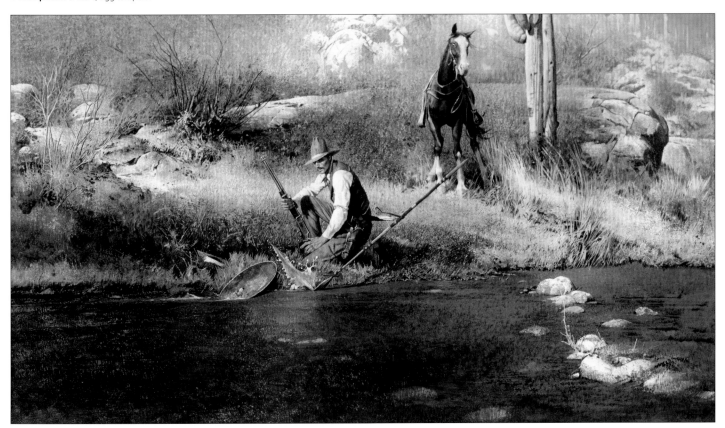

↑ **Gold Dust:** c.1995, egg tempera

← **Point Rider:** c.1996, egg tempera

LANDSCAPES

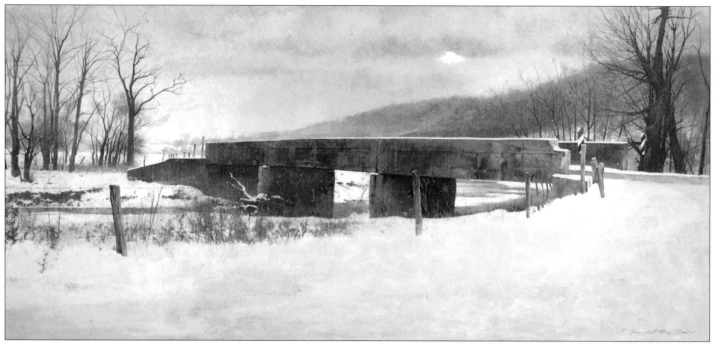

↑ **Indian Creek in Winter:** c.1989, egg tempera

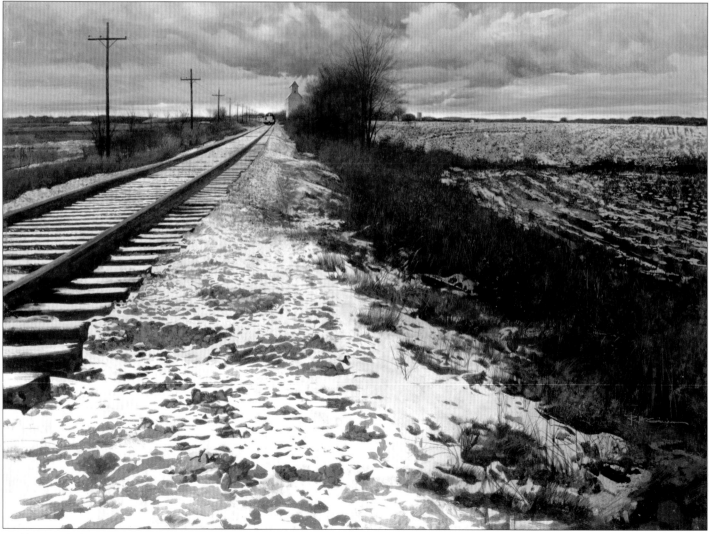

↑ **Baltimore and Ohio:** c.1990, egg tempera

→ **Untitled castle in a river:** c.1998, egg tempera

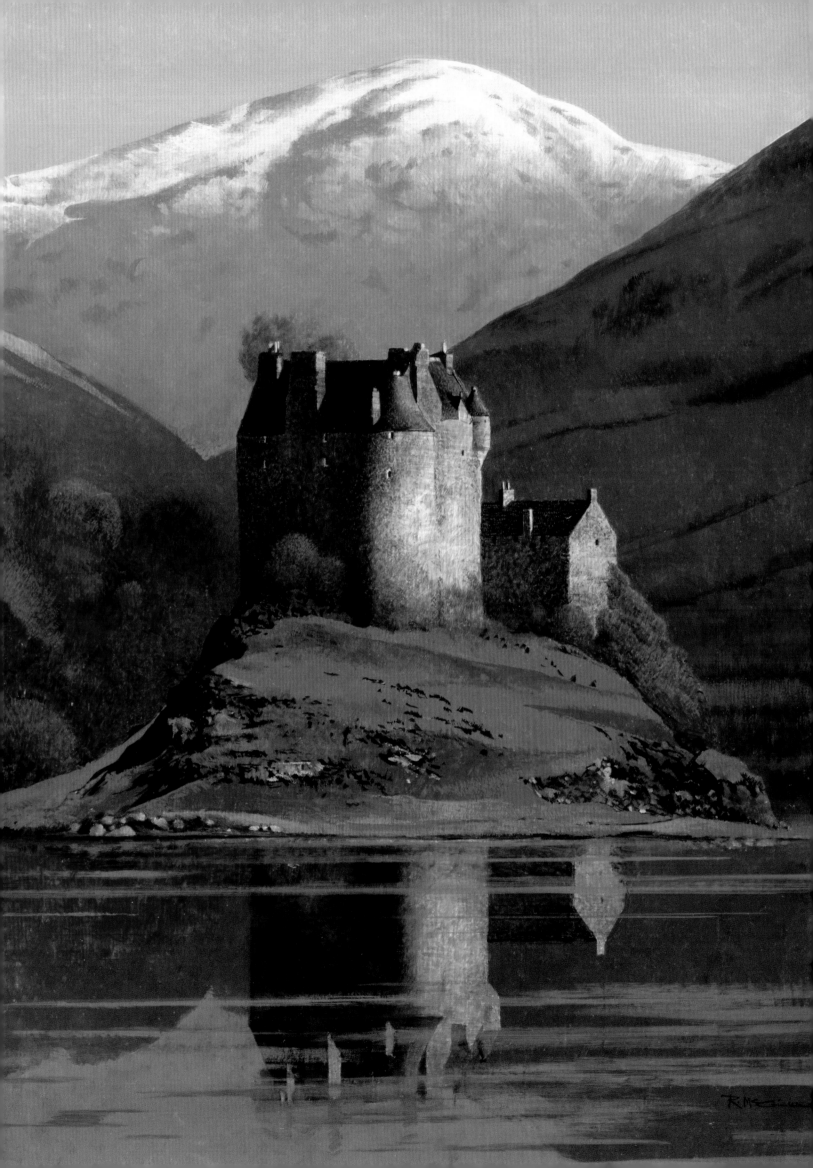

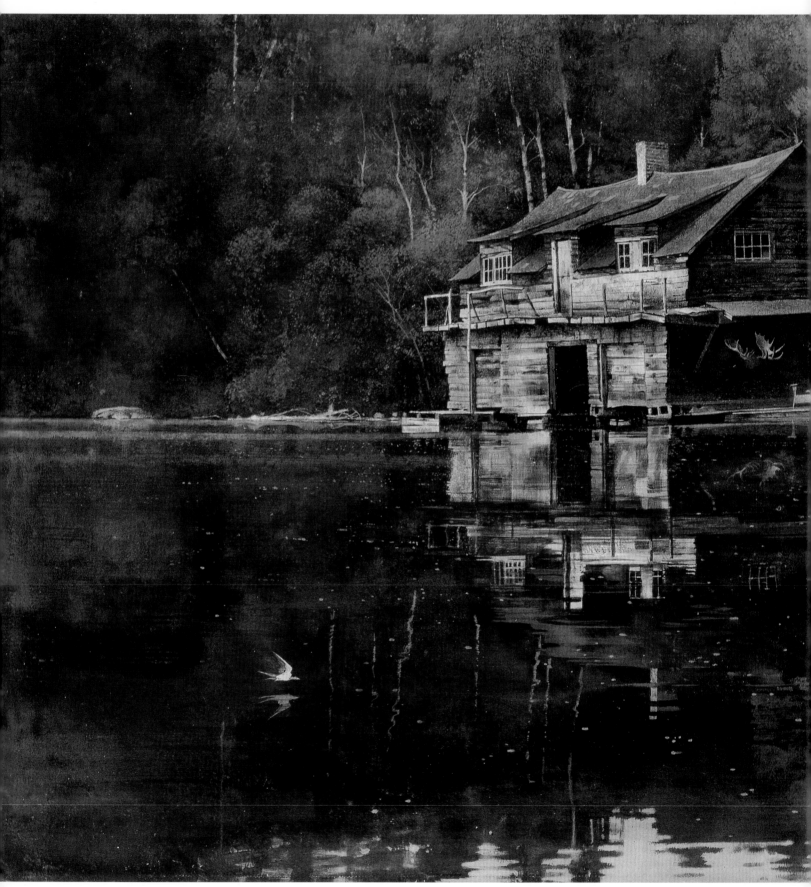

↑ **Spring Returns on Ahmic Lake:** 1994, egg tempera

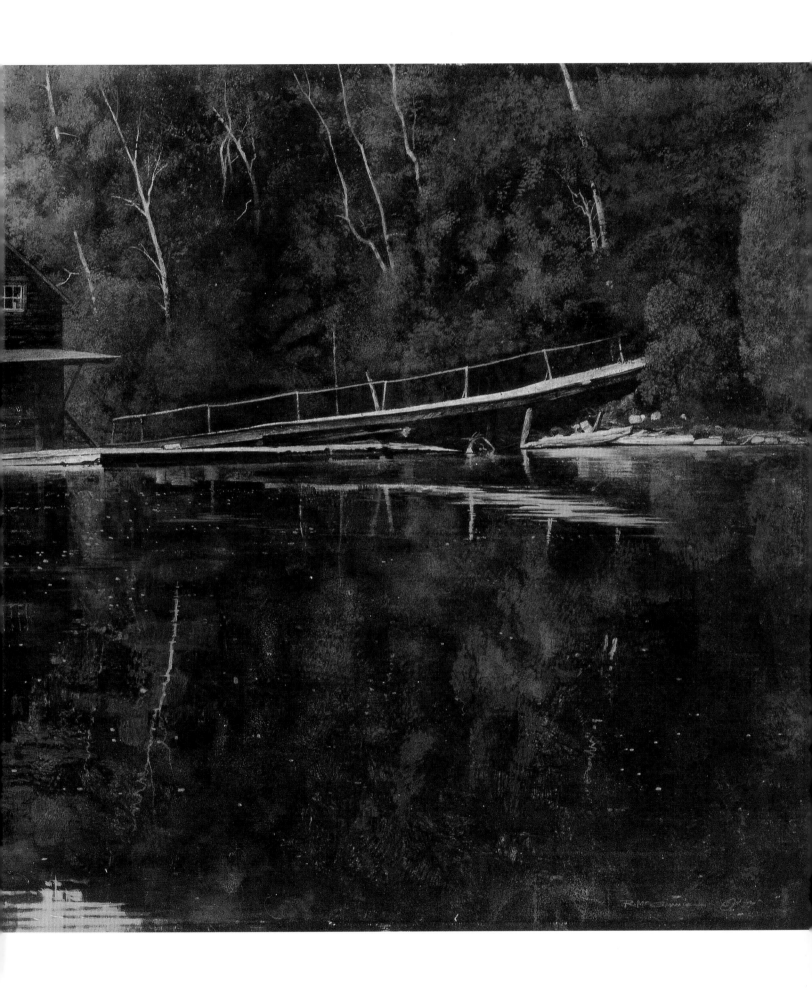

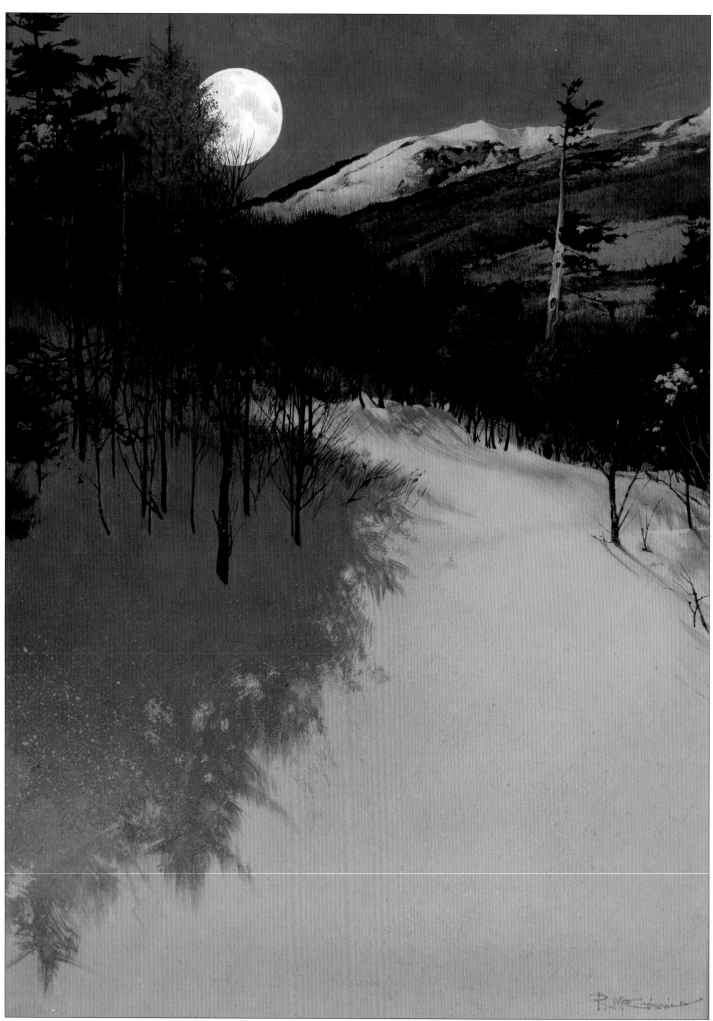

↑ **Moonlight Sonata:** 1992, egg tempera

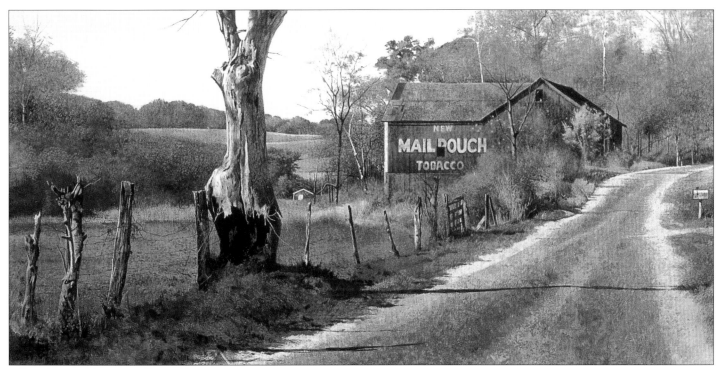

↑ **Ohio Farmstead:** c.1988, egg tempera

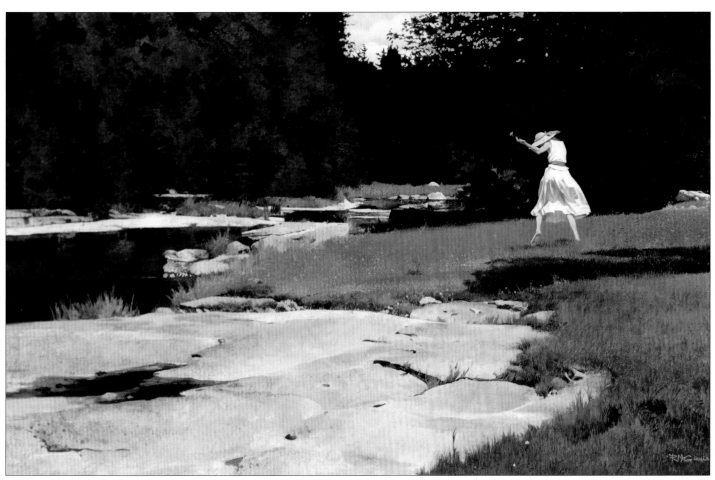

↑ **Lowville Lady:** c.1989, egg tempera

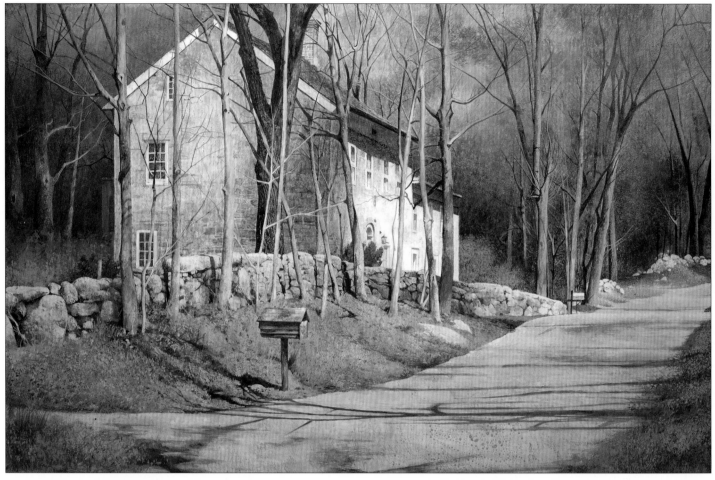

↑ **The Block House – Connecticut 1721:** 2011, egg tempera

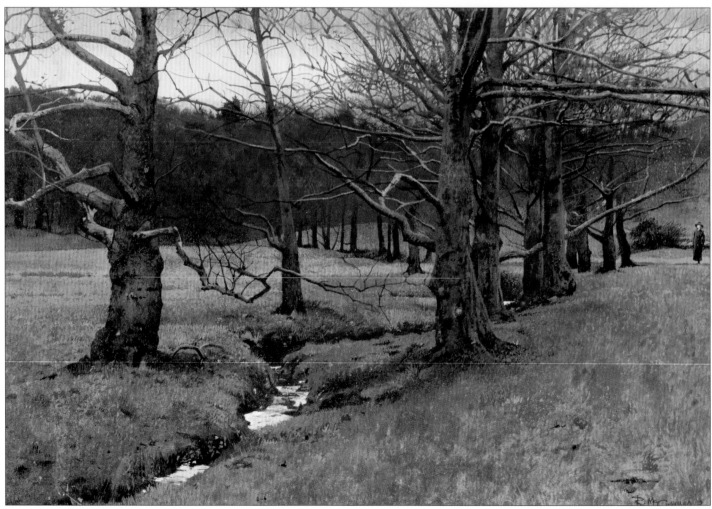

↑ **Pocantico:** c.1992, egg tempera